MW01275176

Rockport Publishers, Inc.
and
Allworth Press

R A

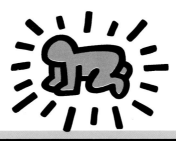

MARKETING BY DESIGN

Design-Driven Merchandising

"*Passion removes all doubt.*"
–Paula Cole. ABC Carpet & Home

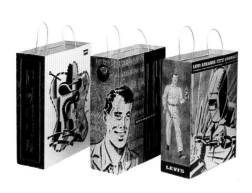

DK HOLLAND *with* SHERWIN HARRIS

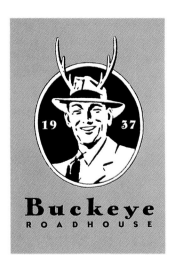

*First published in the United States by Rockport/Allworth
Editions, a trade name of Rockport Publishers, Inc. and
Allworth Press.*

*Rockport Publishers, Inc.
146 Granite Street
Rockport, Massachusetts 01966
Telephone: 508.546.9590
Facsimile: 508.546.7141*

*Allworth Press
10 East 23rd Street
New York, NY 10010
Telephone: 212.777.8395
Facsimile: 212.777.8261*

*Distribution to the book and art trade in the United States
and Canada by: Consortium Book Sales & Distribution, Inc.
1045 Westgate Drive
Saint Paul, MN 55114
Telephone: 612.221.9035
 800.283.3572*

*Distributed to the book and art trade throughout the rest of the
world by: Rockport Publishers, Inc. Rockport, Massachusetts 01966*

*ISBN: 1-56496-109-5
Printed in Hong Kong*

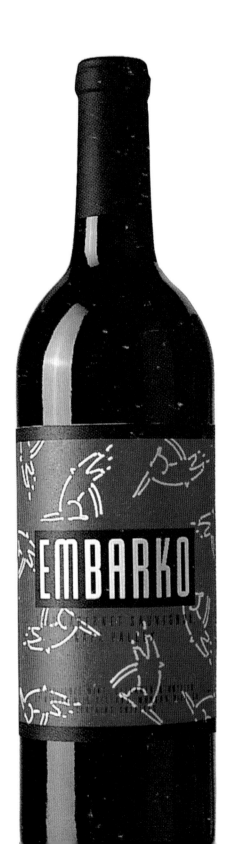

CONTENTS

DESIGN–DRIVEN MERCHANDISING
Over a dozen great examples of marketing success... by design.

CONTENTS *continued*

DRIVEN TO DESIGN

About the graphic designers who devote their careers to the perfection of the expression of design.

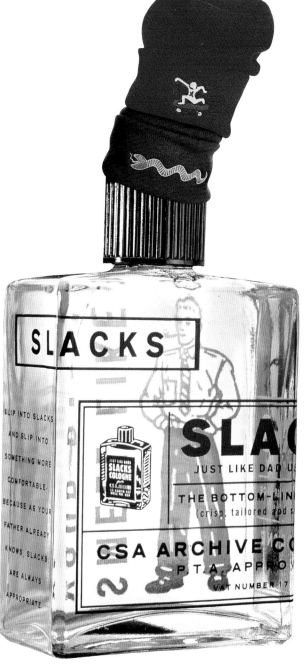

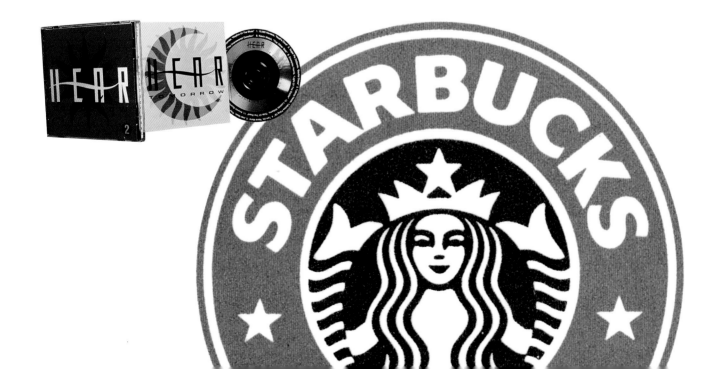

ACKNOWLEGMENTS

BRANCHING OFF INTO A NEW FORMAT FOR A BOOK IS A RISKY ONE FOR ANY PUBLISHER. BOOKSELLERS ARE USED TO SELLING BOOKS ON GRAPHIC DESIGN IN DISTINCT, NARROW CATEGORIES SUCH AS A BOOK ON RESTAURANT GRAPHICS OR A BOOK OF LETTERHEADS. TAD CRAWFORD OF ALLWORTH PRESS HAD THE COURAGE TO SUPPORT A DIFFERENT KIND OF BOOK, ONE MORE CONCEPTUAL—LIKE *MARKETING BY DESIGN*. HE THEN HAD THE VISION TO INCLUDE ROCKPORT PUBLISHERS AS CO-PUBLISHERS OF THE BOOK. ROCKPORT PUBLISHERS' STAN PATEY AND ARTHUR FURST ADDED THEIR INVALUABLE PUBLISHING AND SALES EXPERTISE AND WISDOM THROUGHOUT THE PROJECT.

THANKS TO TED GACHOT AND REBECCA HOROWITZ WHO EDITED THIS BOOK. LAURA BERKOWITZ WHO, WHILE A GRADUATE STUDENT AT PRATT INSTITUTE, HELPED TO CONTACT THE DESIGNERS IN THE BEGINNING. SIVAN BEN-HORI, A DESIGN STUDENT AT THE FASHION INSTITUTE OF TECHNOLOGY, DEVOTED MANY HOURS WORKING WITH THE PARTICIPANTS TO HELP THEM FEEL COMFORTABLE WITH THEIR SECTIONS AND ADVISE THEM IN GENERAL ABOUT THE NATURALLY SLOW PROGRESS OF THE BOOK. SHERWIN HARRIS, WHO TOOK OVER CHERYL LEWIN'S ROLE IN THE DESIGN AND ART DIRECTION OF THE BOOK EARLY ON IN THE PROJECT, IMMEDIATELY INJECTED HIS WHOLE HEART AND SOUL INTO THE PROJECT. SHERWIN TOOK ON THE DAUNTING TASK OF DESIGNING A FORMAT THAT LET THE BOOK LOOK CONTEMPORARY WITHOUT OVER-SHADOWING THE DESIGNERS' WORK. UNDER SHERWIN'S TUTE-LAGE WERE DESIGNERS MEREDITH HARTE, LARRY WAMPLER, ANDREA AMADIO, SUSAN P. HAMBY, AND JAN BOROWICZ.

BUT IT WAS STEVEN BROWER (IF YOU CAN BELIEVE THIS) WHO TOOK OVER PRODUCTION FROM SHERWIN WHEN HE HAD TO LEAVE THAT ROLE IN THE BOOK. STEVEN RAN THIS FOOTBALL FOR THE TOUCHDOWN AFTER THREE YEARS IN THE WORKS. A SPECIAL THANK YOU GOES TO JENNIFER KRIEFF, KATHRIN BLOM AND BARBARA DIPAOLA WHO CAME IN AT THE FINAL AND CRUCIAL MOMENTS OF THE PROJECT AND CONTRIBUTED THEIR TIME, SKILLS AND FINE EYE FOR DETAILS, UNDER SHERWIN'S WATCHFUL EYE, MAKING THE BOOK EVEN MORE PERFECT. WORKING UNDER A TIGHT DEADLINE, BARBARA COMPLETED THE LAST DETAILS OF THE BOOK WITH THE KIND OF STRONG DEDICATION THAT'S AMAZING TO FIND IN ONE WHO ENTERED THE PROJECT SO FAR ALONG. FINALLY, WE WISH TO THANK THE PEOPLE AT REGENT PRINTING IN HONG KONG FOR THEIR ARTFUL HANDLING OF THE PRINTING PROCESS.

As many good notions do, the motivation behind this book came from a need: The need to make the world aware of the creative and intellectual abilities that graphic designers bring to the marketing of products, the value of that process and its resulting expressions.

Merchandising by Design was conceived of by Cheryl Lewin and myself. We approached Rockport/Allworth Editions about a notion that merchandising is at its best when all possible components work in harmony: to create a consistent image which supports the marketing strategy—advertising complements store design, packaging, and promotional materials that helps to reinforce the image—and, ultimately, sells the product.

Unfortunately (or fortunately, depending on how you look at it), the sales force didn't *get* what merchandising meant. We realized the title was too esoteric, so we changed the name to *Marketing by Design*. However, when you look through the book, if you think of merchandising as anything that helps to get products to market, you got the gist of what Cheryl and I were thinking. Marketing is more of a broad concept that includes services and many other categories beyond consumer products. Albeit, it is simply a more familiar word to our audience (hence, a better *merchandising* word).

There are two sections to the book. The first section shows the products and stories of the people who do it all: how they approached their merchandising/marketing objectives, what makes them tick, and what sells. The second is a section of graphic designers and design firms who are often commissioned by clients (entrepreneurs, manufacturers, retailers) to communicate the goal, strategies or marketing plan in order to merchandise the products. Designers become familiar with the client's goals, the value of the client's offering (retail store, catalog, product line), and move forward together to develop a design strategy including advertising, in store displays, packaging—all the things that Cheryl and I mentioned in our initial proposal—to its fullest potential.

Although Cheryl Lewin left the project early to pursue new opportunities, the book still represents some of the terrific vision she had originally brought in. Before Cheryl left we asked Harry Murphy, the original designer of the Gap, to write the introduction. As Cheryl said, "He's a legend." He complied with his usual enthusiasm. But, I am sad to say, Harry Murphy died in July of 1994. I dedicate this book to him: it's the kind of spirit Harry had that we emulate here—intuitive, courageous, curious and unique.

The design firms were told up front that this book required financial participation to help defray costs in order to be published. In fact, this book could not exist without that investment. Nonetheless, this book was very, very difficult to do. Sometimes it felt like I was crawling across the Mohave Desert on bare knees at high noon with no canteen.

But, at the end of the day, the passion did remove all doubt—it was passion that saw me through to end of this project.

DK Holland

Dedicated to a design legend

Harry Murphy was an original: An inspiration to many designers and clients, he brought a keen sense of the simplicity of design to the retail environment. Perhaps his greatest claim to fame was the original design of the Gap. He made a deal with Don Fisher who owned the Gap. "Show me the retail world and I'll teach you about design," Harry said. This long-lasting relationship served both well.

Murphy, who was known affectionately by designers as Mr. Helvetica, had a design studio in Marin County, California until he was diagnosed in 1994 with cancer. I visited him there around that time, having not seen him for almost 15 years. A sign with his moniker, Harry Murphy+Friends typeset in the upper and lower case tight-but-not-touching Helvetica medium, greeted me outside his door. Harry, a bit softer—less the star, more the man—greeted me. We spoke for several hours of the old days and days to come. At that point, Harry was a well man.

This book is dedicated to the memory of a iron-willed designer who never waivered to the ebbs and flows of style trends: A story-teller who illuminated a path to understanding for many young designers, myself included: Harry Murphy 1935 to 1995.

INTRODUCTION

Design-driven merchandising

"PASSION REMOVES ALL DOUBT," SAYS PAULETTE COLE, THE INSPI-
RATION BEHIND THE EXPANSION OF ABC CARPET AND HOME IN
NEW YORK. PASSION, SHE EXPLAINS, IS HER GUIDE. SHE KNOWS
THE WAY PEOPLE FEEL ABOUT THEIR HOMES AND THE OBJECTS THEY PUT IN THEIR
HOMES. SHE HAS DEVELOPED A PHILOSOPHY OF DESIGN THAT, COUPLED WITH HER
OWN INTUITION AND GOOD EYE FOR DESIGN, HAS RESULTED IN ONE OF THE MOST
AMAZING STORES OF THE 1990S.

"SO WHAT DO WE DO NEXT?" ASKS HER STAFF WHEN THEY ARE FACED
WITH THE TASK OF ORGANIZING A NEW PART OF THE STORE. HER ANSWER, "I
HAVE NO IDEA." THAT'S BECAUSE THINGS JUST COME TO PAULETTE COLE, AS IF
EAGER TO CHANNEL FOR THE SPIRITS WHO DELIGHT AND INSPIRE HER. AND AT
THE END OF THE DAY, A NEW PART OF THE STORE EXISTS: IN ITS BRILLIANCE, IT
IS PERFECT AND PAULETTE COLE CAN NOT TELL YOU HOW IT CAME TO BE.

COLE IS NOT ALONE: MOST OF THE INDIVIDUAL ENTREPRENEURS
INCLUDED IN THIS BOOK SHARE A COMMON *MODUS OPERANDI*. AND THOUGH
THEY DIFFER IN DESIGN ATTITUDES, PASSION IS ALWAYS THE KEY. BEYOND THE
OBVIOUS MOTIVATION (TO MAKE A LIVING) THERE IS A PRIMARY SOURCE OF
INSPIRATION (AN INVENTION, A HOBBY, A LOVE) COMBINED WITH TALENT AND
WILL THAT DRIVES THEM. THESE ENTREPRENEURS CAN NOT ARTICULATE NOR
CAN THEY FORMULATE HOW THEIR SUCCESSES CAME TO BE: IN FACT THEY OFTEN
SAY THAT SUCCESS CAME IN SPITE OF THEMSELVES.

Parallel to the essay "Design-driven Merchandising",
the next 16 pages gives examples of anti-marketing. A
bit of irony: an anti-mall, an anti-marketeer and an
anti-catalog, all whimsical responses to the excesses
of marketing in the end the same century in which
marketing was born and flourished.

The central livingroom in The Lab (left), the anti-mall in
Costa Mesa, CA, provides a comfortable place for shoppers
to feel right at home—a statement about the anonymity
of American malls.

How things got turned around

PRODUCT MARKETING AND DESIGN SHARE A COMMON DENOMINATOR WHERE THEY MAY ACHIEVE HARMONY: PEOPLE. PEOPLE (EACH A THUMBPRINT; A UNIQUE ENTITY) PROVIDE A FOIL FOR DESIGN (I.E. PLANNING). PRODUCT MARKETING HAS IMPLIED IN ITS DEFINITION 'MASS MARKET APPEAL'. IF THE DEFINITION OF MARKETING IS TO BRING A PRODUCT TO THE PEOPLE, THE IDEA OF APPEALING TO A MASS AUDIENCE IS OFTEN IN CONTRADICTION TO THE WILL OF THE INDIVIDUAL. TO UNDERSTAND WHERE THE IDEA OF 'MASS MARKETING' COMES FROM, YOU NEED ONLY LOOK BACK ONE-HUNDRED YEARS. UP UNTIL THE INDUSTRIAL REVOLUTION, STORES AND MANUFACTURERS WERE EXTREMELY PAROCHIAL AND HUMAN BASED. THE PRIVILEGED CLASSES, SMALL IN NUMBER, WERE THE CONSUMERS OF HIGH-END PRODUCTS AND GOODS PROVIDED BY WORKERS WHO MADE AND PACKAGED THEM BY HAND AND PRODUCED THEM IN SMALL QUANTITIES FOR IMMEDIATE DISTRIBUTION. THE WORKERS, ON THE OTHER HAND, WERE CONSUMERS AS WELL, BUT OF A MORE PRAGMATIC NATURE: DRY GOODS, SENSIBLE CLOTHING, FOOD, DISHWARE, COOKING WARE.

WEALTHY VICTORIANS COLLECTED EGYPTIAN ARTIFACTS, ORIENTAL RUGS, JAPANESE PRINTS AND OTHER EXOTIC TREASURES DURING THEIR TRAVELS. FASCINATED BY THE MYSTERIOUS AND GLAMOROUS, THE UPPER CLASS DEVELOPED A TASTE FOR THE UNUSUAL, OFTEN FOR THE BIZARRE.

BUT WITH THE LANDSLIDE OF MECHANICAL INVENTIONS NEAR THE TURN OF THE 20TH CENTURY, COUPLED WITH THE DEVELOPMENT OF MODERN TRANSPORTATION AND COMMUNICATION, IT BECAME CLEAR THAT THE WORLD WAS SHRINKING.

A symmetrically distressed entrance to the Lab, (above). A hall in The Lab (bottom) is decorated by discarded junk furniture given a fresh paint job. Crew, the store in the photograph, is a counter culture hair salon.

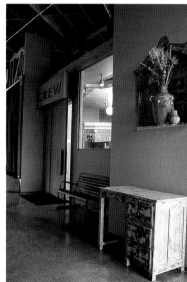

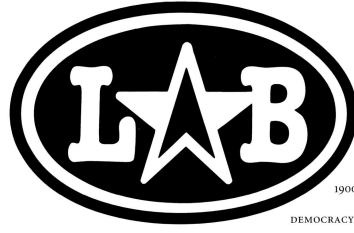

The Lab logo (above). Unlike the glorious centerpieces in many of the malls across the country, The Lab 'anti mall' installed a steel drum water fountain (below) as one of its many sophisticated counter-cultural statements.

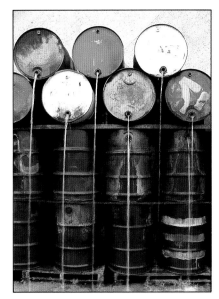

THE DEMAND FOR VARIETY, AND THEREFORE, THE TASTE FOR ECLECTICISM, WAS BROADENING. THE LINES THAT DIVIDED THE CLASSES STARTED TO BLUR.

THE WORKING AMERICAN WAS GAINING GROUND IN THE EARLY 1900S: SUFFRAGISTS WERE FIGHTING FOR VOTING RIGHTS AND DEMOCRACY WAS ON THE RISE, WHILE THE AMERICAN WHITE ARISTOCRACY'S POWER WAS STARTING TO SLIP. IN EASTERN EUROPE, THE SOCIALIST MOVEMENTS EXPLODED, ARISTOCRATIC RULE WAS CRUMBLING THERE TOO. A NEW WORLD ORDER WAS STARTING TO FALL INTO PLACE: IN OTHER WORDS, NEW MARKETS WERE BEING CREATED WITH FAR LARGER NUMBERS, MORE BUYING POWER AND WIDER INTERESTS THAN EVER BEFORE. THE BIG QUESTION WAS (AND STILL IS) "HOW DO YOU REACH THIS AUDIENCE, CAPTURE THEIR INTEREST AND MAKE THEM WANT TO BUY?"

IN POLYGLOT AMERICA, THE WEST WAS WON AND COMMERCE BOOMED. NOUVEAU-RICHE FAMILIES EMERGED IN CALIFORNIA, FOR INSTANCE, HAVING AMASSED FORTUNES IN GOLD AND SILVER. ORANGES WERE SHIPPED IN CRATES FROM THE GOLDEN STATE OF CALIFORNIA IN RAILROAD CARS. ON THOSE ORANGE CRATES WERE LABELS (SOMETIMES WITH REAL GOLD DUST ON THE LETTERING OR BORDER) THAT REPRESENTED ONE OF THE FIRST ATTEMPTS TO MARKET A PRODUCT TO A BROAD GEOGRAPHIC/SOCIO-ECONOMIC AUDIENCE.

SINCE ORANGES ALL LOOK PRETTY MUCH ALIKE, ORANGE GROVES WERE DIFFERENTIATED BY THEIR LABELS. WHEN THE LABEL SALESMAN CAME ON A SALES CALL TO THE GROVES, THE ORANGE GROWERS AND SALESMAN CONCOCTED THE LABEL'S IMAGE TOGETHER. LIKE MUCH OF THE MARKETING APPROACHES THAT WERE TO COME, THE LABELS WERE BASED ESSENTIALLY ON THE WISHFUL THINKING AND WHIMSY OF THE GROWER. SOME OF THE IMAGES WERE QUITE OUTLANDISH: THE WONDERLAND BRAND LABEL ILLUSTRATED A SCHOOL TEACHER IN A CLASSROOM POINTING TO A MAP THAT SHOWED HER SMALL STUDENTS THAT

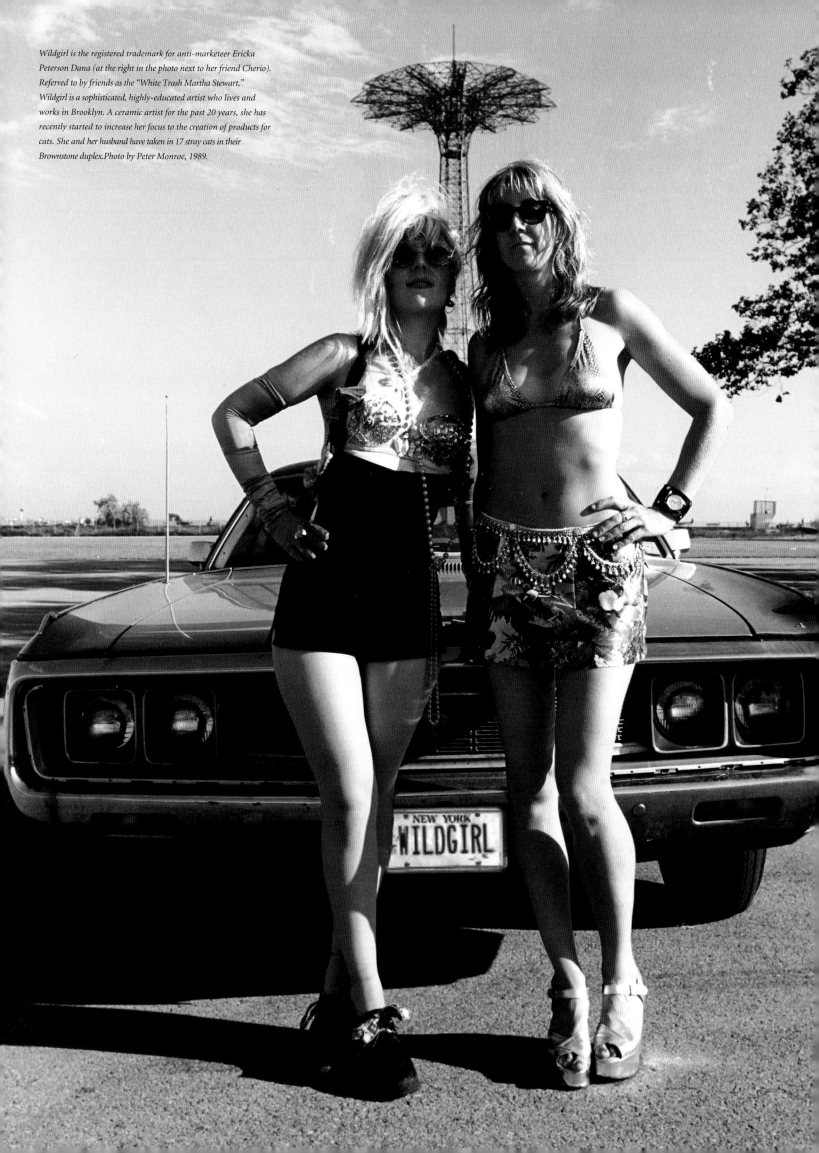

Wildgirl is the registered trademark for anti-marketeer Ericka Peterson Dana (at the right in the photo next to her friend Cherio). Referred to by friends as the "White Trash Martha Stewart," Wildgirl is a sophisticated, highly-educated artist who lives and works in Brooklyn. A ceramic artist for the past 20 years, she has recently started to increase her focus to the creation of products for cats. She and her husband have taken in 17 stray cats in their Brownstone duplex. Photo by Peter Monroe, 1989.

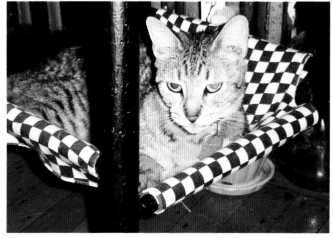

"Wonderland" was somewhere between Santa Barbara and Los Angeles. For all those on the rest of the country knew, this could well have been true. The brand Oriole shows this wild bird flying over the lush orange groves. Three frogs forming a fife and drum core marching across a swamp in full regalia became the identity for Yankee brand. Interestingly, since few Easterners had actually been that far west, a myth developed that lingers yet: The myth of the land of plenty illustrated on the crate label—California, a fantasy land.

The new American aristocracy—the industrialists—started to see that competitive mass marketing was the wave of the future for the sale of goods and services. But devoid of packaging until this time, a dry-goods store owner, for example, would arrange decorated boxes and tins of food of other products just to attract the eye; much the way the orange growers put their oranges in crates, and obviously, for the same reasons.

Concurrently, in Europe, a collective of artists, architects, industrial and graphic designers, known as the Bauhaus, started in Germany in 1919 to help make the shift from craft-oriented production to mass production in order to accommodate the needs and desires of the proletariat population. The Bauhaus included great minds such as

A patent-pending chair hammock for cats (top) designed specifically for small apartments. The model is Mommy, one of Peterson Dana's 17 former strays. She has cared for an additional 20 strays to become "renovated" (i.e., all testing, appropriate shots, flea bath, neutering) and then adopted. A catnip-filled rat designed by Wildgirl (above, shown 80 percent of actual size) has several functions. "Once they kill it, they use it as a pillow," says Peterson Dana with a glint in her eye. "And you can just put in the washing machine and dryer when it gets too dirty."
Rat Photo by Vinitsky/Solomita

LASZLO MOHOLY-NAGY, WASSILY KANDINSKY, MIES VAN DER ROHE, PAUL KLEE, JOSEF ALBERS AND WALTER GROPIUS. TOGETHER THEY ESTABLISHED NEW COLOR AND FORM THEORIES, PROBLEM-SOLVING APPROACHES AND PHILOSOPHIES THAT PERHAPS REMAIN THE GREATEST INFLUENCES ON WESTERN GRAPHIC DESIGN TODAY. THEORIES STARTED TO EVOLVE ABOUT THE WAY HUMANS PERCEIVED COMMUNICATION—THEORIES THAT EFFECTED THE MARKETING OF MASS PRODUCTS. FORM FOLLOWS FUNCTION WAS THE RULE OF THE BAUHAUS: IN ORDER TO UNDERSTAND HOW A THING SHOULD BE DESIGNED, ONE HAD TO FIRST UNDERSTAND THE FUNCTION OF THE THING. THEN ONE HAD TO COMMUNICATE WHAT THE THING WAS FOR AND HOW TO EMPLOY THE THING.

BUT THERE WERE THEORIES THAT COMPLICATED THE CONTEXT OF FORM AND FUNCTION. STRUCTURALISM, A DESIGN THEORY DEVELOPED IN FRANCE, WAS LANGUAGE BASED. IN OTHER WORDS, MEANING WAS FOUND IN THE STRUCTURE OF THE WORDS IN A SENTENCE. SO, IN THE COMMUNICATING OF THE WAYS TO USE THE THING, LANGUAGE WAS CRUCIAL. RECEPTIONISM, A THEORY EMANATING FROM EASTERN EUROPE, SAID THAT MEANING ULTIMATELY EXISTED IN THE VALUE SYSTEM AND CONTEXT OF THE RECEIVER. SO IN COMMUNICATING THE ESSENCE OF THE THING AND HOW TO USE IT, IT WAS UP TO THE RECEIVER (I.E. THE INDIVIDUAL) TO INTERPRET ITS VALUE. DESIGN (IN THIS CASE: PACKAGING, PRODUCT, PROMOTION) IS SUPPOSED TO CLARIFY. CLARIFY WHAT? THE WORDS, AS THE STRUCTURALISTS WOULD WANT? OR THE CONTEXT ACCORDING TO THE VALUES OF THE RECEIVER AS THE RECEPTIONISTS WOULD RECOMMEND? OR THE FUNCTION AS THE BAUHAUS ARTISTS WOULD SAY?

Mirror frames, dishware and jewelry are Wildgirl products, all sold wholesale to specialty stores internationally. Wildgirl also designs ceramic flower pots and candlesticks. The marketing of Wildgirl products is minimal, in fact, non-existent. The purpose of her products are so obvious that they need no explanation. Those that know her work, know how to find her.

18

THE BAUHAUS MANAGED TO PRODUCE POWERFUL GRAPHIC AND
COMMUNICATION TOOLS. BY 1939, THE RIGHT-WING ALL-CONTROLLING
NATIONAL SOCIALIST PARTY HAD
REALIZED THE POTENTIAL DANGER THE
INDEPENDENT BAUHAUS REPRESENTED
AND HAD IT SHUT DOWN, ITS BUILDINGS
DEMOLISHED BEFORE WORLD WAR II.
MEANWHILE, THE UNITED STATES, HAVING SUFFERED THROUGH THE GREAT
DEPRESSION OF THE EARLY 1930S, WAS HEALING ITSELF.

ONE OF THE MECHANISMS USED TO RE-CHARGE THE ECONOMY WAS
"PLANNED OBSOLESCENCE." MANUFACTURERS REALIZED THAT IF THEY DESIGNED
GENERIC-LOOKING REFRIGERATORS THAT LASTED THIRTY YEARS,
THEY WOULD SELL FAR FEWER REFRIGERATORS. HOWEVER, IF THE
DESIGN CHANGED AFTER A FEW YEARS THE CONSUMER MIGHT BE
CONVINCED A NEW ONE WAS NEEDED. "KEEPING US WITH THE JONES'S IS"
WHAT PEOPLE CALLED IT. THIS WAS TRUE OF EVERYTHING CONSUMABLE AND
NON-CONSUMABLE, CONFIRMING THAT DESIGN WAS A
TOOL TO INFLUENCE THE MARKETPLACE. MANY
OF THE BAUHAUS DESIGNERS
IMMIGRATED TO AMERICA DURING WORLD
WAR II, BRINGING THEIR THEORIES AND
SENSIBILITIES TO FREEDOM AND A CULTURE THAT WAS
MUCH MORE OPEN TO NEW MEANS OF EXPRESSION.
AMERICANS SLOWLY (AS PART OF THEIR TRANSITION
FROM LIVING WITH THE EXCLUSIVISM OF
THE VERY WEALTHY TO EMBRACING THE
INCLUSIVISM OF THE MIDDLE AMERICAN)
BECAME EVER MORE SOPHISTI-
CATED AND CARING ABOUT
THE THINGS THEY BOUGHT. MOVEMENTS LIKE

STREAMLINE, FUTURISM AND MODERNISM, ALONG WITH REVIVALS OF

MOVEMENTS LIKE ART DECO AND ART NOUVEAU BECAME

HOUSEHOLD WORDS IN MORE SOPHISTICATED CIRCLES.

THERE WAS A PUBLISHER'S CONVENTION IN THE 1970S WHERE

AN EDITOR PRESENTED A BOOK TO THE SALES FORCE CALLED

FROM ART NOUVEAU TO ART DECO ON THE SPRING LIST. A

SALESMAN RAISED HIS HAND, "I KNOW WHO ART DECO WAS BUT WHO WAS

ART NOUVEAU?" THIS WAS A NOT-TOO-SUBTLE REMINDER OF THE LACK

OF ART EDUCATION MANY AMERICANS HAVE, EVEN

THOUGH THE EXPOSURE TO DESIGN AND ART

WAS ALL AROUND, EVERYWHERE.

THE AMERICAN NEW WAVE DESIGNERS

OF THE 1980S, AS THEY WERE CALLED, SHOOK

THINGS UP BY IGNORING *ALL* THE TRADI-

TIONS. AMERICAN GRAPHIC DESIGNERS

LIKE DAN FRIEDMAN AND APRIL

GRIEMAN—FOSTERED BY DESIGN SCHOOLS LIKE CRANBROOK

AND CAL ARTS—STARTED THE NEW WAVE MOVEMENT WHICH

ENCOURAGED LAYERING IMAGERY AND TYPE AND INJECTING

A PERSONAL, AND THEREFORE QUITE INSCRUTABLE, ELEMENT.

UNREADABILITY WAS ALL THE RAGE. IT WOULD SEEM THAT

THIS WAS A TOTAL REJECTION OF FORM FOLLOWING

FUNCTION. THIS OUTRAGED THE MODERNISTS

WHO, OF COURSE, ADHERED STRICTLY TO THAT PHILO-

SOPHICAL CORNERSTONE.

"WHAT IF THE FUNCTION IS TO EXPRESS AN EMOTION?"

THE NEW WAVE DESIGNERS ARGUED. THIS RATIONALE FOR

ILLEGIBILITY OVERRODE THE FUNCTION OF READABILITY. NOW IN

THE 1990S, THIS LOGIC IS HARD TO DENY WHEN DESIGNERS ARE WORK-

ING IN STYLE-DRIVEN INDUSTRIES SUCH AS FASHION AND ENTERTAINMENT.

CONSUMERS IN THESE ARENAS (I.E. A GROUP OF QUIRKY, ALTOGETHER

Wildgirl iconography is conjured up from the essential pri-mal imagery of Peterson Dana's unconscious. "Some of the faces on my critters express the often perilous nature of existence," she says. "People identify with them." (Opposite page) Wildgirl's main sales tool is an actual-size, color copy of her products. "I like the quality the color copy has. Most of my customers know my work well enough to order from it."

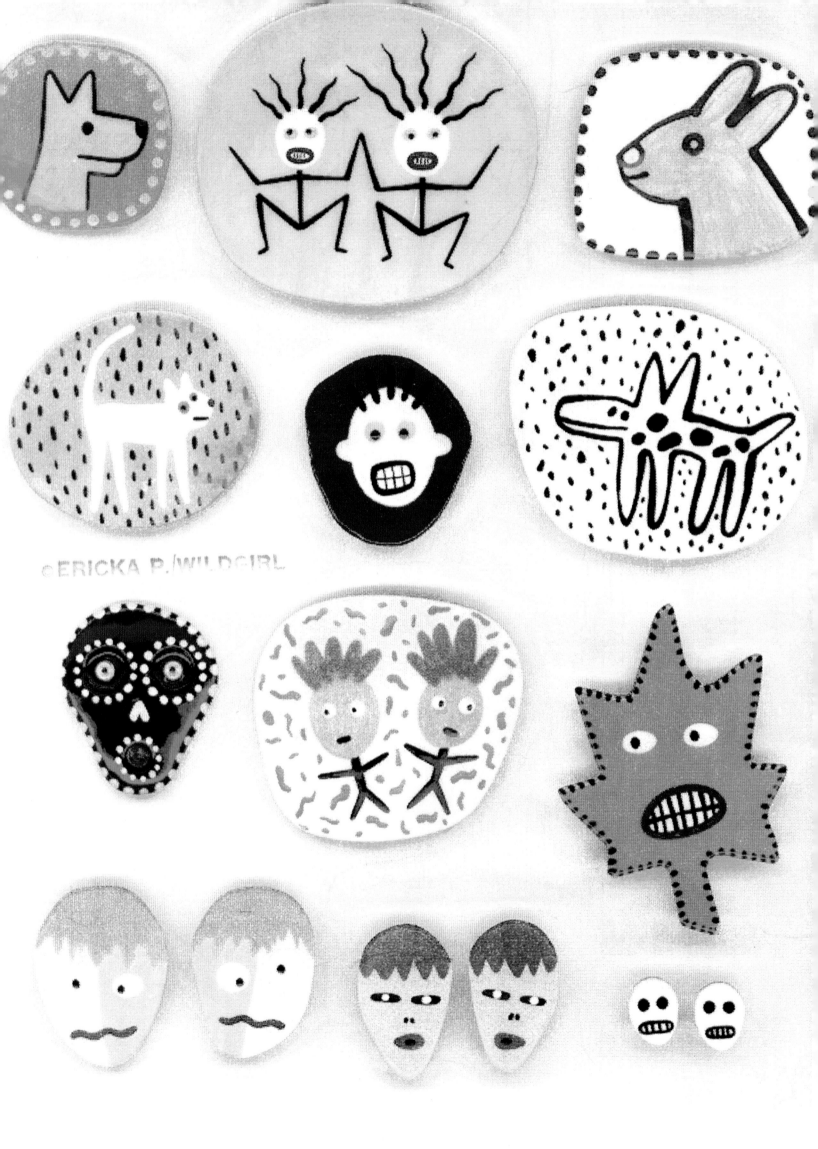

©ERICKA P./WILDGIRL

MERCURIAL INDIVIDUALS) DECIDE WHETHER THE PRODUCT FLIES OR NOT. PERIOD.

IT IS THEREFORE ACKNOWLEDGED THAT FUNCTION IS NOT FUNCTIONAL UNLESS ONE DEFINES THE FUNCTION. IF THE FUNCTION IS TO SELL SOMETHING, PERHAPS IN THE END GREAT DESIGN, WHETHER MODERNIST OR NEW WAVE, MAY OR MAY NOT BE WHAT IS NEEDED FOR *THE THING* TO DO THE JOB THAT NEEDS DOING. IN THE END, IT IS THE MARKETPLACE THAT DECIDES WHAT'S SUCCESSFUL. OR TIMING. OR LUCK. AS A COLLEAGUE OF MINE SAYS, "LUCK IS TIMING."

OFTEN THERE IS NO LOGIC TO IT AT ALL: ECHO PAULETTE COLE, "PASSION REMOVES ALL DOUBT." GO FIGURE.

IF PEOPLE DON'T BUY A PRODUCT WITH A HUNGER AND PASSION IT'S BECAUSE THEY LACK EITHER A DESIRE OR NEED FOR IT. BUT, WE ALSO LIVE IN A WORLD WHERE FUZZY LOGIC IS SUMMED UP WITH A PHRASE THAT IDIOT-SAVANT FORREST GUMP, FROM THE MOVIE OF THE SAME NAME SUPPOSEDLY COINED, "SHIT HAPPENS." OR, TO PUT A MORE GENTEEL SPIN ON IT: THE PROLETARIATS DON'T KNOW MUCH ABOUT DESIGN, BUT THEY DO KNOW WHAT THEY ARE WILLING TO PAY FOR.

A new level of value for visual literacy is emerging

DEMOGRAPHICS WERE SIMULTANEOUSLY DEVELOPED IN THE MIDDLE OF THE CENTURY AS A TOOL FOR RATIONALIZING THE NEEDS AND DESIRES OF THE MASSES. PORTRAITURE AND STATISTICAL DEMOGRAPHICS ARE THE TWO MOST COMMON METHODS USED TO DEFINE AN AUDIENCE TO WHOM THE DESIGNER AND CLIENT "SPEAK." FOR INSTANCE, THE STATISTICAL POPULATION METHOD MIGHT STATE: "50,000 HOUSEHOLDS IN DES MOINES, IOWA TOTAL 250,000 INDIVIDUALS. AN AVERAGE OF $500,000 WORTH OF GROCERIES IS PURCHASED PER WEEK BY THESE HOUSEHOLDS." WHEREAS A COMPOSITE PORTRAIT MIGHT SAY: "THE HOUSEWIFE IN DES MOINES HAS ONE AND A HALF CHILDREN, A HUSBAND, AND BUYS $100 WORTH OF GROCERIES FOR HER FAMILY EACH WEEK." BOTH ARE DIFFERENT WAYS TO SAY MORE OR LESS THE SAME THING.

TODAY, WE KNOW THIS ISN'T TRUE. THERE MAY *INDEED BE* 250,000 INDIVIDUALS IN DES MOINES. ONE OF WHOM IS A SINGLE MOM NAMED LORRAINE; SHE'S BLACK, HAS AN EXECUTIVE LEVEL JOB AND LIKES TO ROLLER BLADE ON WEEKENDS WITH HER TWO KIDS. THEY EAT OUT A LOT BECAUSE SHE HAS LITTLE TIME TO COOK SO SHE DOESN'T GROCERY SHOP EVERY WEEK. AND THERE'S NO ONE QUITE LIKE HER. PATRICK WHITNEY, DIRECTOR OF THE INSTITUTE OF DESIGN IN CHICAGO, SAYS, "SHE IS A MARKETPLACE OF ONE. WE NEED FLEXIBLE PRODUCTION FOR THIS NEW INDIVIDUAL-BASED MARKETPLACE.

Wildgirl was a Go-Go girl who organized Wildgirl's Go-Go-Rama in Coney Island. She also was a radio DJ for WFMU and newscaster for drag races, and played music on her radio show that related to, as well as covered, drag car racing events. Now an avid gardener, Ericka Peterson Dana will undoubtedly go through several more incarnations, guided by her instincts and passions. Her vivaciousness and endless energy are a great part of her appeal and have created a following of Wildgirl enthusiasts.

THIS MARKETPLACE WANTS OPTIONS. WITH THE DEVELOPMENT OF COMPUTER TECHNOLOGY, ESPECIALLY WITH INTERACTIVE MEDIA, WE CAN CELEBRATE THE DEMISE OF MASS PRODUCTION."

MOHOLY-NAGY, WHO RELOCATED TO CHICAGO IN THE 1940S TO START THE INSTITUTE OF DESIGN, BROUGHT WITH HIM MUCH OF THE SPIRIT AND THINKING OF THE ORIGINAL BAUHAUS COLLECTIVE. ID, KNOWN NOW AS THE NEW BAUHAUS, EMPHASIZES DESIGN PLANNING. IN ITS NEWNESS, IT ALSO HAS A MORE DEVELOPED PHILOSO-PHY BASED NOT ON THE PROJECTED NEEDS OF ANONYMOUS MASSES BUT ON HUMAN-CENTERED DESIGN, WHICH TAKES IN ALL FACTORS—PHYSICAL, COGNITIVE, SOCIAL AND CUL-TURAL.

WHITNEY SAYS, "ID'S FOCUS IS ON THE KNOWLEDGE AND INTERESTS OF THE USER, NOT THE CLIENT, NOT THE DESIGNER." IN CONJUNCTION WITH THIS PHILOSOPHY, WHITNEY OBSERVES THAT, "THE NORMAL COURSE OF ACTION WHEN CREATING A NEW MARKETING SCHEME IS TO HOLD FOCUS GROUPS, CONDUCT MARKET SURVEYS. WE BELIEVE THAT TYPE OF RESEARCH IS BACKWARD THINKING. WE NEVER ASK THE USER WHAT THEY WANT AND THEN CREATE IT. THEY DON'T KNOW. WE DON'T ASK THEM IF THEY *LIKE* IT. THIS WOULD GIVE US A DISTORTED PICTURE OF WHAT THE END RESULT OF OUR PROCESS SHOULD BE."

ONCE AGAIN, PAULETTE COLE'S WORDS HAUNT ME, "PASSION REMOVES ALL DOUBT." PASSION TRANSCENDS TIME AND TIME IS THE ENEMY OF MARKETING. IF A PRODUCT IS TO BE SUCCESSFUL, IT NEEDS TO BE OUT THERE QUICKLY AND ECONOMICALLY EFFICIENT.

AS I HAVE TRAVELED THROUGH THE FOUR-YEAR PROCESS THAT IT TOOK TO COMPILE AND PRODUCE THIS BOOK, I FOUND TIME AND AGAIN THAT THOSE

Strategic Uni-Sourcing is the newest buzzword these days. At Virtual Telemetrix it's nothing new! We've been the primary supply source for many companies since 1991.

People say, "What's the point?" They're wrong. The 'point', such as it is now (or may be?), rarely registers our frenzied cries of, "Wait a minute! Speak to me!" We clutch, we grasp, we attend evening seminars and free lectures, yet never do we attain the concentrated diamond intensity of concept we have falsely learned to call 'the point'. Yes, what is it? How could it be otherwise? Ideas and impressions explode, then reassemble into fully formed statements and/or overt actions bearing scant resemblance to their former impetus. A phoenix of one thing rises from the ashes that were (not are) another thing. Time to slam on the brakes! What we're discussing is not simply another tired straphanger on the plodding, polluting bus that is popular chaos theory. Quite the opposite- there is an ordered approach at the center of the problem. Consider the following dilemma. Say we know that what we want (that which was formerly called the point) lies within either a maze or a labyrinth, and so we must prepare for both. You will recall that a labyrinth differs from a maze in that the former is a single path (with a ratio of turns:concentric paths equal to not less than 5:7 and not more than 11:21), while a maze has numerous paths in which all but one lead to a dead end. Now add a further wrinkle. Evidence suggests that walking a labyrinth constructed along Earth's naturally occurring energy lines produces good health, albeit feelings of giddiness and euphoria. Here comes the crux. What is the Minotaur that roams the labyrinth, ready to destroy all tangibility? What are the dead ends that impede clarity and block emotion in the maze? If the answer to both is 'the point', then we must ask: Can you vanquish the Minotaur with a balloon? Can you traverse the maze using only a divining rod? This is like saying "I get the point." <laughter> But if the answer is "the lack of a point, pointlessness", then we are on the true path. The Minotaur becomes idea, the dead ends become all possible resulting actions, and the energy lines, while pleasantly distracting at first, now become emotion. We didn't 'get the point', now the point becomes us; not becomes as in 'we are now the point' but becomes as in the point is now attractively suitable to us. Now that that's over, one final caveat. There are conditions where the position (Newtonian state) of one entity is directly, physically influenced by the actions of another entity for an unbounded period of time. This encompasses the concepts of towing, containment, ferrying, airlifting, and transport services in general. Ceci n'est pas un catalogue. Regardless, this is and is not a worthy catalog. I could have really used some of this gear when I was in the Navy.

Mr. Williams

A few years ago, John Bielenberg of Bielenberg Design, San Francisco, created a fictitious company named Virtual Telemetrix. His first project was to design and circulate an annual report. To his amusement and amazement, it won awards and had stock analysts calling about the company. Realizing he had managed to dupe many otherwise intelligent people, Bielenberg then conceptualized "Ceci n'est pas un Catalogue," an extremely sophisticated anti-consumerism vehicle. Bielenberg invited colleagues to make contributions of unlikely product prototypes. Printed on the back cover of this anti-catalog is the line, "The more you know, the less you need. An Australian Aboriginal proverb." The cover's mood shot is a closeup of the Liver on a Stalk shown on the next spread. The first spread of "Ceci n'est pas un Catalogue" (left) invites the consumer to spend while providing convoluted, yet hysterically written prose by "Mr. Williams," the presumable owner of Virtual Telemetrix. (Copy written by Chris Williams at I Am Swill Corporation, Boston, MA.)

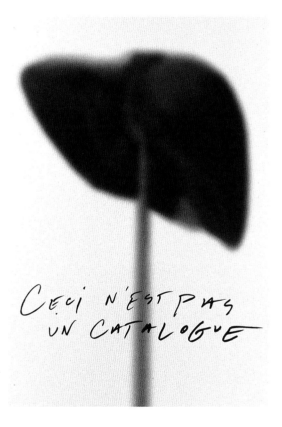

Ceci n'est pas un Catalogue

Right: Graphigenius Headlight, "Impress clients with your illuminating genius... an intermittent flashing light bulb that signals to others each time you have a bright idea... Specify 'SoftWhite' or 'FloodLight' (If unsure, send your portfolio... we will determine the wattage for you... $327.43" (Design firm, Tharp Did It; photo by Kelly O'Connor). Far right: Virtual Baby Software, "...design your very own baby! Choose from over 15 million different combinations and colors... $50.00" (Designers, John Bielenberg and Chuck Denison).

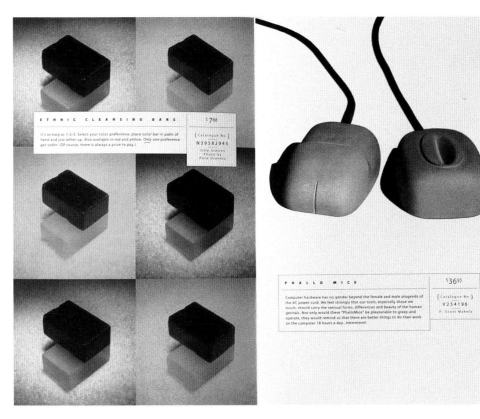

WHO SUCCEEDED DID NOT *JUST* HAVE TALENT. IT WAS THE UNWAVERING *PASSION* FOR SHOWING THE WORLD THEIR VISION—A VISION THAT INCLUDED THE MARKETING OF THEIR PRODUCTS—IT WAS THEIR IMMEDIACY AND CONFIDENCE IN THEIR PRODUCT THAT ALLOWED THEM TO DO SOMETHING DIFFERENT, DARING AND GENUINE.

AS GERTRUDE STEIN ONCE SAID, "I WRITE FOR MYSELF AND STRANGERS." BECAUSE, IN ORDER FOR THE CREATOR TO BE TRUE TO THE PASSION THAT GUIDES, THE CREATOR MUST AVOID THE CHAOS OF VOICES THAT SURROUND ALL OF US. IN THIS RESPECT THE MARKETS *FIND* THE PRODUCTS THAT FOLLOW THIS INTRODUCTION.

*Above: The left page features Ethnic Cleansing Bars, "It's
as easy as 1-2-3. Select your color preference, place color
bar in palm of hand and just lather up. Also available in red
and yellow. Only one preference per order. (Of course, there
is always a price to pay)... $7.88" (Designer, Jilly Simons).
On the right page are Phallo Mice, "Computer hardware
has no gender beyond the female and male plugends of the
AC power cord...Not only would these 'Phallo Mice' be
pleasurable to grasp and operate, they would remind us that
there are better things to do than work on the computer 18
hours a day... $36.95" (Designer, P. Scott Makela).*

Coming full circle

THE DEPERSONALIZATION THAT RESULTED FROM THE MASS MARKET MENTALITY ULTIMATELY LED US BACK TO THE CRAFT-ORIENTATED PERSONALIZATION. IN THE PAGES THAT FOLLOW, YOU'LL FIND MANY EXAMPLES OF PRODUCTS THAT WERE DESIGNED TO BE SOLD TO A SMALL NUMBER OF INDIVIDUALS WHO WOULD BE

*Right: CA Annual Shower Curtain,
"View the best in award winning graphic design
while showering... $21.00" (Designer, Erik Adigard)
Far right: Homeboy, "Developed as a joint venture
between IBM and The Gap... Homeboy fits on the
end of your finger, putting YOU on-line and in-style
instantly... Homeboy fills your head with random
interactive objects that you name, send and receive.
The sorting mechanism is your brain, Homeboy does
the rest... $39.95" (Designer, Brian Boram).*

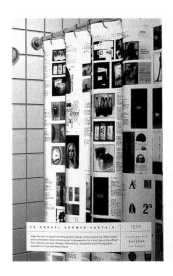

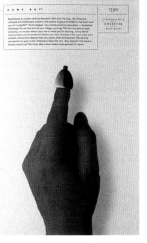

ATTRACTED TO THE PRODUCT FOR MUCH OF THE SAME REASON THAT THE DESIGNER HAD IN MAKING IT—IT INTRIGUED THEM OR TOUCHED THEM OR IN SOME OTHER REAL WAY, RELATING TO THEIR INDIVIDUALISM. THIS, OF COURSE, DOESN'T DIMINISH THE DEMAND FOR MASS MARKETING AND BAD OR MEDIOCRE DESIGN. SUPERMARKETS AND DEPARTMENT STORES HAVE AISLES FILLED WITH PRODUCTS THAT DO NOT REQUIRE ANY EMOTIONAL APPEAL WHATSOEVER. MOTOR OIL, TOILET PAPER, LAUNDRY DETERGENT AND PHARMACEUTICALS CAN BE DESIGNED VERY PRAGMATICALLY; FORM FOLLOWING FUNCTION AS WELL IT SHOULD. THEN AGAIN, PERHAPS YOU ARE EMOTIONALLY ATTACHED TO YOUR DETERGENT BOX. (I KNOW SOME DESIGNERS WHO ARE PASSIONATE ABOUT THE MOST COMMON PACKAGE DESIGNS).

THIS BOOK IS NOT ABOUT EVERYDAY PRODUCTS. IT'S ABOUT THE PRODUCTS THAT COME INTO OUR LIVES AND OUR HOMES ADDING VALUE AND WARMTH TO OUR EXISTENCE IN A WAY THAT GOES BEYOND THE PRACTICAL. IN A WAY, THESE PRODUCTS REMIND US OF OUR HUMANITY, MAKING LIFE MORE ENJOYABLE. IT'S ABOUT THE PASSION THAT WE LIVE FOR— THE PASSION THAT REMOVES ALL DOUBT. — DK HOLLAND

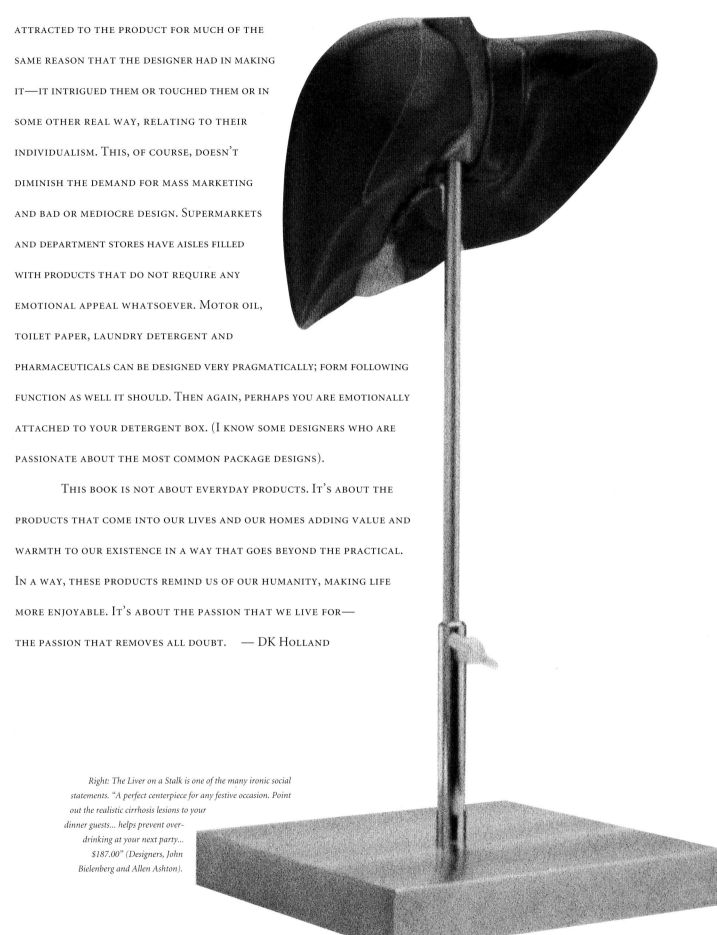

Right: The Liver on a Stalk is one of the many ironic social statements. "A perfect centerpiece for any festive occasion. Point out the realistic cirrhosis lesions to your dinner guests... helps prevent over- drinking at your next party... $187.00" (Designers, John Bielenberg and Allen Ashton).

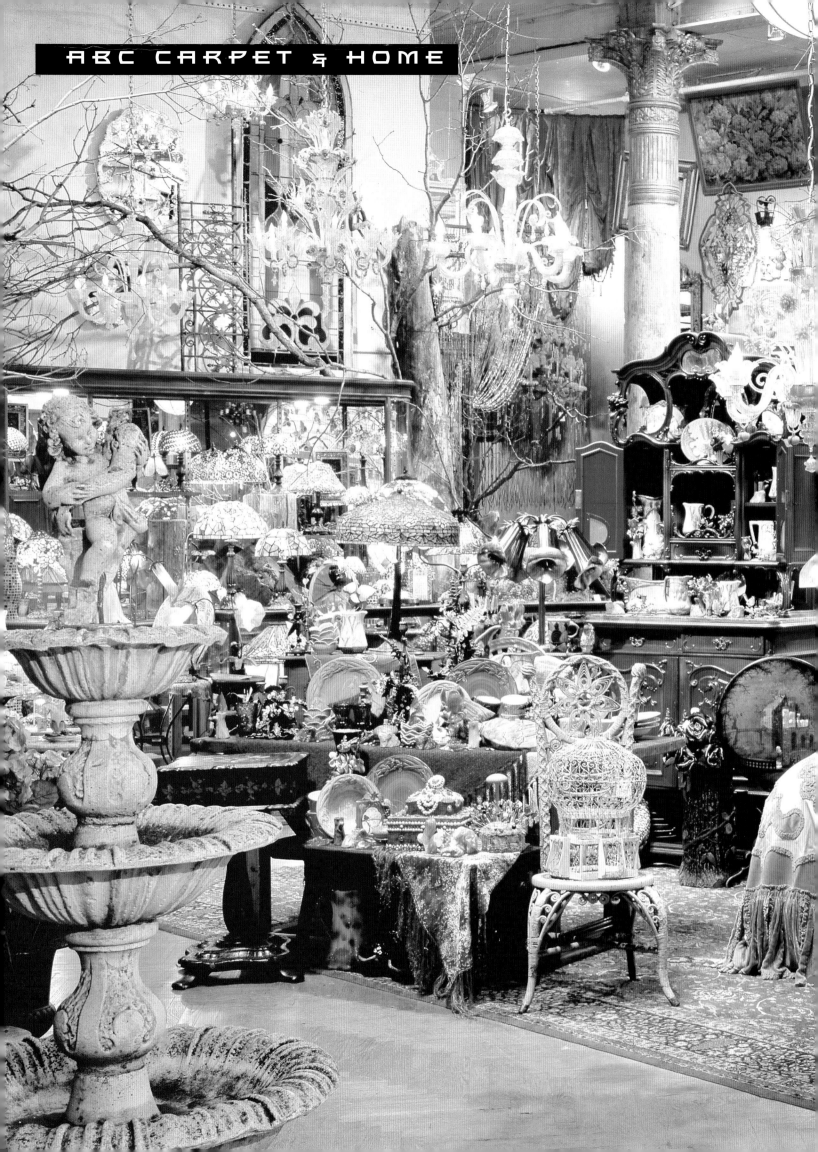

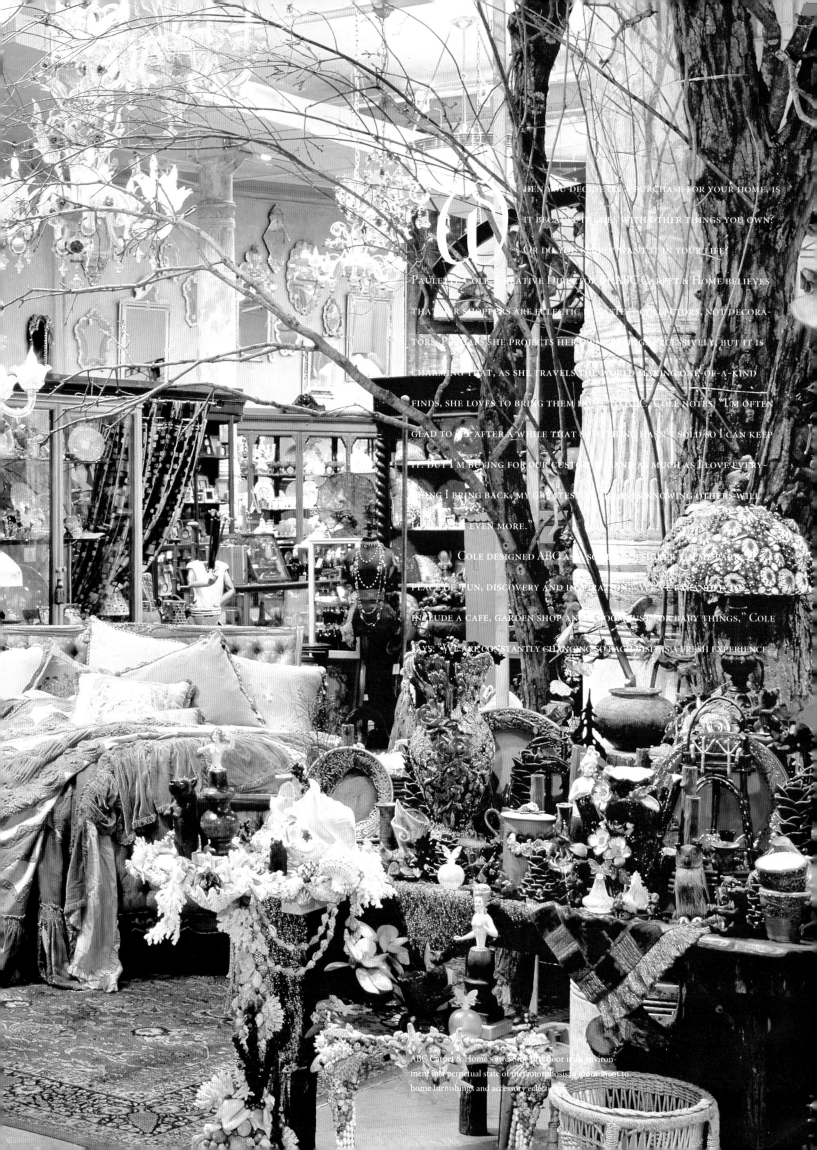

HEN YOU DECIDE TO PURCHASE FOR YOUR HOME, IS
IT BECAUSE IT GOES WITH OTHER THINGS YOU OWN?
OR DO YOU SIMPLY WANT IT IN YOUR LIFE?

PAULETTE COLE, CREATIVE DIRECTOR OF ABC CARPET & HOME BELIEVES
THAT HER SHOPPERS ARE ECLECTIC IN TASTE—COLLECTORS, NOT DECORA-
TORS. PERHAPS SHE PROJECTS HER OWN FEELINGS EXCESSIVELY, BUT IT IS
CHARMING THAT, AS SHE TRAVELS THE WORLD MAKING ONE-OF-A-KIND
FINDS, SHE LOVES TO BRING THEM BACK TO ABC. COLE NOTES, "I'M OFTEN
GLAD TO SEE AFTER A WHILE THAT SOMETHING HASN'T SOLD SO I CAN KEEP
IT. BUT I'M BUYING FOR OUR CUSTOMERS, AND AS MUCH AS I LOVE EVERY-
THING I BRING BACK, MY GREATEST PLEASURE IS KNOWING OTHERS WILL
LOVE THEM EVEN MORE."

COLE DESIGNED ABC AS A SORT OF DESIGNER THEME PARK, A
PLACE OF FUN, DISCOVERY AND INSPIRATION. "WE'VE EXPANDED TO
INCLUDE A CAFE, GARDEN SHOP AND A NOOK JUST FOR BABY THINGS," COLE
SAYS. "WE ARE CONSTANTLY CHANGING SO EACH VISIT IS A FRESH EXPERIENCE."

ABC Carpet & Home's awesome first floor is an environ-
ment in a perpetual state of metamorphosis; a monument to
home furnishings and accessory eclecticism.

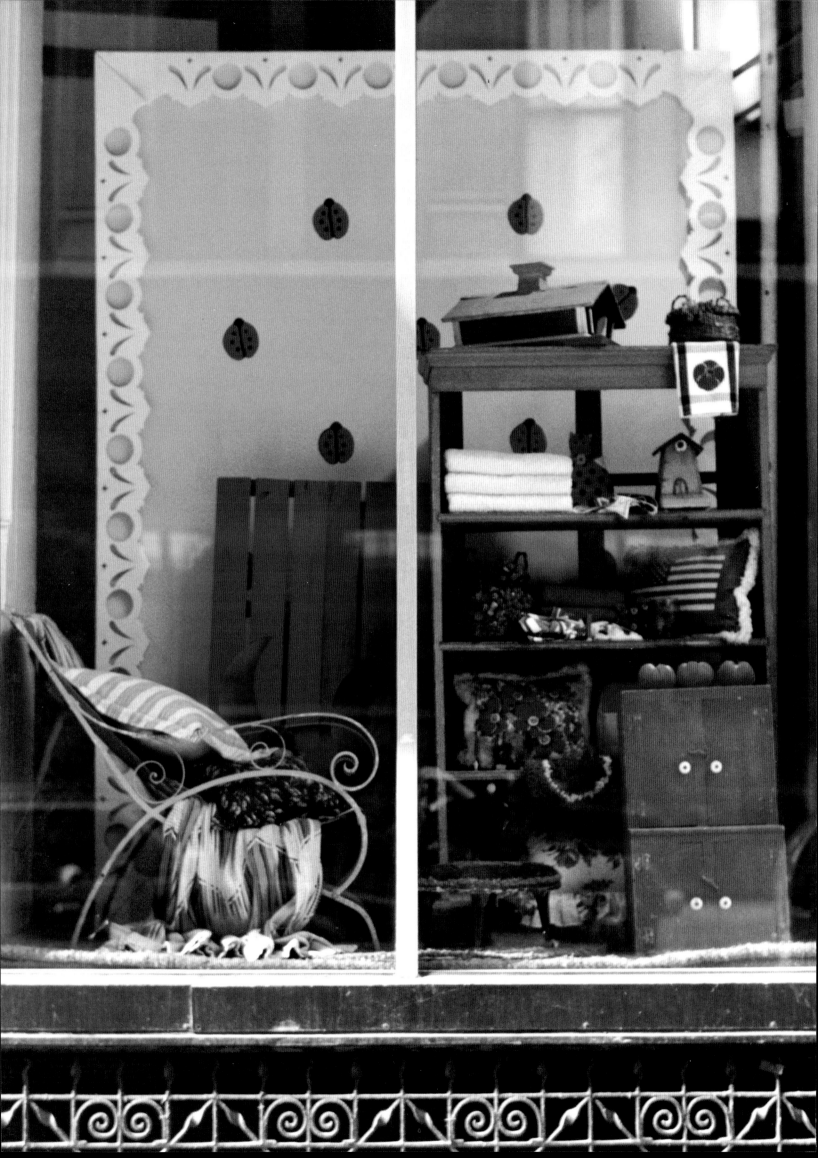

ABC gained a reputation for ever-changing and inspired window displays. Yet, when customers walked in the front door, the first floor was filled with only one product—rugs. The cross-merchandising approach seen in the windows eventually became the store interior design philosophy as well.

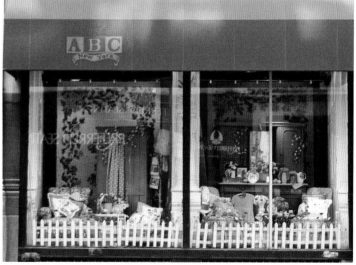

ABC's windows wrap-around the front and side of the stores on both the east and west side of Broadway and 19th Streets in Manhattan.

ABC sells many one-of-a-kind items in its store making the
advance marketing (such as catalogs) problematic. ABC often
sells a mood in its advertising, not necessarily a specific product.

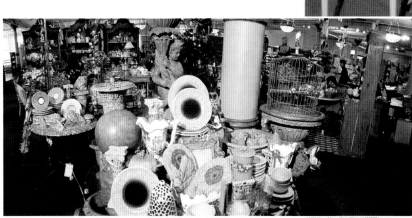

Paulette Cole's approach to interior design is to create an endless fantasy room of
one-of-a-kind products juxtaposed to enhance each other. The photography for an
advertising campaign for ABC Carpet & Home exaggerated even further the fantasy
world that Paulette Cole has created in the store. Photography, Gentl & Hyers.

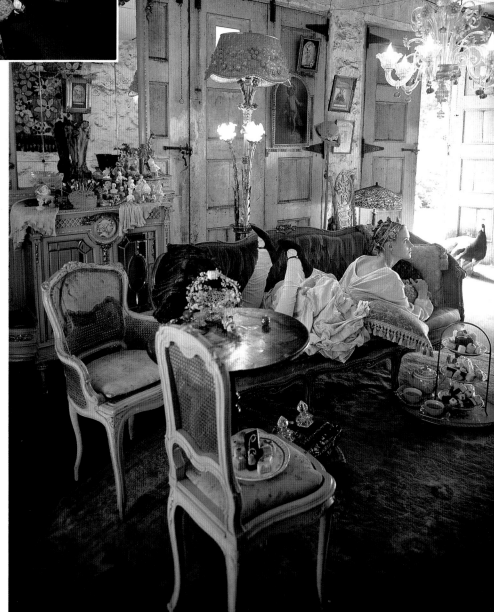

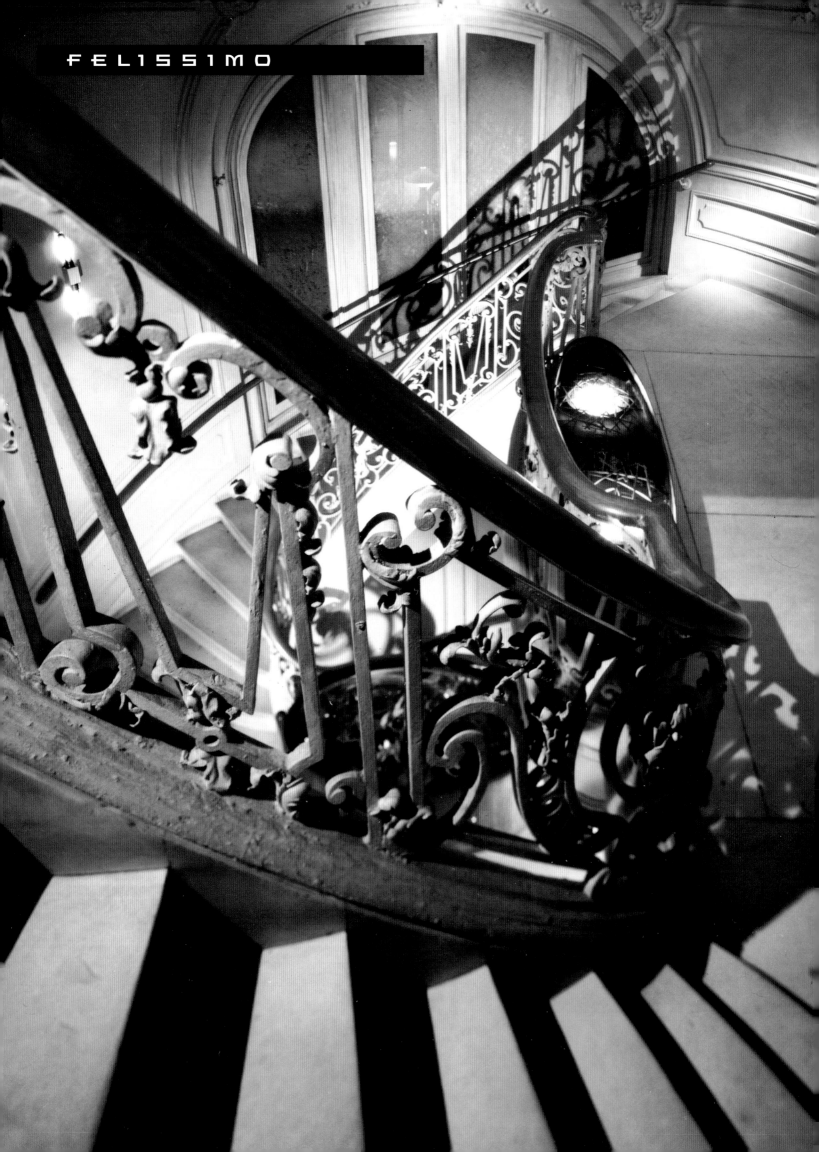

FELISSIMO: THE WORD DERIVES FROM "FELICITAS," WHICH IS A LATIN EXPRESSION OF HAPPINESS. MORE OF A STATE OF MIND THAN A BOUTIQUE, FELISSIMO IS A FOUR-STORY STORE OFF MANHATTAN'S CHIC FIFTH AVENUE ON 56TH STREET. THE 1903 BEAUX-ARTS TOWNHOUSE WAS PURCHASED AND SENSITIVELY RESTORED BY THE YAZAKI FAMILY OF KOBE, JAPAN TO BECOME THE AMERICAN HOME OF THEIR COMPANY, FELISSIMO. PRODUCTS ARE EARTHY, OFTEN HANDMADE AND DISPLAYED UNPREDICTABLY IN THIS EXQUISITE, MAGICAL HOME. THERE IS A LOGIC TO THE LAYOUT: THE GARDEN ATRIUM IS ON THE FIRST FLOOR, ONE THEN ASCENDS A LUXURIOUS, WINDING MARBLE STAIRCASE TO ENTER THE BED AND BATH PRODUCTS. THE LIVING ROOM IS ON THREE, AND THEN RELAX AND MEDITATE IN THE TEAROOM ON THE TOP FLOOR. "WE WANTED TO CREATE A SHOPPING SANCTUARY THAT WAS SOOTHING AND AESTHETICALLY PLEASING TO THE SENSES," SAYS RONA TISON, EXECUTIVE VICE PRESIDENT. "TO DO THAT, WE STIMULATE THE SENSES THROUGH SOUND, SPACE, TEXTURE, AROMA AND GREENS." TISON, WHO IS HALF JAPANESE, SITS BACK AND OBSERVES, "CONSIDER THE JAPANESE TEA CEREMONY. AS YOU ENTER THE TRADITIONAL TEAROOM, YOU LEAVE THE WORLDLY BEHIND AND IMMERSE YOURSELF IN A TRANQUIL AND SOOTHING ENVIRONMENT: YOU ARE AWARE THAT EVERY DETAIL IS PERFECTION. THE IRREGULAR STEPPING STONES LEADING TO THE TEAHOUSE FORCES ONE TO EXPERIENCE THE SENSATION OF STEPPING ON EACH STONE. THAT'S THE FEELING WITH WHICH FELISSIMO WAS DESIGNED."

The nineteenth century limestone townhouse that the owners of Felissimo purchased on 56th Street between Fifth Avenue and Avenue of the Americas in midtown Manhattan is magnificently restored; a symbol of the company's commitment to excellence and longevity in this location.

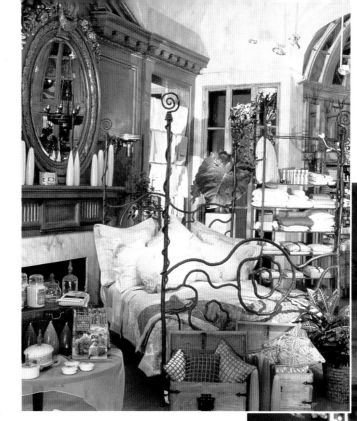

Each floor in Felissimo represents a different part of the home—shoppers may choose to climb its elegant winding marble staircase or ride the elevator up and down its four selling floors. During the renovation process, the walls were hand painted. Tison says, "I'm so delighted when people ask who the artist was." Original interior design of the store was done by Clodagh, who orchestrated thirty artists to refurbish the townhouse.

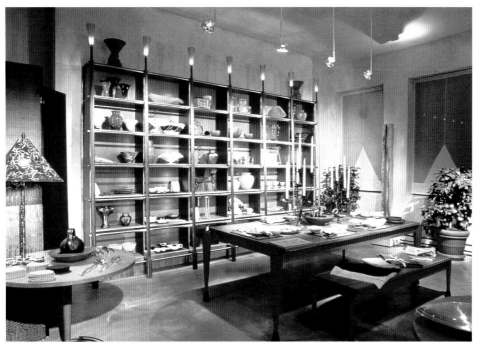

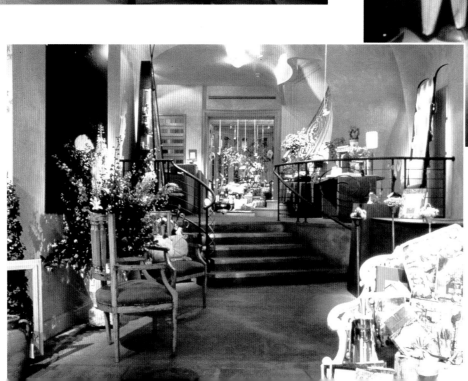

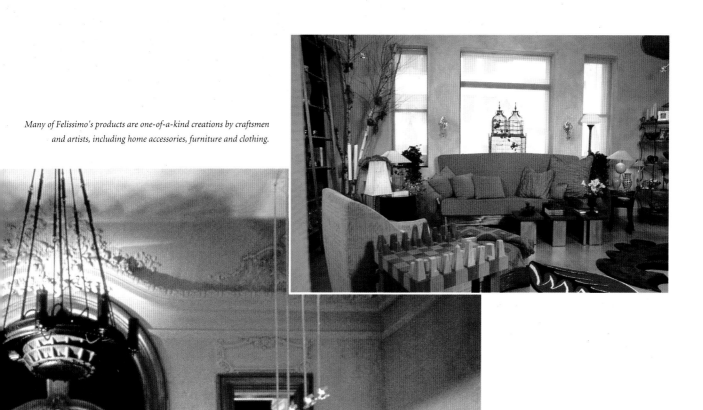

Many of Felissimo's products are one-of-a-kind creations by craftsmen and artists, including home accessories, furniture and clothing.

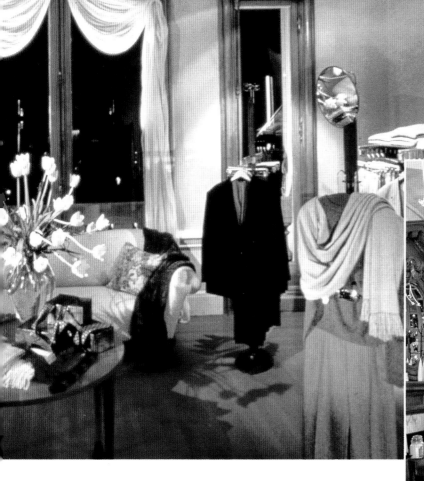

"It's not only about making a sale," says Rona Tison, Executive Vice President of Felissimo. "It's about creating a shopping experience that inspires and beckons you back." The top floor has a tearoom where shoppers may renew and enjoy a light fare.

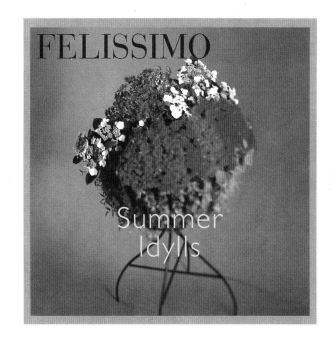

The mail order catalog for Felissimo features products that enrich everyday life. Private products are an effective way to capitalize and build on the Felissimo allure. Felissimo 56 Fragrance and Home Collection was inspired by the pure simplicity of Earl Grey tea and touched with the essences of Bergamot, Orange and Jasmine blossoms. The product line will include spray fragrances, candles, soaps, shampoo and body lotion.

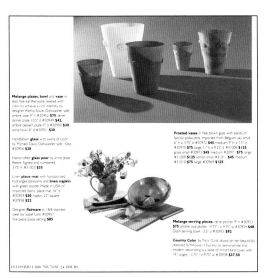

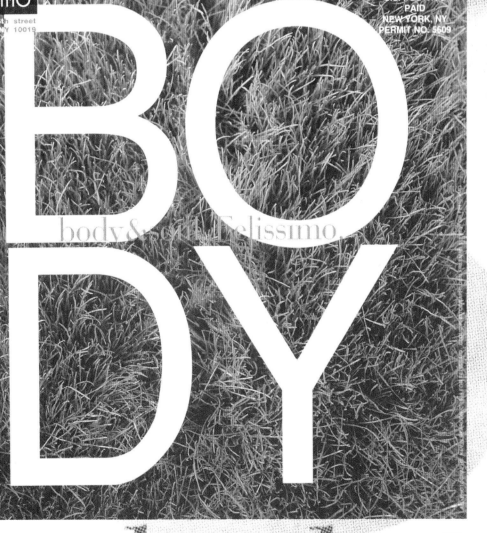

FELISSIMO

0 west 56th street
ew York, NY 10019

BO DY

body&soul Felissimo

body&soul

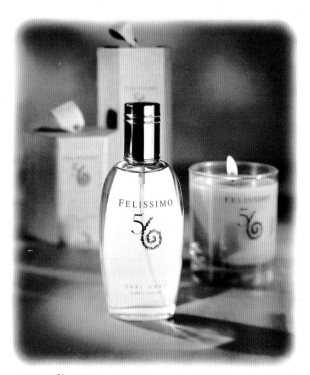

body and soul

FELISSIMO **56** FRAGRANCE and **HOME COLLECTION** inspired by the pure simplicity of earl grey tea. Imported from France. Exclusively for Felissimo. $30-80

FELISSIMO
10 west 56th street NYC

monday - saturday 10 - 6 thursday 10 - 8 bridal registry personal shopping corporate gift to place an order 800.565.6785

Almost every Felissimo product, promotion and printed matter is designed by an in-house art department under the direction of Mitria DiGiacomo. When the New York store opened, a new logo was designed for Felissimo by Paul Niski of Studio N and used in advertising and on wrapping papers and in this accordion-fold brochure. On the other side of this brochure is copy and imagery that illuminate the store's philosophy.

PROVENCE

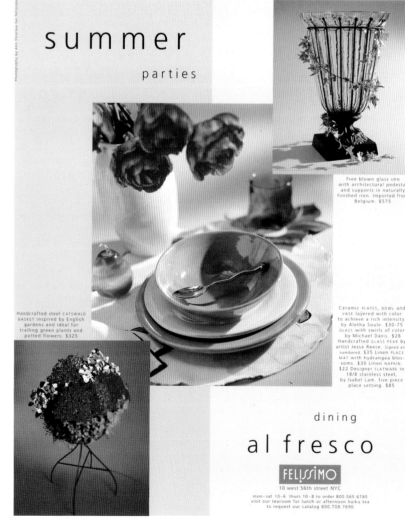

summer

parties

The advertisement, at right, for Felissimo's Town and Country selections: (top right) "Free blown glass urn with architectural pedestals and supports in naturally finished iron."; (center) "Ceramic plates, bowl and vase layered with color to achieve a rich intensity... Handcrafted glass pear by artist Jesse Reece... Linen place mat with hydrangea blossoms... Linen napkin... Designer flatware in 18/8 stainless steel, by Isabel Lam."; (bottom left) "Handcrafted steel catswald basket inspired by English gardens and ideal for trailing green plants and potted and flowers."

Free blown glass URN with architectural pedestal and supports in naturally finished iron. Imported from Belgium. $575

Handcrafted steel CATSWALD BASKET inspired by English gardens and ideal for trailing green plants and potted flowers. $325

Ceramic PLATES, BOWL and vase layered with color to achieve a rich intensity, by Aletha Soule. $30-75 GLASS with swirls of color by Michael Davis. $28 Handcrafted GLASS PEAR by artist Jesse Reece. Signed and numbered. $35 Linen PLACE MAT with hydrangea blossoms. $30 Linen NAPKIN. $22 Designer FLATWARE in 18/8 stainless steel, by Isabel Lam. five piece place setting. $85

dining

al fresco

FELISSIMO
10 west 56th street NYC
mon-sat 10-6 thurs 10-8 to order 800.565.6785
visit our tearoom for lunch or afternoon haiku tea
to request our catalog 800.708.7690

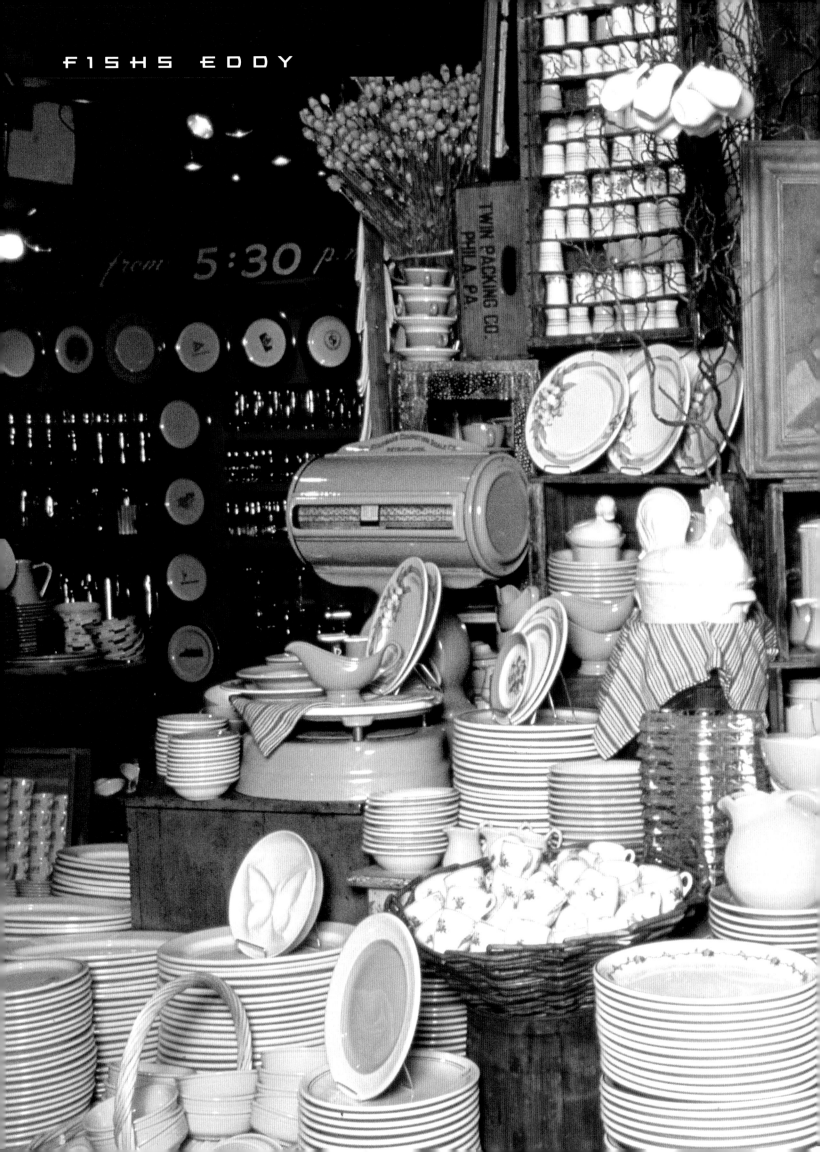

*J*ULIE GAINES AND DAVID LENOVITZ WERE TRAVELING

THROUGH THE COUNTRYSIDE AND FOUND A FIRE SALE IN

AN OLD WAREHOUSE. THEY DUMPED CRATES OF BLACKENED

STONEWARE CHINA IN THE BACK OF THEIR TRUNK AND TOOK IT HOME.

SCRUBBING IT UP, TO THEIR JOY, THEY FOUND NO BREAKAGE, CHIPPING

OR DISCOLORATION. THEY REALIZED HOW PRACTICAL AND SPECIAL THIS

INDUSTRIAL GRADE DISHWARE WAS. NEW DISHWARE MADE OF BAKED CLAY

IS FRAGILE IN COMPARISON. ALL YOU NEED TO DO IS BREAK ONE DISH, AND

THEN YOUR SET IS INCOMPLETE. WHEN THEY OPENED FISHS EDDY TO SELL

INDUSTRIAL GRADE STONEWARE AND GLASSWARE, THEY PURCHASED BOXES

OF UNUSED DISHES FROM THE HARVARD CLUB, SEVERAL OCEANLINERS,

AND RESTAURANTS THAT HAD GONE OUT OF BUSINESS. THE PATTERNS ON

THE STONEWARE ARE ALWAYS DIFFERENT, OFTEN USING GREAT RETRO

GRAPHICS, TYPOGRAPHY AND LOGOS. WHEN JULIE AND DAVID WENT TO

MAKE THE FISHS EDDY PATTERN OF STONEWARE, THEY WENT TO THE SAME

SOURCES THAT HAD MADE MUCH OF THE OLD LOTS THEY HAD PURCHASED:

AMERICAN STONEWARE IS THE BEST, THEY SAY.

Before opening Fishs Eddy, the owners had an antique junk store in the Gramercy Park area of Manhattan. When their focus shifted to marketing industrial grade dishware, they mixed their old shop's wares in with the new inventory.

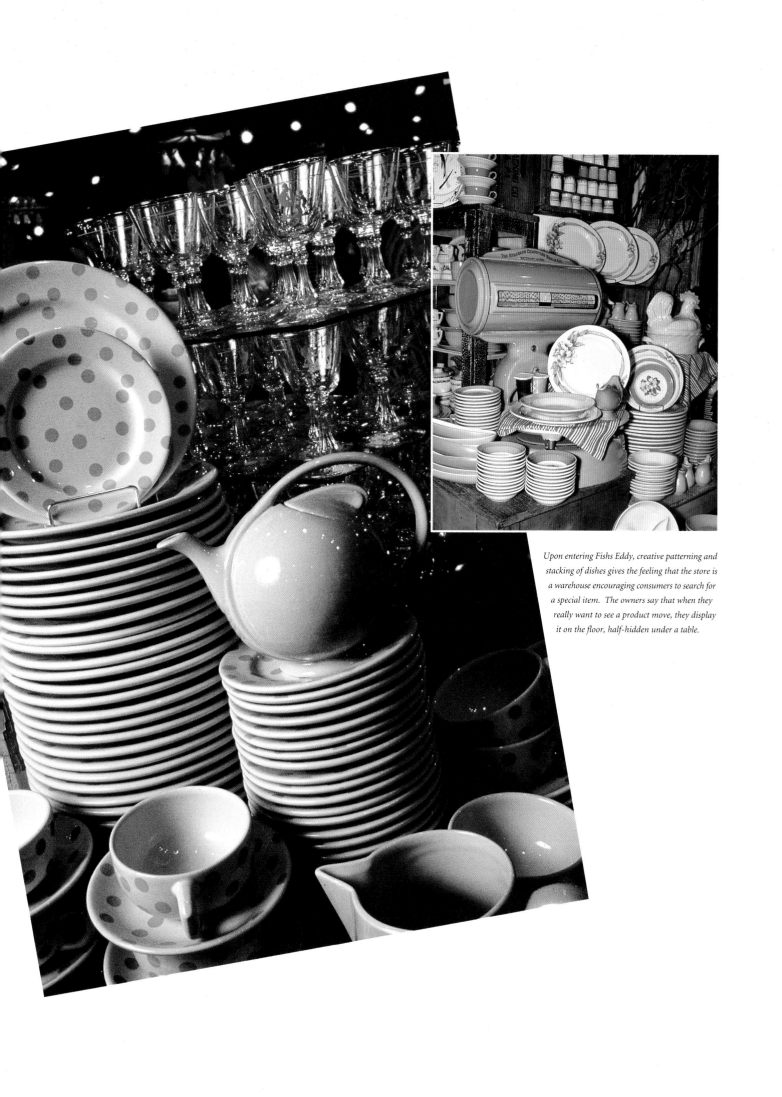

Upon entering Fishs Eddy, creative patterning and stacking of dishes gives the feeling that the store is a warehouse encouraging consumers to search for a special item. The owners say that when they really want to see a product move, they display it on the floor, half-hidden under a table.

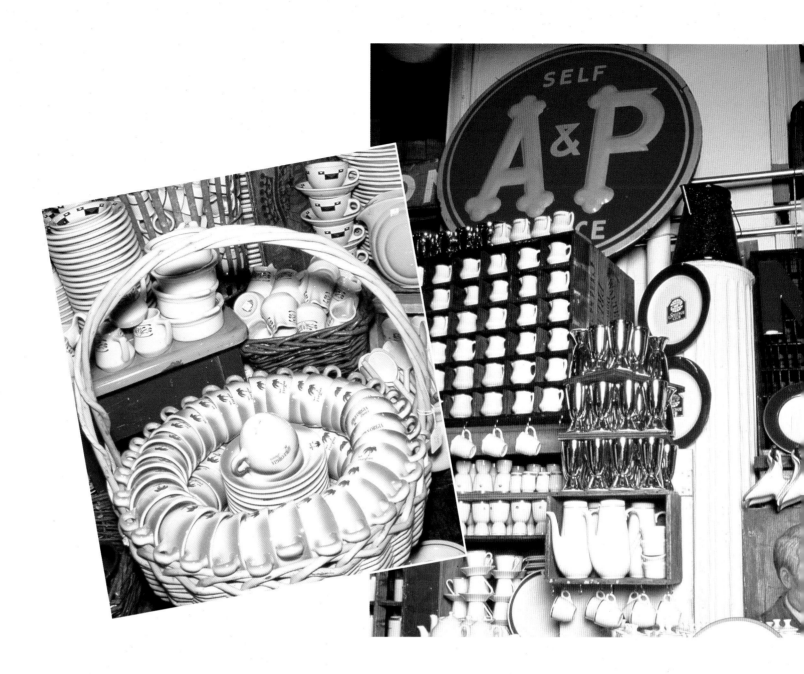

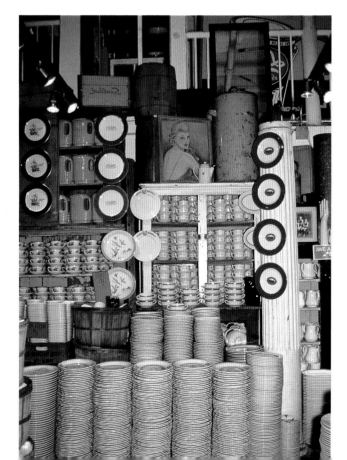

The logo is garage sale chic, a good message for the customer who is looking for a place that isn't pricey and full of surprises. The first Fishs Eddy opened on East 17th Street, and has since expanded to Broadway and 19th Street, as well as a South Hampton shop.

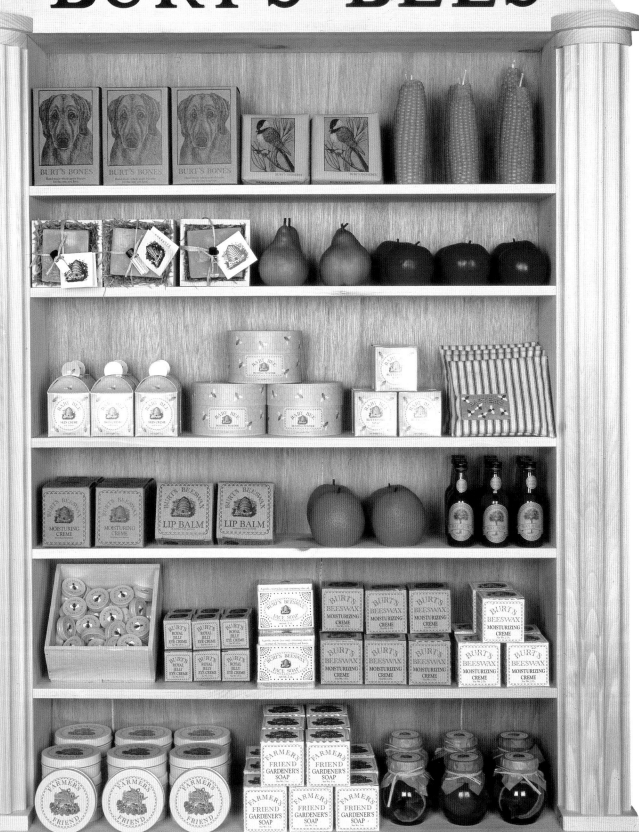

46

ℛOXANNE QUIMBY FELL IN LOVE WITH A BEEKEEPER NAMED
BURT. A FINE ARTIST AND A GARDENER, EVERYTHING THAT
ROXANNE TOUCHES RELATES TO NATURE AND BECOMES ART.
SO IT'S NOT SURPRISING THAT SITTING AT BURT'S KITCHEN TABLE, ROXANNE
STARTED TO MAKE CANDLES WITH BURT OUT OF HIS BEES' WAX. LOVE BLOS-
SOMED AND SO DID ROXANNE AND BURT'S BUSINESS, APTLY NAMED FOR THE
KEEPERS OF THE WAX, BURT'S BEES. THE COMPANY GREW TO POINT WHERE
HER LITTLE WORKSHOP IN MAINE WAS NO LONGER ABLE TO ACCOMMODATE
THE VOLUME OF ORDERS FOR THE EVER-EXTENDING LINE OF PRODUCTS THAT
ROXANNE CONJURED UP. SCOPING OUT LOCATIONS FOR FACTORIES, ROXANNE
TURNED TO THE CAROLINAS, NEAR RALIEGH. ALAS, BURT IS A MAINE-IAC AND
SO ROXANNE COMMUTES. ALL IN THE NAME OF LOVE.

*Candles made from wax lovingly designed by fine artist Roxanne
Quimby for Burt's Bees. The line of personal and home products
encompass the entire spectrum: talcum powder, lip balm, bath
salts, herbal soaps, cleansing creams, cologne, hair products, dog
biscuits, honey and candles—to name a few.*

A wholesale catalog cover with metallic gold leaves designed by Roxanne Quimby. Burt and Roxanne's life in Maine is the inspiration for many of Burt's Bees products.

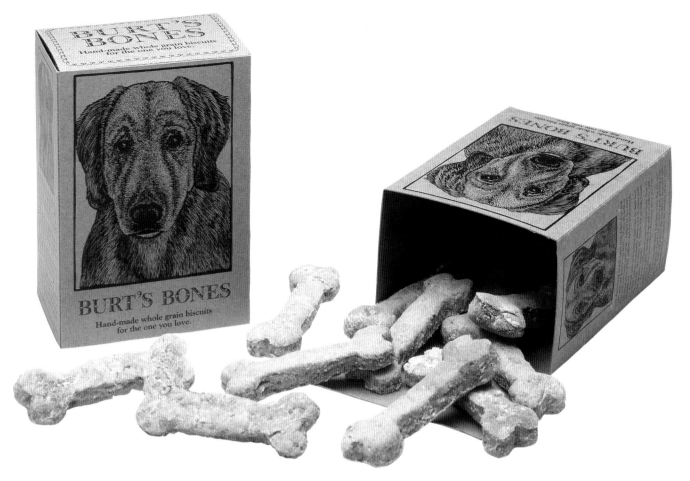

Burt's Bones and Burt's Desserts are touches of humor that add value and help to reinforce the brand name, Burt's Bees. Burt Shavitz started beekeeping 25 years ago: the beekeeper from Maine was immortalized onto the brand logo (opposite page).

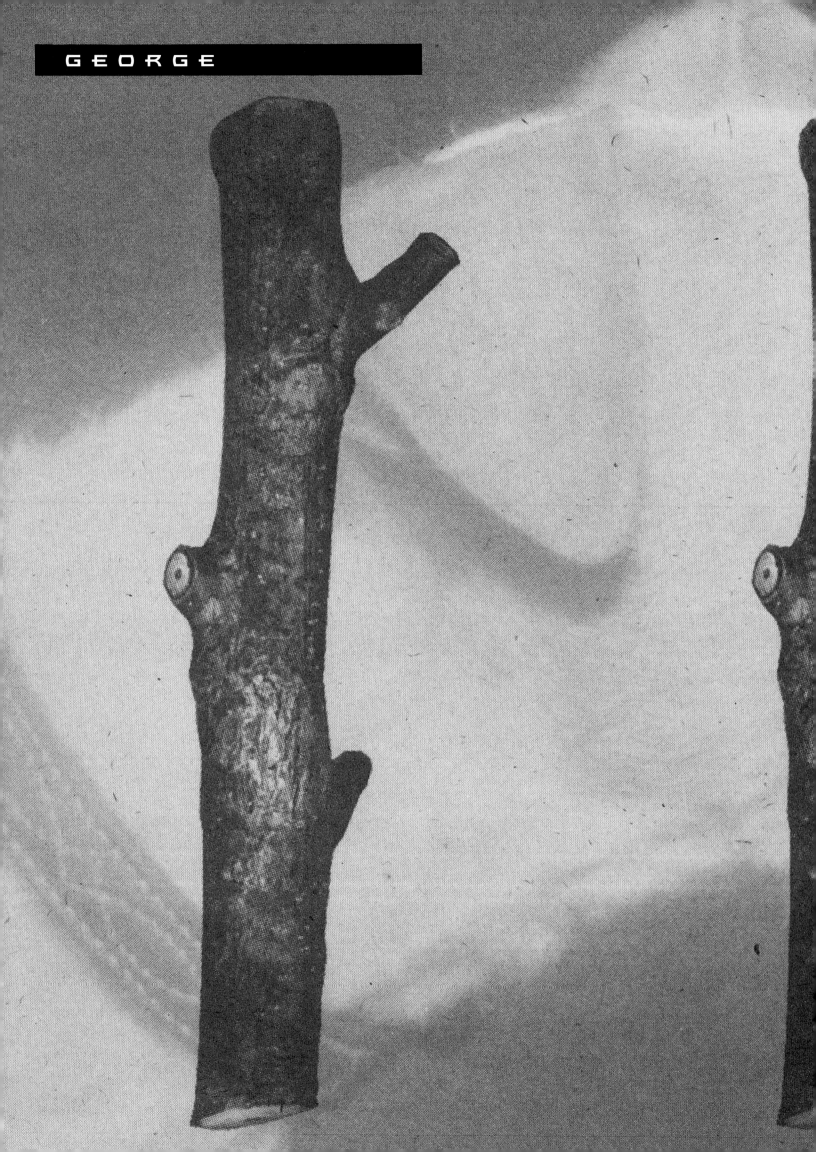

For the adoration of a little Wire Fox terrier, Bobby Wise and Lyndon Lambert developed a line of toys, apparel, bedding—just about everything the well-bred dog should have in his life. The story goes that George was just a puppy romping through New York's Central Park in the midst of winter. Bobby threw a stick and when George jumped to grab it, he just kept on going. Terrified, Bobby and Lyndon ran after the little pup, across busy intersections, past Park Avenue, only then to lose sight of him. Several hours later they received a call from a stranger who had found him in front of a pet store. They went to the apartment only to find poor George hiding underneath a bed with poodles yapping at him. Needless to say, this event brought George even closer to their hearts. Perhaps this was one incident of many that helped to spawn the specialty pet shop that provides products for cats and dogs with a different flavor. "There weren't any products on the market for George that appealed to us," said Bobby. It is speculated that the reason George bolted was because the stick was temporarily lodged in his throat, which caused him to panic—and not to mention Bobby and Lyndon. The store's trademark, a yellow stick, is a reminder to both dog and owner that, like George, every dog has its day.

Postcard designed by Tom Bonauro. George's logo is just a stick, but the image of the company is George himself, a pedigreed Wire Fox terrier. The stick is applied to most other George paraphernalia.

Seven lucky charms designed by Todd Oldham and Tom Bonauro (below and right). "A portion of the proceeds benefits various organizations which care for the animals of homebound AIDS patients." A postcard (opposite page) that is a play of images and words, expressing the delight of the dog being in the water.

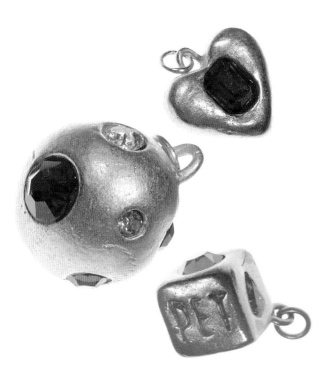

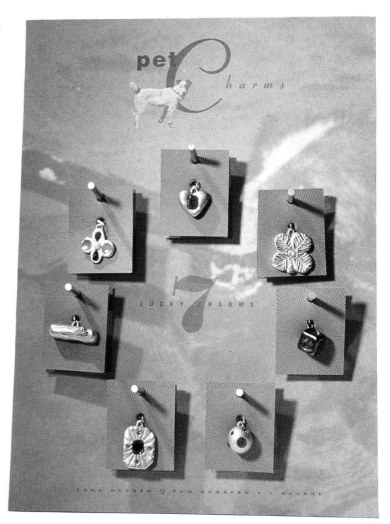

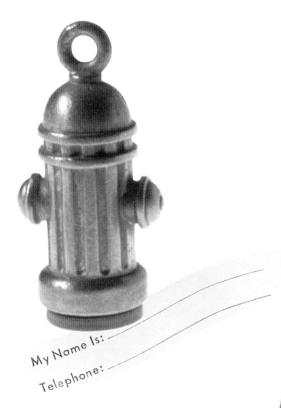

Above and right: An identification tag rolls up and fits into the tiny hydrant that attaches to the dog's collar. The stainless steel bone is hung on the wall as a place to train the owner as where to put the dog's leash. The lightweight, die-cast zinc identification tags display pet-positive pictures or words and come with a complimentary engraving.

at the flowin

d so inviting h

his time just t

ave the feel of th

body. An olde

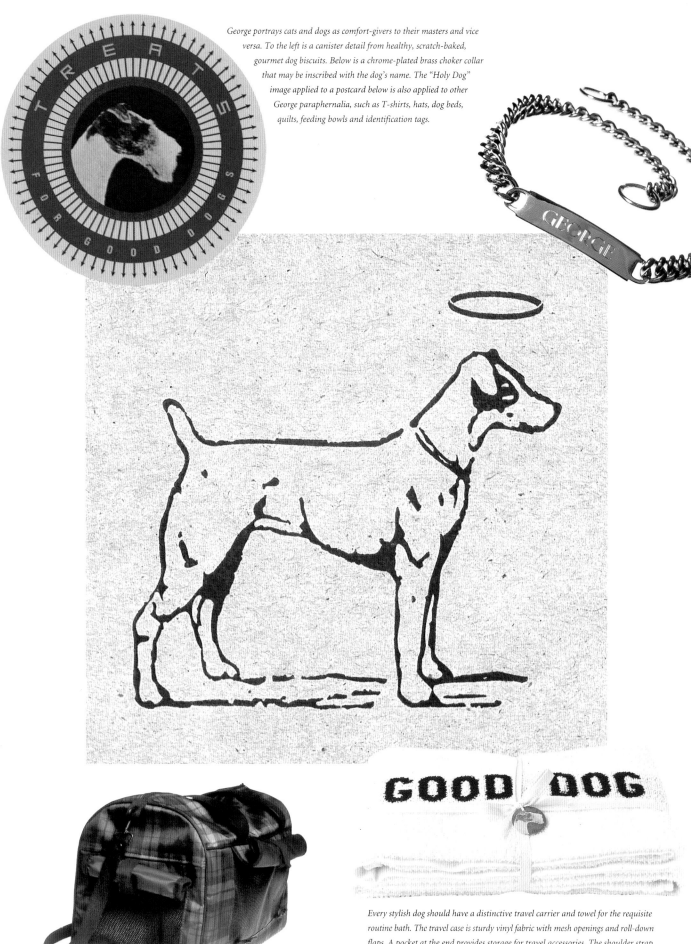

George portrays cats and dogs as comfort-givers to their masters and vice versa. To the left is a canister detail from healthy, scratch-baked, gourmet dog biscuits. Below is a chrome-plated brass choker collar that may be inscribed with the dog's name. The "Holy Dog" image applied to a postcard below is also applied to other George paraphernalia, such as T-shirts, hats, dog beds, quilts, feeding bowls and identification tags.

TREATS FOR GOOD DOGS

GEORGE

GOOD DOG

Every stylish dog should have a distinctive travel carrier and towel for the requisite routine bath. The travel case is sturdy vinyl fabric with mesh openings and roll-down flaps. A pocket at the end provides storage for travel accessories. The shoulder strap converts into an emergency lead, and the zippered top comes with a lock. On the opposite page is the black and white cover of a George catalog. The "3/3" translates into "1", (a bit of dog-logic, perhaps?).

GEORGE

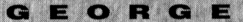

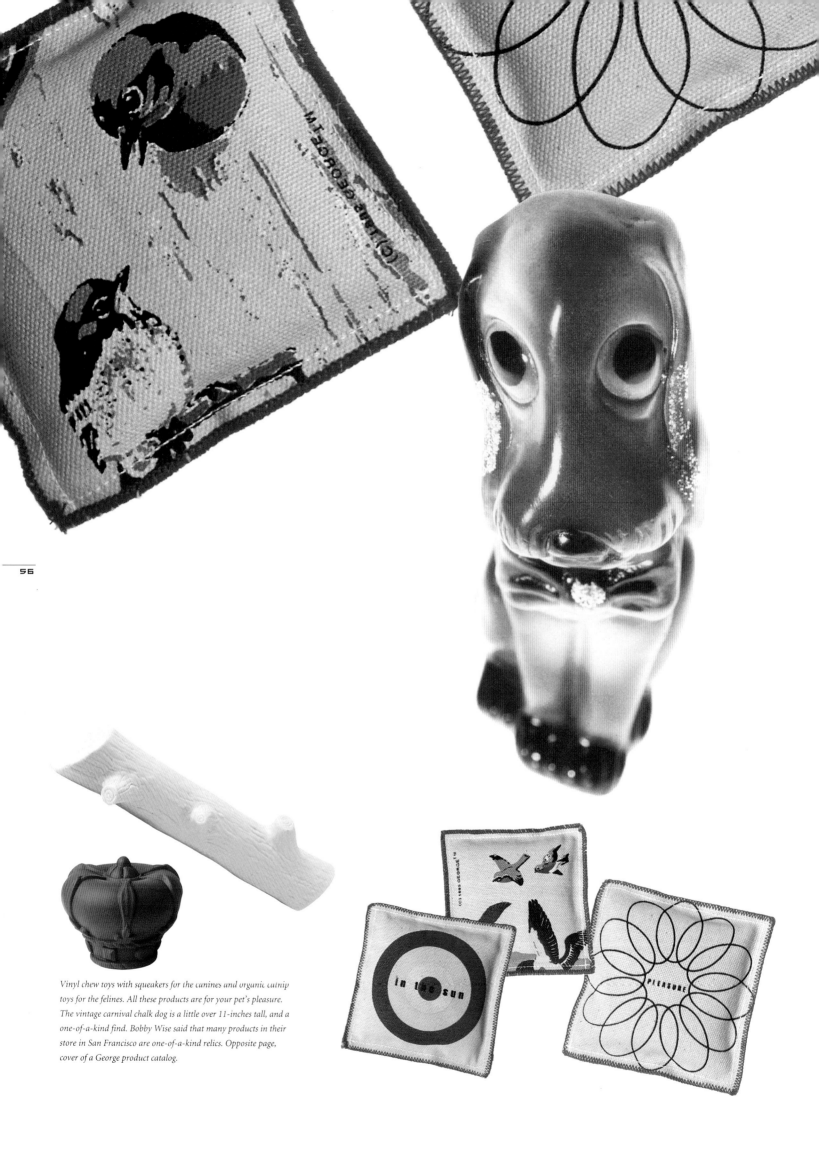

Vinyl chew toys with squeakers for the canines and organic catnip toys for the felines. All these products are for your pet's pleasure. The vintage carnival chalk dog is a little over 11-inches tall, and a one-of-a-kind find. Bobby Wise said that many products in their store in San Francisco are one-of-a-kind relics. Opposite page, cover of a George product catalog.

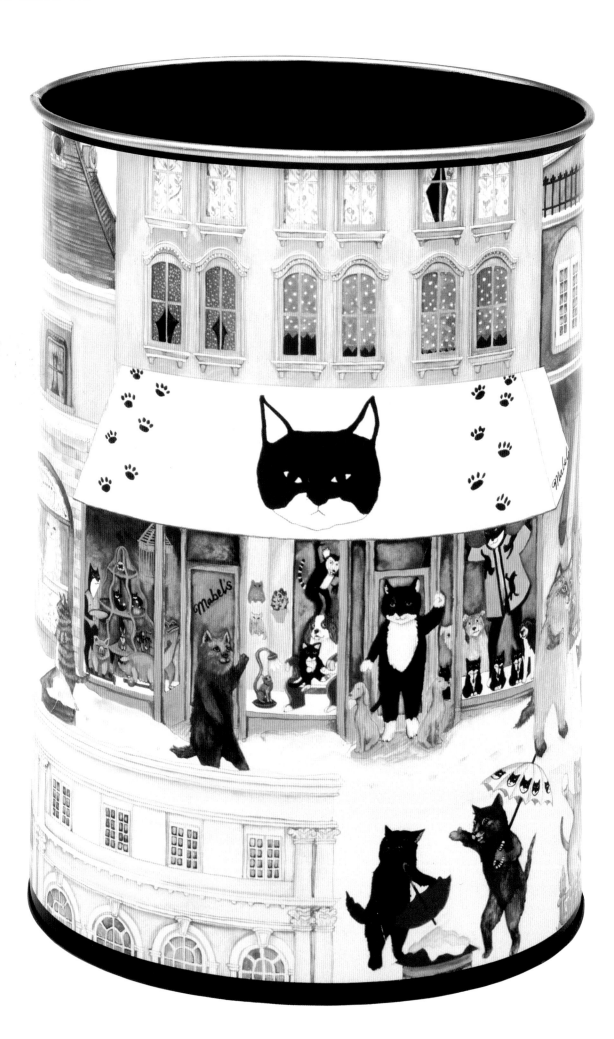

"Making money is not high on my agenda," says Peaches Gilbert, the originator and owner of Mabel's. She is standing in the doorway to her store which is in a historic house at the entrance to the Arts and Crafts area of Santa Fe, New Mexico. Peaches has clearly balanced her business with pleasure in a way that many would envy and, a former model, Peaches completes the great American fantasy of having it all: brains, beauty and balanced life. Gilbert started Mabel's in New York on the fashionable upper Madison Avenue. She created and purchased all the nature-inspired products in her store and handled the promotions herself. She is a savvy businesswoman, and Mabel's enjoys an international reputation—Mabel's is a registered trademark in six different countries. "Mabel's is a whimsical shop filled with handmade items both for the home, as well as for people, all inspired by Mabel, a charming, witty, and elegant black and white cat," quotes the catalog. Peaches fell in love with Santa Fe and phased out her New York store. The Sante Fe shop, called Mother Nature, is an umbrella for Mabel's products, as well as other handmade items. "I recall customers in Japan and Europe saying, 'start a Mabel's in Paris and Tokyo!'" Peaches laughs. "I thought, 'When would I have time to spend my money if I did all that?'" Obviously, Peaches Gilbert is content with the heaven she's found.

Fixated on her black and white cat Mabel, Peaches Gilbert started a store in Manhattan at Madison Avenue and 70th Street. The illustration on the wastebasket is an interpretation of the street scene in front of the store.

Night Bloomer Lamps
$95 to $125

Handmade Armoire $2400.
(84" x 24" x 44")

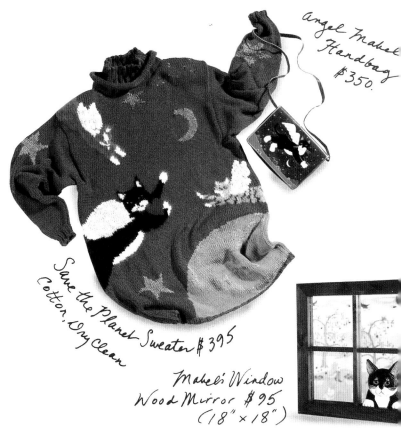

angel Mabel Handbag $350.

Save the Planet Sweater $395
Cotton, Dry Clean

Mabel's Window Wood Mirror $95
(18" x 18")

A foldout catalog shows the products carried in Mother Nature, a store in Sante Fe that is the umbrella for Mabel's. The catalog is printed only once a year in hopes to bring a bit of both Mother Nature and Mabel's products to those who can't visit the store. However, many of the items are one-of-a-kind. It states specifically that items may no longer be available, which is why there is no order form in the catalog; only a telephone number that a customer can call and a representative describes all the product options (styles, variations, etc.) over the phone.

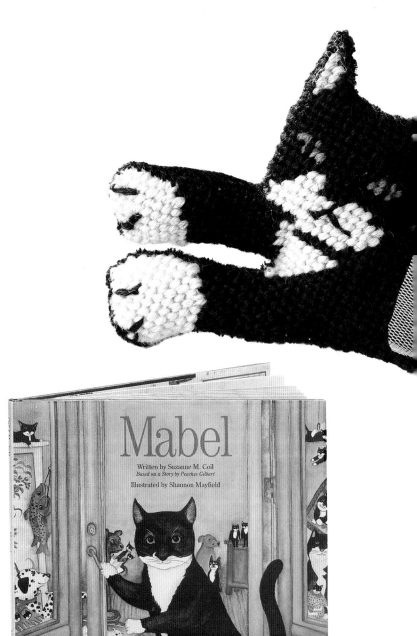

Mabel

Written by Suzanne M. Coil
Based on a Story by Peaches Gilbert

Illustrated by Shannon Mayfield

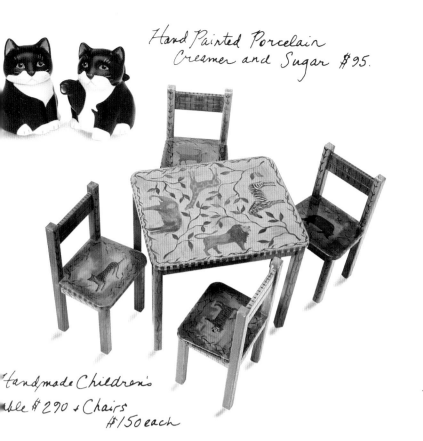

Hand Painted Porcelain Creamer and Sugar $95.

Handmade Children's Table $290 & *Chairs* $150 each

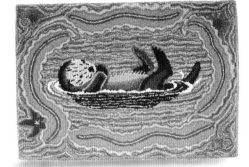

Hand Hooked Wool Sea Otter Rug (25" x 40") $550.

Hand Hooked Wool Tropical Fish Rug (26" x 38") $490.

Hand Carved Wooden Frogs $390 each

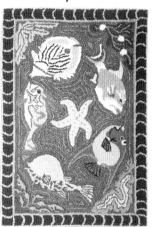

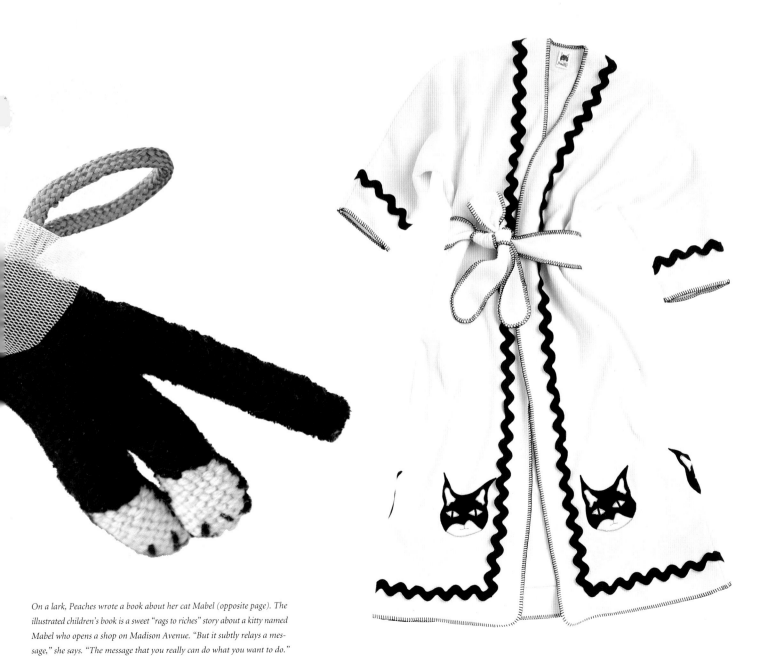

On a lark, Peaches wrote a book about her cat Mabel (opposite page). The illustrated children's book is a sweet "rags to riches" story about a kitty named Mabel who opens a shop on Madison Avenue. "But it subtly relays a message," she says. "The message that you really can do what you want to do."

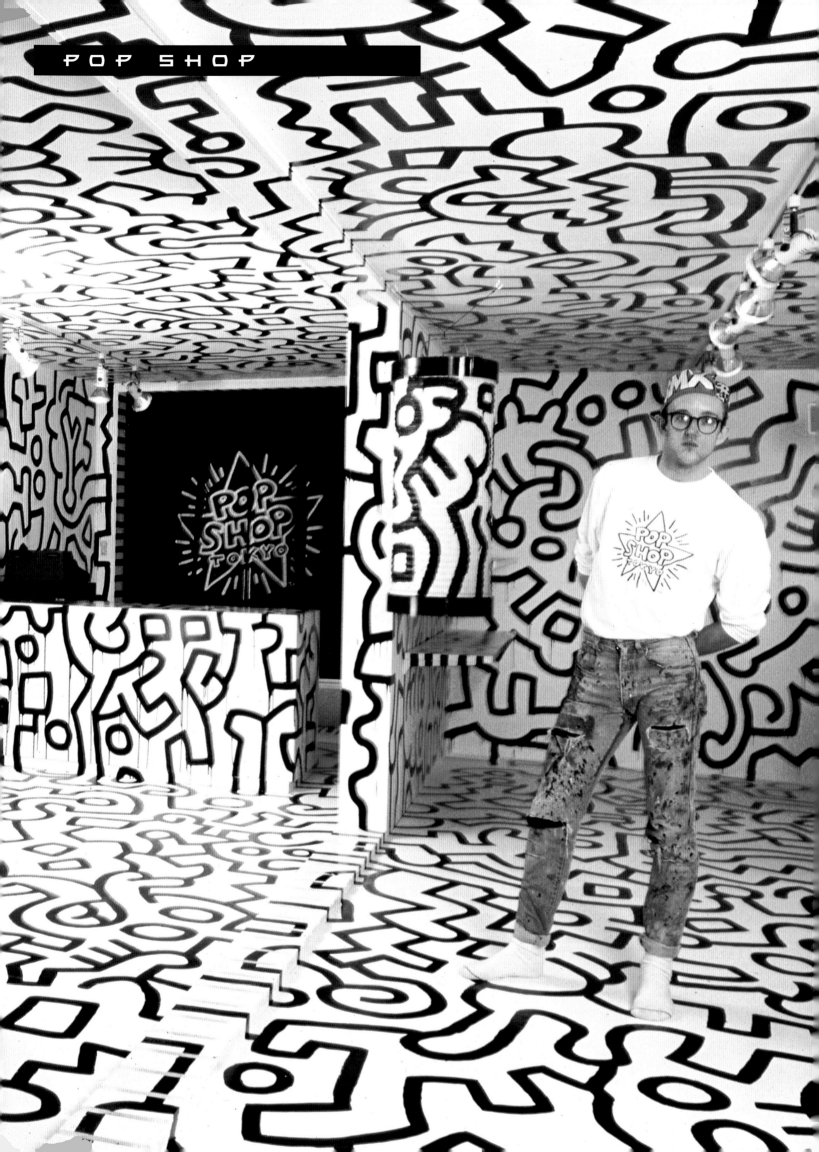

T HE POP SHOP WAS OPENED IN APRIL 1986 AS AN EXTENSION OF KEITH HARING'S ART AND HIS DESIRE TO REACH A LARGE AUDIENCE WITH HIS IMAGERY. HARING'S METEORIC RISE BEGAN SOON AFTER HE WAS A STUDENT AT THE SCHOOL OF VISUAL ARTS. HE STARTED DOING WHITE CHALK DRAWINGS ON BLACK PAPER IN THE NEW YORK SUBWAYS. THESE DRAWINGS, WHICH QUICKLY BECAME ENORMOUSLY POPULAR, WERE OFTEN INTERPRETED AS EITHER HUMOROUS OR AS SERIOUS POLITICAL STATEMENTS. HARING WAS ALWAYS SOCIALLY CONCERNED AND HELPED TO STEER INNER-CITY KIDS AWAY FROM DRUGS AND CRIME. DEAD AT THE EARLY AGE OF 31, HARING LEFT HIS ASSETS TO A FOUNDATION TO SUPPORT CHILDREN AND AIDS ORGANIZATIONS. SINCE HE LEFT MOSTLY ART WORK, THE INTELLECTUAL PROPERTY THAT HARING LEFT TO THE FOUNDATION WAS OF GREAT VALUE. THE OPPORTUNITIES TO EXPLOIT HARING'S WORK—AS ONE OF THE MOST POPULAR ICONOGRAPHIC DESIGNERS IN THE WORLD OF POP ART—WERE FULLY REALIZED IN THE POP SHOP'S MERCHANDISE. THE FOUNDATION CONTINUES TO REVIEW POTENTIAL LICENSEES AND CREATES CONTRACTS TO PROTECT THE ART WHILE CREATING REVENUE STREAMS. SOME OF THE INCOME FROM THIS ACTIVITY GOES TO ORGANIZATIONS SUCH AS CHILDREN'S VILLAGE ORPHANAGE, THE OLDEST ORPHANAGE IN NEW YORK STATE, WHICH IS NOW A HOME FOR SEVERELY NEGLECTED AND ABUSED YOUNG BOYS. MANY PRODUCTS NOT SEEN IN THIS BOOK INCLUDE TOYS, GAMES AND OTHER INVENTIVE PRODUCTS.

*Keith Haring in the Pop Shop in Tokyo (left). It was taken in January
1988 by Tseng Kwong Chi. The first Pop Shop opened in 1986 on
Lafayette Street below Houston in lower Manhattan. Haring's "tag" of
The Baby is one of the most publicly indentifiable icons in Haring's work.*

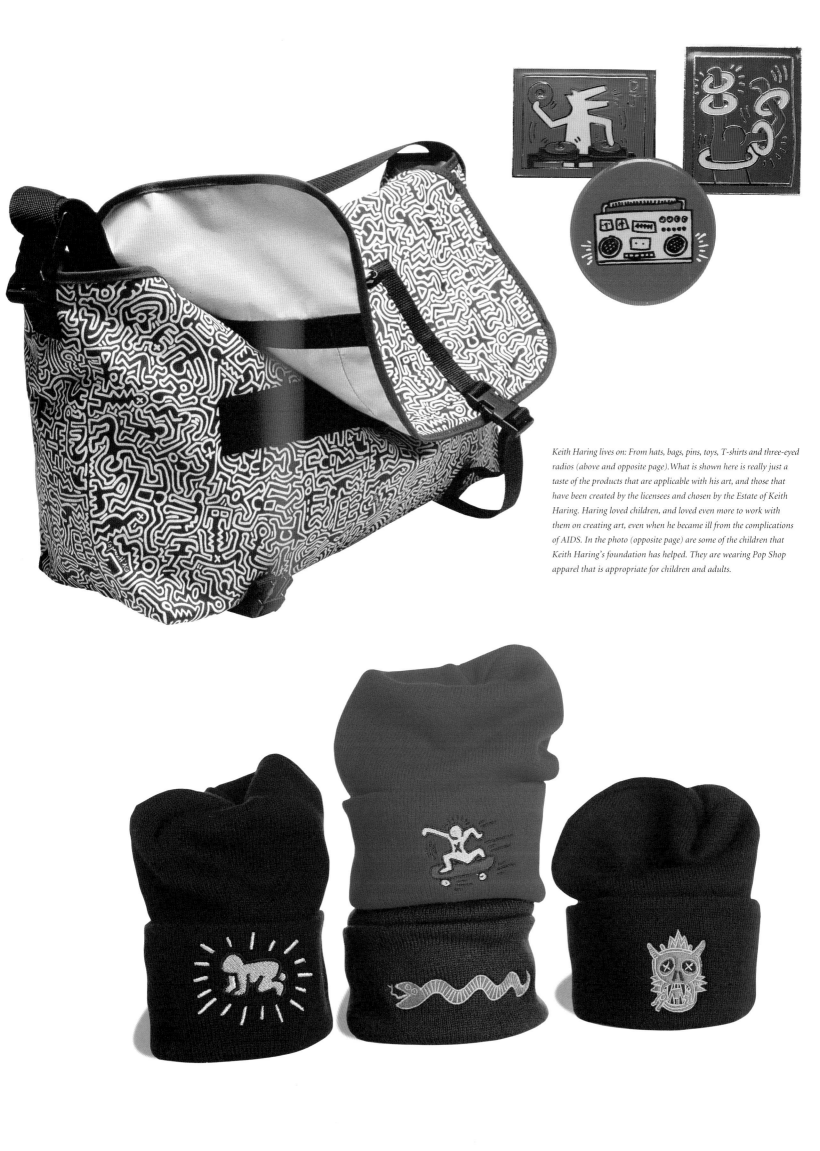

Keith Haring lives on: From hats, bags, pins, toys, T-shirts and three-eyed radios (above and opposite page). What is shown here is really just a taste of the products that are applicable with his art, and those that have been created by the licensees and chosen by the Estate of Keith Haring. Haring loved children, and loved even more to work with them on creating art, even when he became ill from the complications of AIDS. In the photo (opposite page) are some of the children that Keith Haring's foundation has helped. They are wearing Pop Shop apparel that is appropriate for children and adults.

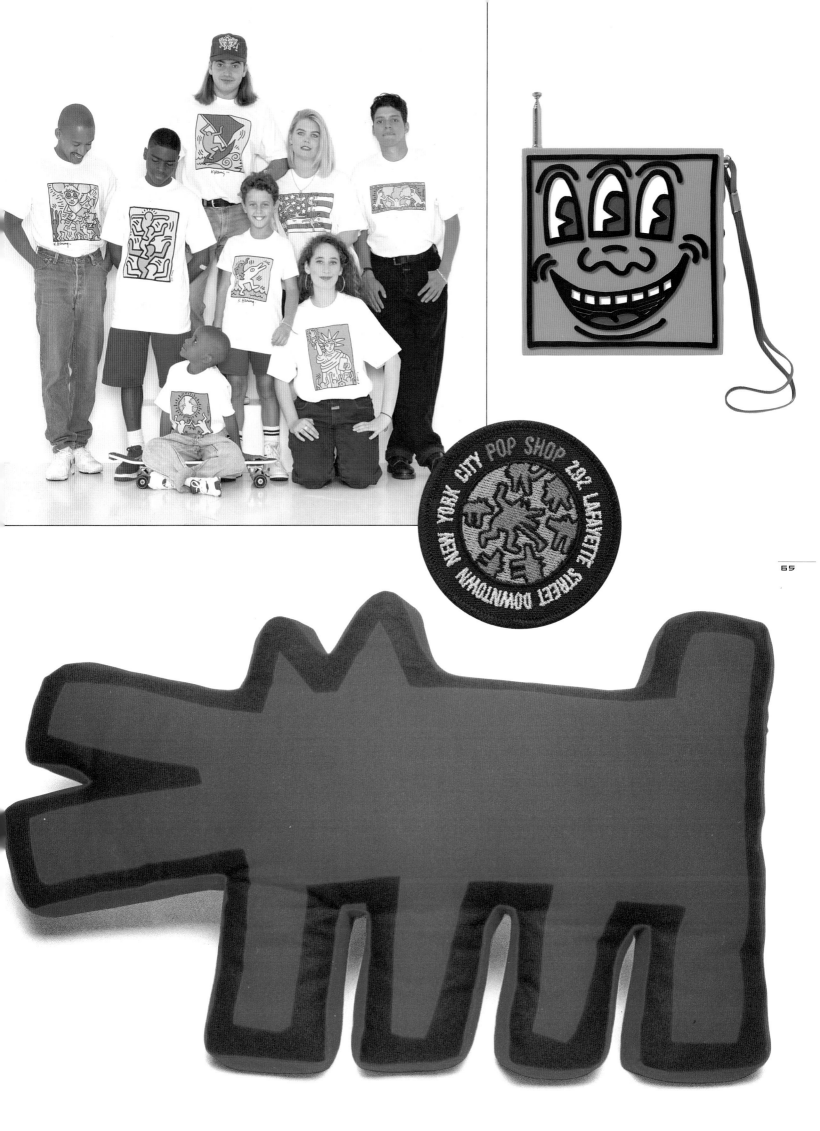

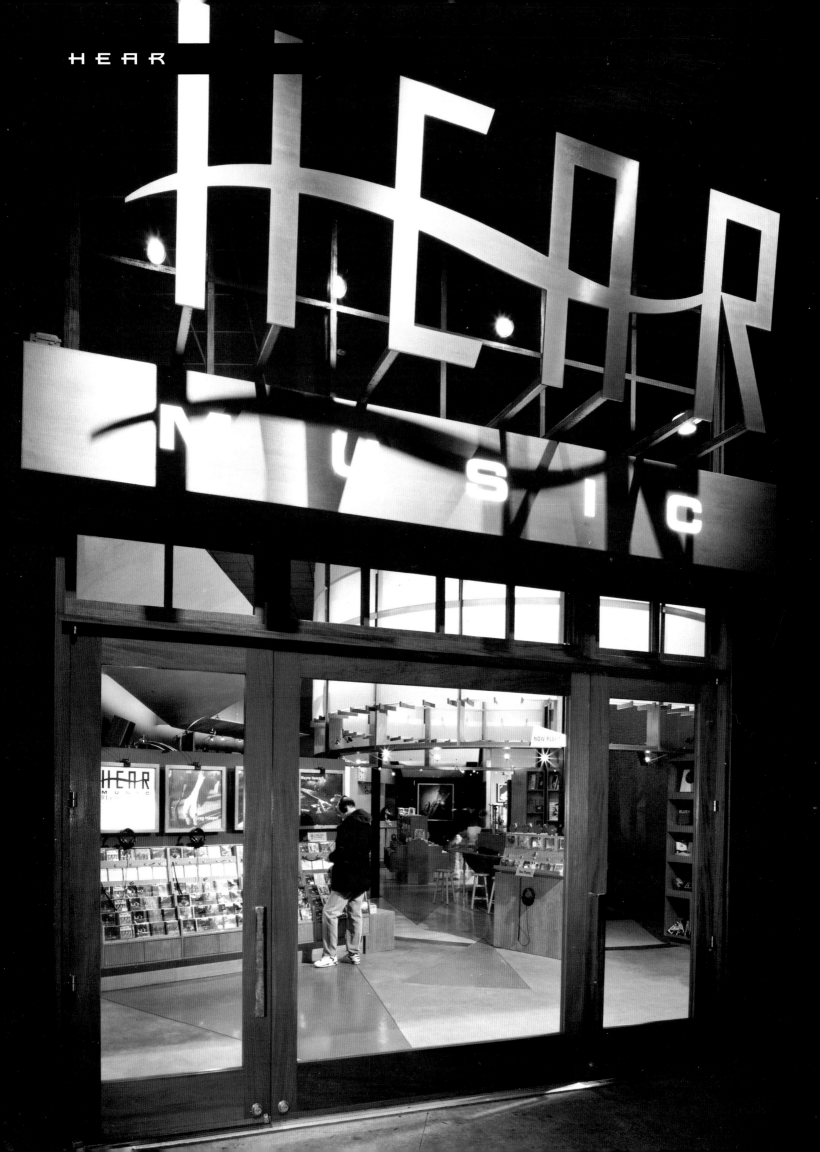

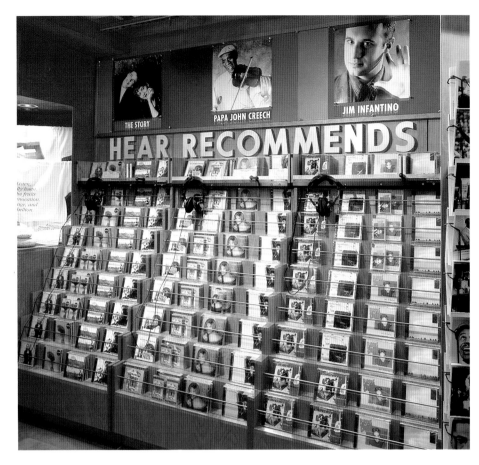

*I*F YOU THINK ABOUT IT, WHEN'S THE LAST TIME YOU HEARD A SONG OR OTHER MUSICAL PIECE ON THE RADIO OR IN A MOVIE, THINKING TO YOURSELF, "I LOVE THIS MUSIC." BUT, LATER YOU CANNOT FIND IT OR EVEN RECALL THE ARTIST'S NAME? WHILE YOU FLIP THROUGH ALBUM AFTER ALBUM IN THE ENDLESS ROWS AND RACKS IN A MUSIC STORE THAT'S ORGANIZED ALPHABETICALLY, DO YOU FEEL LOST? WHEN YOU TRY TO DESCRIBE THE MUSIC YOU'RE LOOKING FOR, DOES THE SALESPERSON JUST LOOK AT YOU QUIZZICALLY? ALSO, DON'T THE GRAPHICS ON THE ALBUM SWAY YOU A LITTLE TOO MUCH, CONSIDERING YOU'RE BUYING SOUND QUALITY NOT DESIGN? IF SO, YOU MAY BE THE CLASSIC HEAR MUSIC TARGET CUSTOMER; ONE WHO LIKES MUSIC, BUT DOESN'T KNOW HOW TO BUY IT. WHILE TRADITIONAL RECORD STORES MARKET THE TOP 40 TO KIDS, HEAR MUSIC HAS FOCUSED ON HELPING ADULTS DISCOVER ALL THE GREAT MUSIC OUT THERE. HEAR COLLAPSED THE ENTIRE PROCESS OF DISCOVERING AN INTANGIBLE BY LOCATING, MARKETING, AND RECOMMENDING ONLY CERTAIN RECORDINGS. THE STORE ALSO GIVES THE CUSTOMER THE ABILITY TO HEAR THE MUSIC THAT IS ORGANIZED BY THEME, NOT CATEGORY OR ARTIST, AND IS ALL LOCATED IN ONE PLACE. FINALLY.

Hear Music started in 1990 as a music catalog in Cambridge, Massachusetts. Areas near major university campuses were then targeted for future stores. The first store opened in Berkeley in 1992. Since then, Hear has spread to a total of nine stores nationally.

HEAR
MUSIC Catalog

HOLIDAY 199

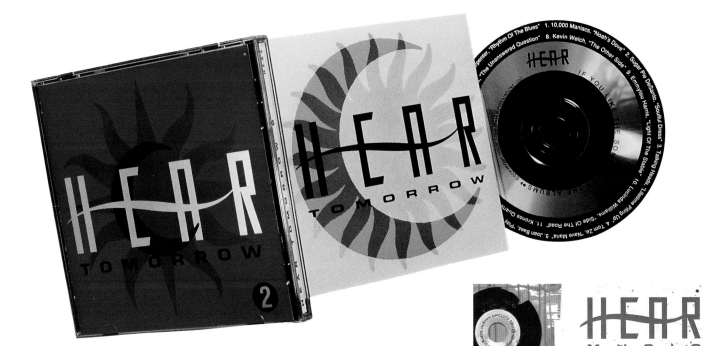

A compact disk sampler above and right provides audible proof of the quality that Hear stands for, addressing the question 'How does one sell a product one can not see or touch?' The cover of a Hear catalog, designed in-house, opposite page.

What you wish would come on the radio when you're driving and guardrails fly past you like teeth on a comb and you pass a dead hedgehog in the road and you're crazy with the smell of rain and death

HEAR
MUSIC

Hear humor and toney literary sense appeals to its target audience of highly educated males and females. The map, right, was illustrated by Jessie Hartland.

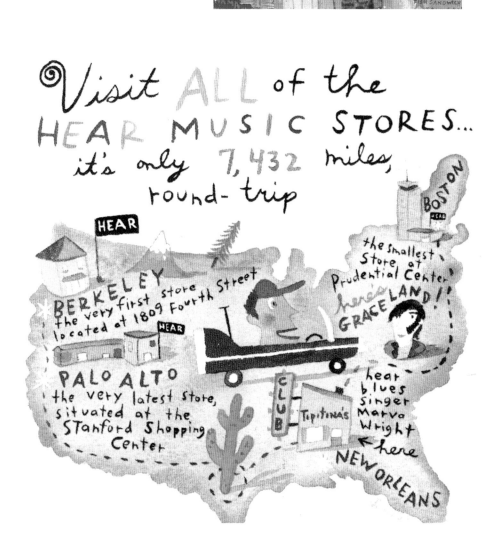

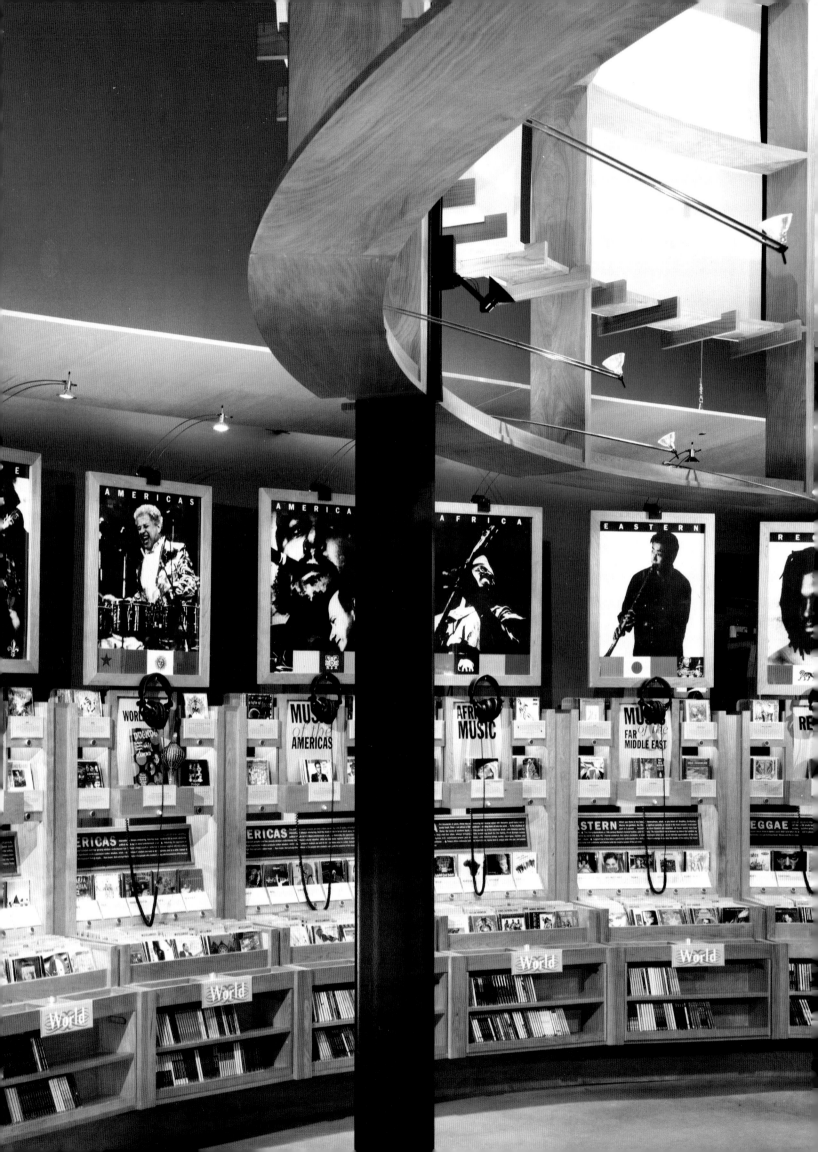

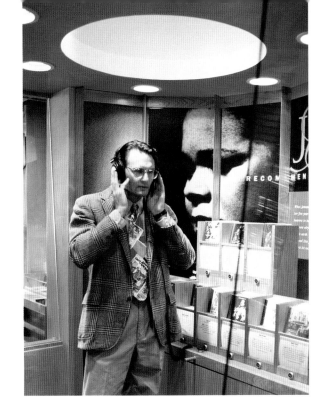

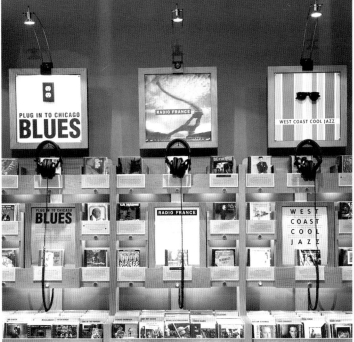

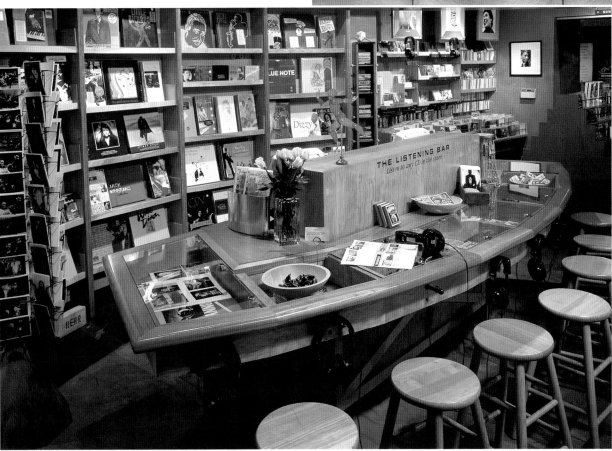

In the 1940s and early 50s, music stores welcomed customers to try out 45's and 78's on turntables located in booths so customers could hear what they were purchasing. Hear Music helped to bring back this marketing technique, which encourages customers to make the Hear store a destination to spend time in, not just place to pick up the latest compact disc of a favorite musician or group.

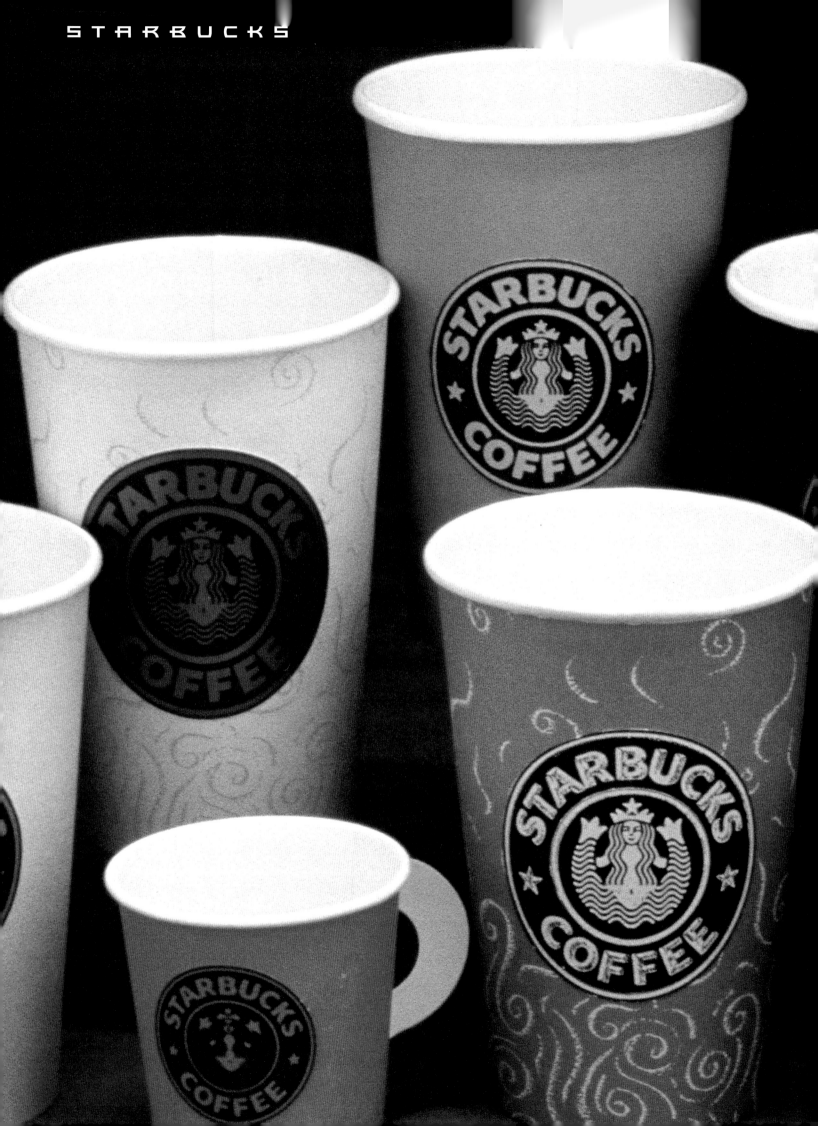

The name Starbuck was derived from the novel *Moby Dick*. The use of a siren connects Starbucks with the romance of the high seas, and the seductiveness of the siren with the powerful lure of great coffee. Its no mystery why such an exotic creature was chosen to represent this high-end market coffee company. Founded in Seattle in 1971, and purchased by Howard Shultz in 1985, Starbucks is the leading retailer, roaster and brand of specialty coffee in North America. The precision with which Starbucks beans are slow-roasted, its secret blends and freshness, plus the ritual that surrounds the making of cappucinos, lattes and espressos are keys to its coffee-brewing success. Starbucks was one of the first high-end coffee purveyors to educate the consumer about what it takes to create a superior cup of coffee. "Fresh beans, fresh water, and fresh brew—at every step of the brewing process, freshness is important." Getting the consumer to "buy" into this artful approach to coffee drinking, along with good service, quality and passion for coffee, helped to revolutionize the industry. The motto of corporate Starbucks: Everything matters.

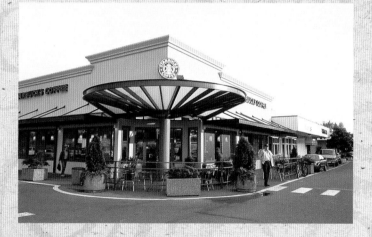

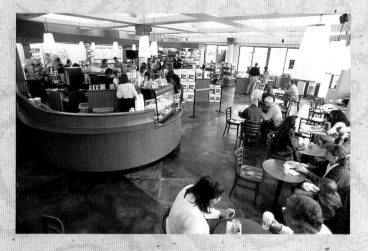

Starbucks was one of the first purveyors of high quality coffee to establish its image by using the paper cup as a primary promotion tool. Essentially, one could say that it walked out of the store and down the street in a customer's hand, becoming free advertising. The cups serve this same purpose now on United Airlines, where Starbucks is the featured coffee at 30,000 feet. The coffee bar phenomena has capitalized on the jolt that coffee gives as well as the pleasures that coffee brings to those who love it. Starbucks is committed to providing a consistently high quality product in an attractive environment served by knowledgeable baristas. It is this commitment to quality many Starbucks customers are attracted to.

Starbucks, a national wholesale and retail chain phenomena headquartered in Seattle, has expanded its sales from strictly fresh roasted coffee products to include coffee-related products. In a world full of coffee drinkers, coffee products may thus be seen as the perfect gift for just about any occasion. An extensive selection of packaged goods including confections, gift baskets and coffee-related items are available in Starbucks stores, and through mail order and on-line shopping.

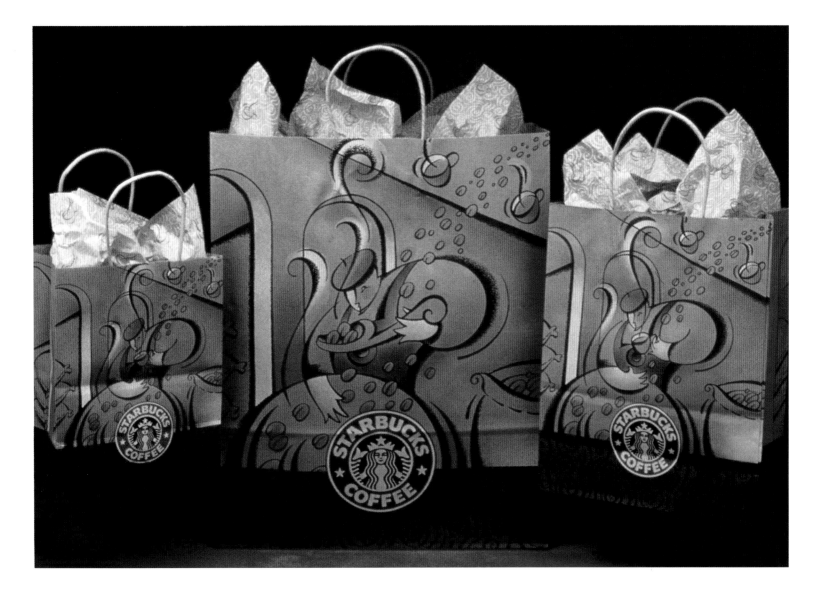

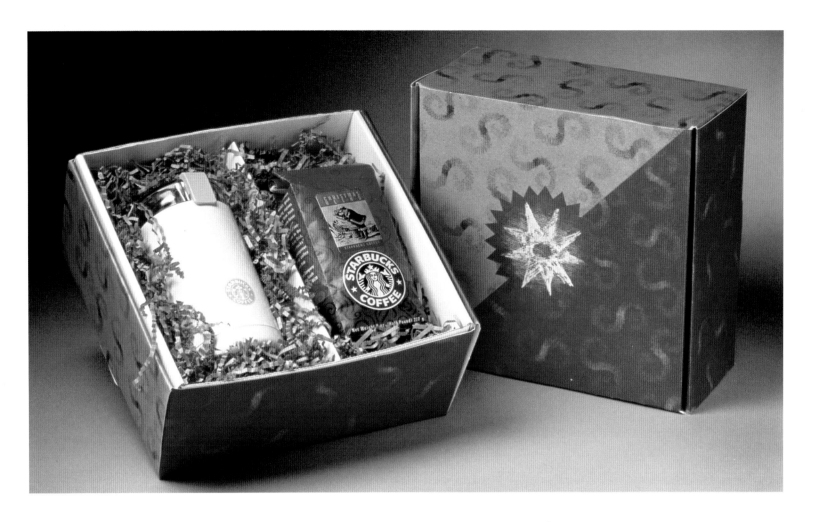

Many Traditions

One World

As Starbucks grows, so has its commitment to supporting the communities in which it operates, such as children's welfare, AIDS outreach programs and environmental awareness. It's involvement with CARE has made Starbucks its largest corporate sponsor of this international aid and development organization. Starbucks is also involved in cultural events, such as jazz and film festivals.

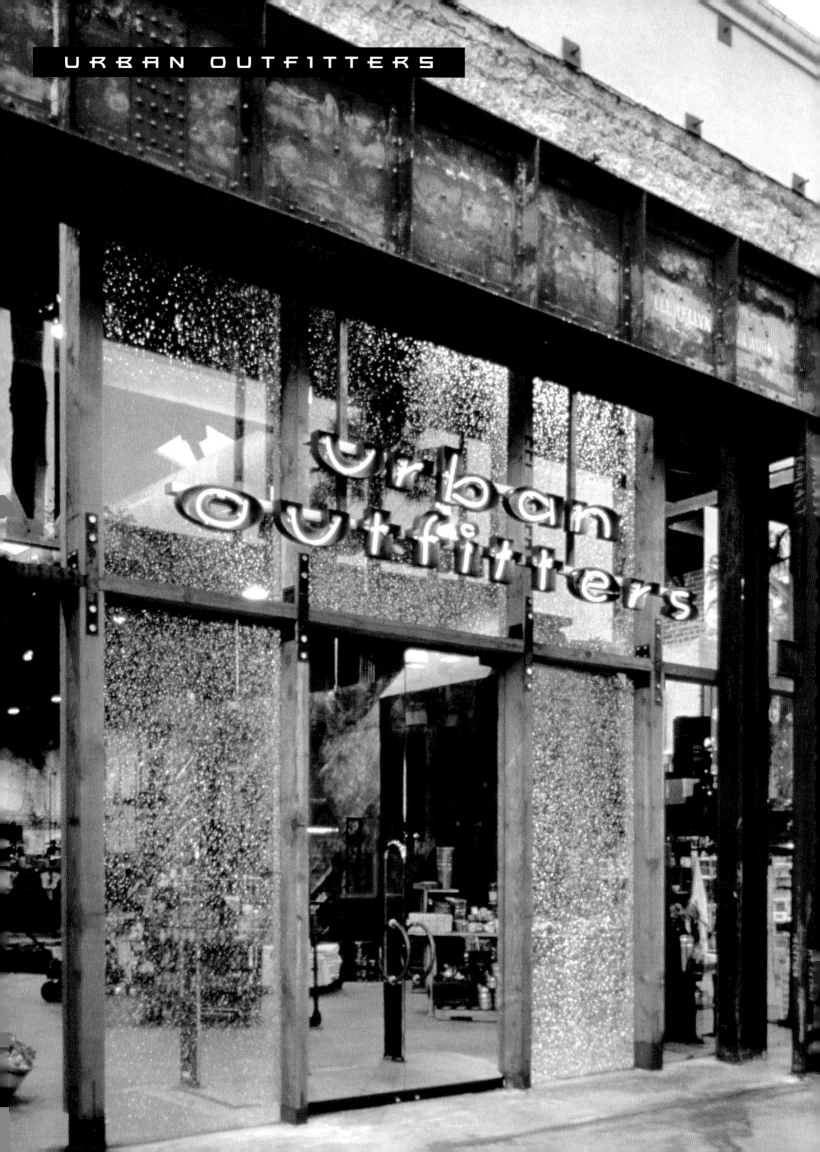

Uˇpscale-homeless and radical-chic are two ways to describe the aura and attraction of Urban Outfitters. By Embracing youth and its culture—and using young management—the philosophy of "Peers servicing peers," says Richard Hayne, the founder of Urban Outfitters, is what makes the store a success. Hayne had the wisdom to recruit a crop of younger, generally cooler, fresher staff for his stores, which became an alternative to other more conventional youth clothing outlets such as the Gap. As Urban Outfitters slowly grew, creative director Sue Otto and the creative team implemented an eclectic mixture of urban style and attitude. A unique approach to merchandising, display and in-store graphics, music and promotions—with independent record companies, and an unconventional approach to advertising with its own in house newspaper—encompass the interests of its energetic customer base. This atmosphere created a distinctive voice and an ingenuine win-win situation for Urban Outfitters, reaffirming that its management understands the soul of its customer.

Urban Outfitters encompasses 23 stores nationwide. With its headquarters in Philadelphia, the stores' structure is often distressed architecture (bare rafters and raw brick walls). Posters (left and above) are unique; designed by Howard Brown and Mike Calkins, these were designed in a series of three, each for a different section of the store. This Spring campaign exemplified the "clean, simple, and functional" direction of the stores during this particular season.

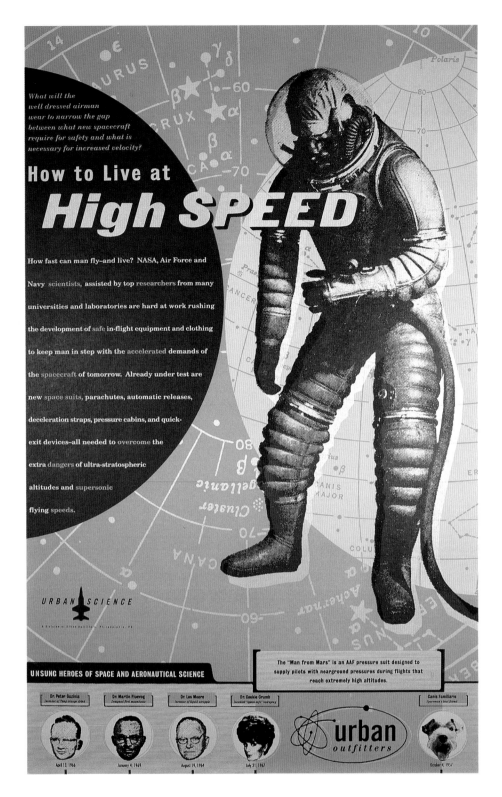

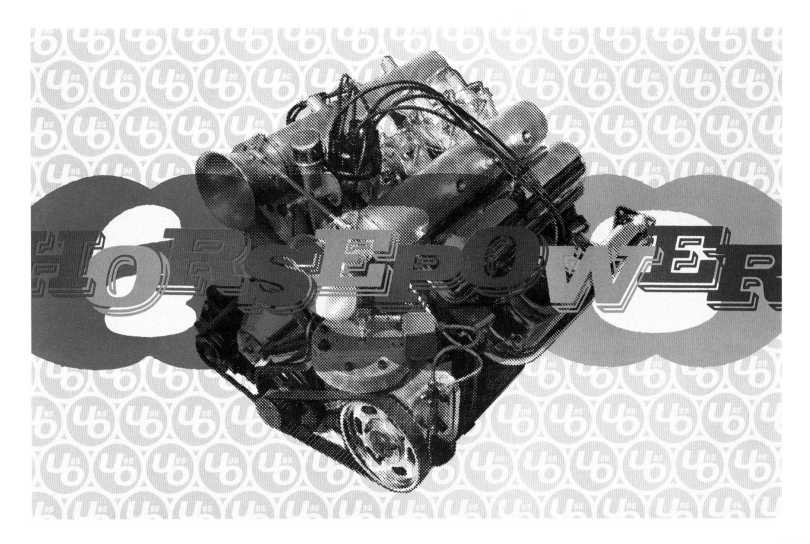

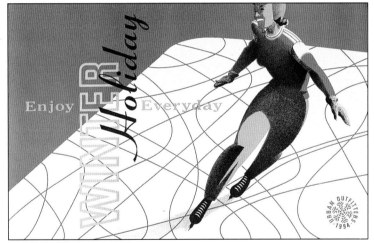

Urban Outfitters' posters rarely, if ever, feature clothing. A favorite vehicle for in-store promotions, the posters are a way to incorporate seasonal variety to reinforce its merchandising and displays. This is just one component that makes Urban Outfitters' strategy unique. The Horsepower and Torkleson's Speed Shop posters were for the store's spring "Hot Rod" campaign. The skater and skier posters were for its holiday "Winter Fun" campaign. All posters shown were designed by Howard Brown and Mike Calkins.

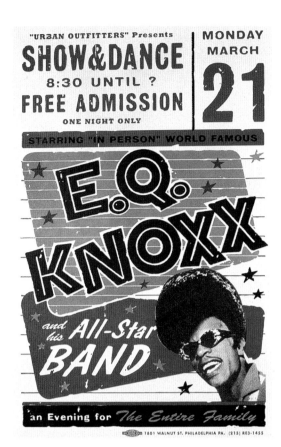

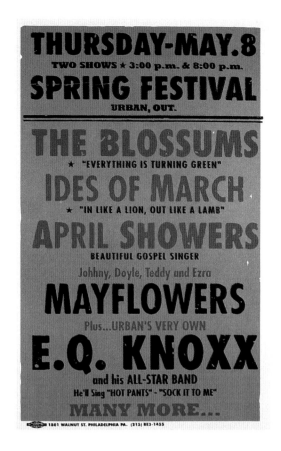

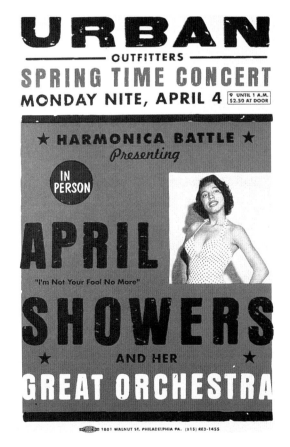

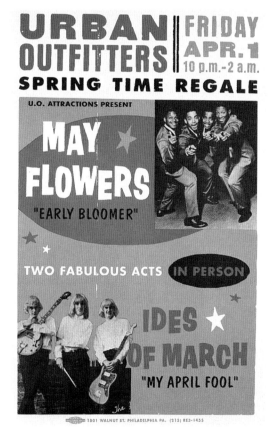

Depictions of Urban Outfitters seasonal poster campaigns focuses on window displays and in-store seasonal signage. This spring poster series was a tribute to old-time rhythm and blues showbills. The copy and performers names play off popular springtime slogans.

The award-winning retro-style annual report emphasizes an attention to detail, vintage printing techniques and materials. Designed by Howard Brown and Mike Calkins; written by Richard Hayne and Ken Cleeland, the majority of Urban Outfitters' annual report is hand assembled. Each year a new Urban Outfitters logo standard is designed, developed and implemented into various corporate and retail programs, including shopping bags and boxes, outdoor signage, banners, windows, T-shirts, employee manuals and other identity systems.

The atypical newsletter: Small. Produced as a bi-weekly xeroxine that is distributed to employees and customers throughout the chain, Small is written and produced by employees. It features music, live show reviews, fanzine reviews, band and employee interviews, job openings, stories, celebrity sightings and events calenders. Unlike Slant's huge, oversized tabloid format, Small is an 11 by 17-inch piece of paper folded into quarters. Used as an informative in-store vehicle, one issue says: "If you have got something to say and you just need some people to listen, if you have any drawings or comics to share, if you have musical insight, if you've seen a good show or heard a good (or bad) album, let us know and reap the riches."

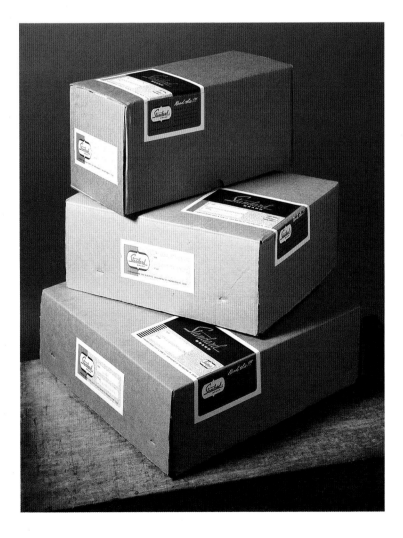

The label development program at Urban Outfitters includes naming, labeling, designing and packaging aspects contributing to the establishment of each label's own "brand" identity. Ace Brand, Big Smokey, Bulldog, Deep Freeze, Fink, Loungers, O'Hanlon Mills, Red Rooster, Standard Brand and Trixie are just a few that were named and designed by Urban Outfitters art department.

Howard Brown is Urban Outfitters' art director, as well as the creator, editorial and art director of Slant. "We wanted to create something both visually and literally unique and compelling. We wanted every page to function as a poster so that someone could tear it out and hang it on their wall: And they do."

Headed by Howard Brown and Mike Calkins, Slant is Urban Outfitters in-house newspaper. Over 50,000 copies are printed and distributed to coffee houses, clubs, clothing stores and record stores throughout North America. Slant incorporates Urban Outfitters' own brand advertising, as well as vendor and independent record companies' advertising. With each issue based on a different subject, the newspaper combines interesting contributions by various artists and writers. Slant proves to be one of the most compelling retail projects because its editorial, art, tone-of-voice and topical content works directly off of the "peers servicing peers" philosophy.

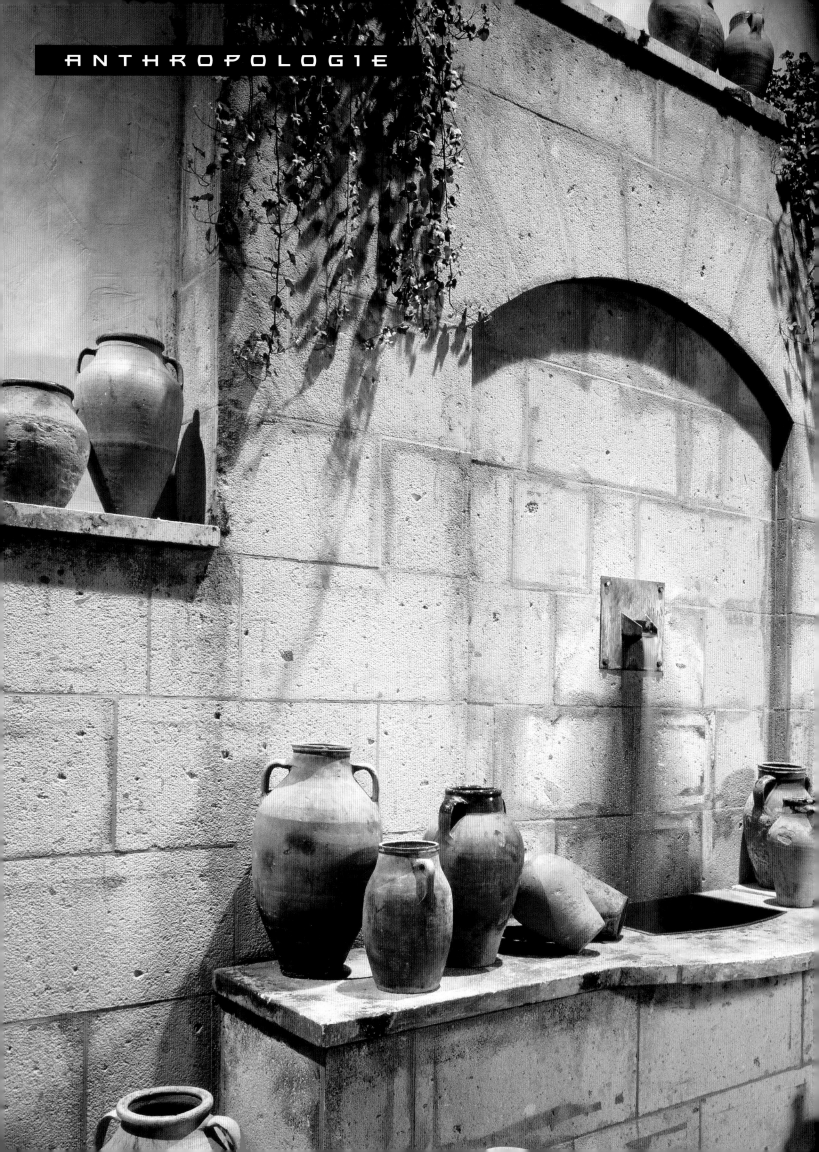

ANTHROPOLOGIE

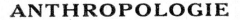

Trade *Mark*

SOHO
New York

TEL: (212) 343-7166
FAX: (212) 343-2589

375 W. BROADWAY
NEW YORK, NY 10012

S THE NAME IMPLIES, ANTHROPOLOGIE IS A STORE THAT'S GOT A LITTLE OF EVERYTHING THAT PEOPLE LIKE: CULTURAL, ONE-OF-A-KIND AND HERITAGE ARE KEY WORDS TO DESCRIBE ITS ALLURE. THE LOGICAL OFFSPRING OF ITS PARENT URBAN OUTFITTERS, ANTHROPOLOGIE PRESENTLY HAS SEVEN STORES AND WAS ESTABLISHED IN 1992 IN WAYNE, PENNSYLVANIA. PROVIDING TO THE LIFESTYLE NEEDS OF URBAN-MINDED ADULTS, THE STORE CONTAINS FURNITURE, MEN AND WOMEN'S CLOTHING, BATH AND BEAUTY, ACCESSORIES, AND EVEN HORTICULTURE (ANTHROPOLOGIE HAS ITS OWN GARDEN SHOP). "OUR CUSTOMER IS SOMEONE WHO SHOPPED URBAN OUTFITTERS 10 TO 15 YEARS AGO, IT'S THAT PSYCHOGRAPHIC." SAYS GLEN SENK, PRESIDENT OF ANTHROPOLOGIE. "BUT THEY HAVE GOTTEN OLDER, SETTLED DOWN AND PROBABLY ARE PARENTS. IF THEY'RE LIVING IN THE SUBURBS, THEY HAVE AN URBAN MENTALITY AND ARE FASHION AWARE."

*A wall inside Anthropologies'
Rockville, Maryland store
houses a fountain with pots and
urns from Italy. The business
card designed by Howard Brown
(above) utilizes the store's
signature flower.*

Inside the store is a garden shop, men's section, bath, beauty and accessory section. Merchandising for the table with grass and saucers, Greg Lehmkuhl; the broken radiator with tuplips, Dean Holdiman; the wheelbarrel chair, Lehmkuhl; the garden shop, Lehmkuhl and Kristen Norris.

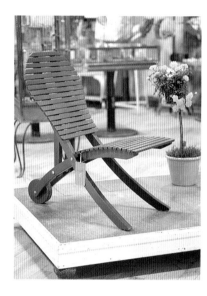

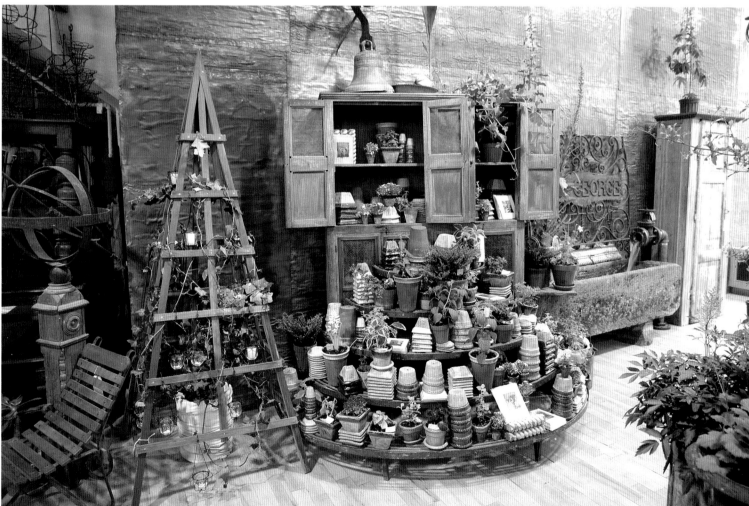

The flower on the business card expresses the store's ability to concentrate on the most minute of details. The flower icon is an interchangeable signature— cotton bulb for apparel; a chair for furniture—and the icons change seasonally, (for example, holly leaves to signify christmas, etc.) The tags are letterpress printed on colored industrial stock and used for a variety of purposes.

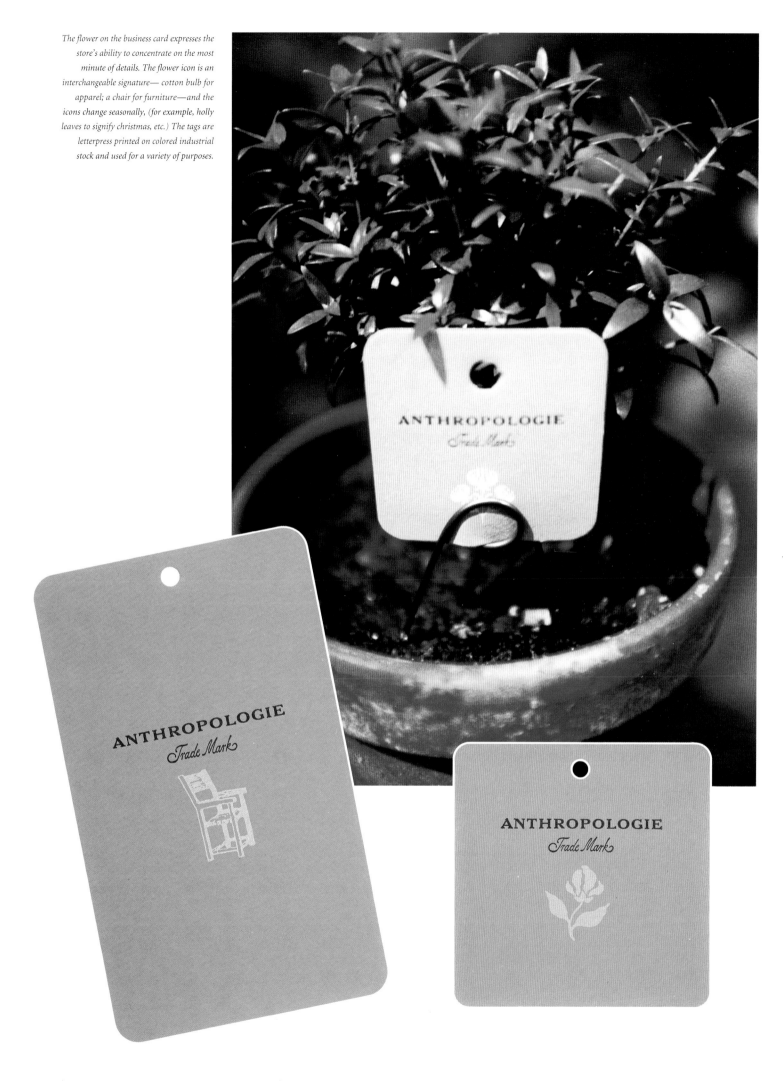

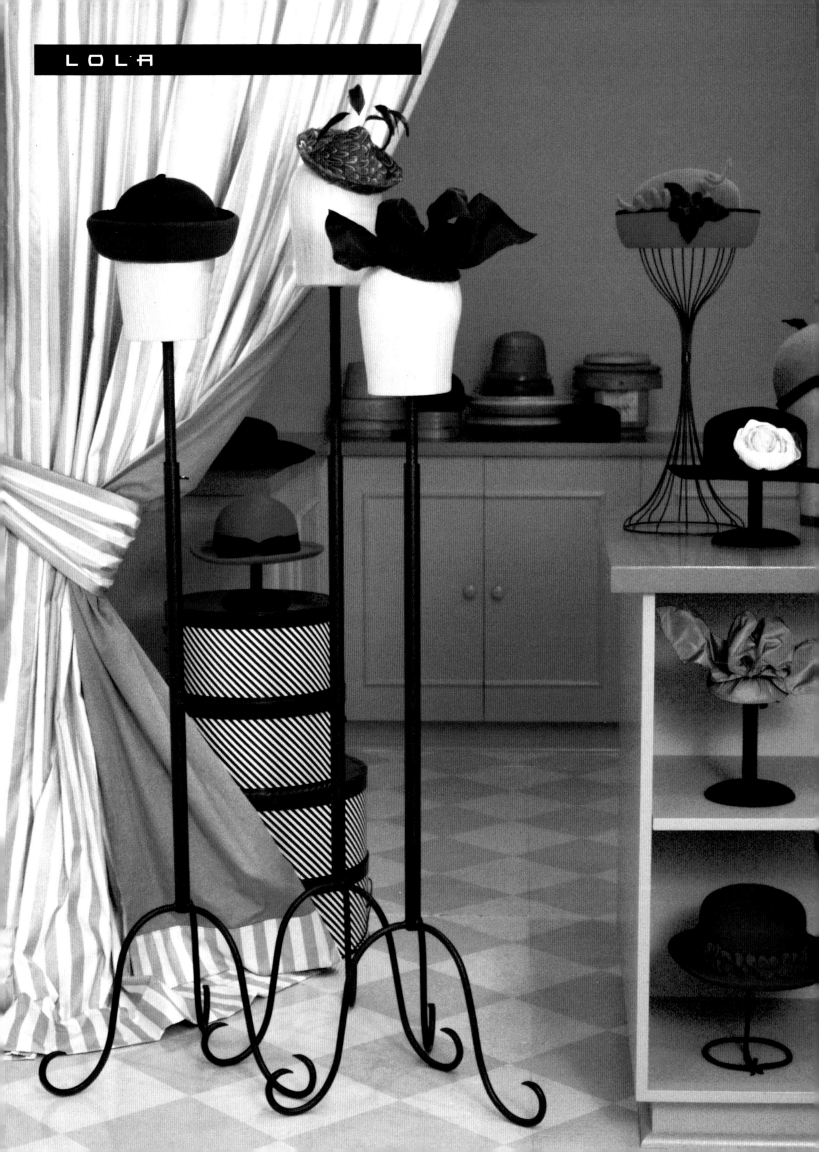

LOLA HAS CREATED A SALON ENVIRONMENT WHICH INVITES WOMEN TO BROWSE AND LINGER. A CUSTOMER MAY STAY SEVERAL HOURS TRYING ON THIS HAT AND THAT. LOLA LOVES HER WORK, AND HER HATS ARE 95 PERCENT CUSTOM MADE. "I WILL SAY TO A WOMAN, 'PERHAPS THIS ONE SUITS YOU BUT WITH A DIFFERENT BOW.' I'LL BRING OUT AN ARRAY OF RIBBONS. SOMETIMES THE WOMAN DOESN'T FIND HER HAT THAT DAY. BUT I DON'T CARE, I ENJOY THE PROCESS ALL THE SAME." ALWAYS HAVING A FRESH PERSPECTIVE IS IMPORTANT TO LOLA, WHO SELLS MANY, MANY MORE HATS ON CONTRACT TO BERGDORF GOODMAN, ALL MAJOR SPECIALTY STORES IN THE UNITED STATES, ASIA AND EUROPE THAN WILL EVER WALK OUT OF HER LITTLE SHOP ON WOMEN'S HEADS. A TINY BOUTIQUE, LOLA HAS DESIGNED THE ROOM IN WHICH HER HATS ARE DISPLAYED USING BUT A FEW PIECES OF FURNITURE. "EACH WEEK I REARRANGE THE FURNITURE. A WOMAN MAY COME IN WHO WAS HERE THE WEEK BEFORE, SEE A HAT AND EXCLAIM, 'WHERE DID THIS COME FROM?' AND YOU KNOW WHAT, IT WAS THERE ALL THE TIME. ONLY THE FURNITURE MOVED!" SHE SAYS, LAUGHING. LOLA HAS A REFRESHING INSIGHT INTO PEOPLE. THAT, HER HUMOR, AND SUBTLE FRENCH DEMEANOR ARE A PART OF HER PERSONA, WHICH MAKE HER (AND HER SHOP) A SHEER DELIGHT TO VISIT WITH.

Lola Erlich and graphic designer Steve Isoz created the environment for her store. Above, part of Lola's identity, the "very Frenchie" figure illustrated is used on all her correspondence and as a swatch guard. Illustrated by Diane Huff.

Lola's intimate two story store on 17th Street and Fifth Avenue in Manhattan serves as her millinery. On the second floor is the workroom where the hats are made, and the selling floor is on the first.

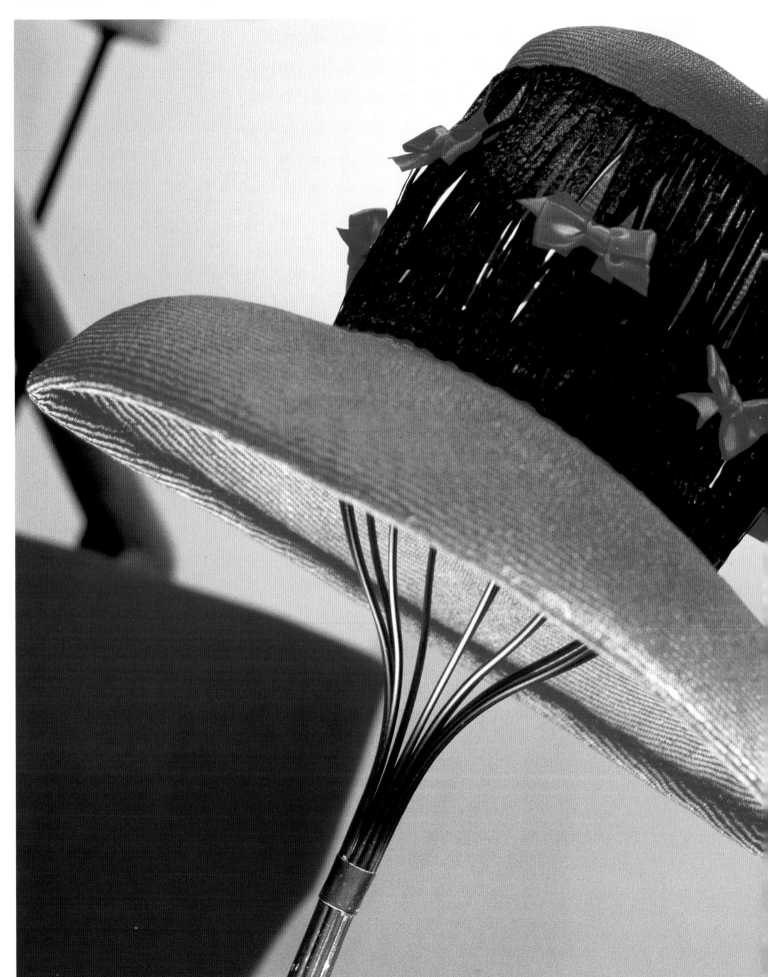

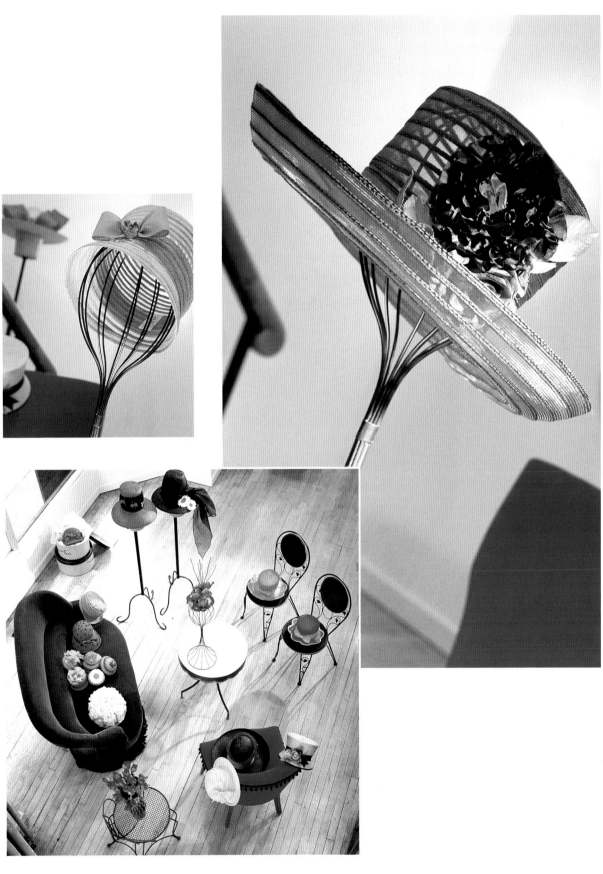

All the hat stands were custom made, sketched out by Lola.
Lola's hats are often custom made for her clients. She delights in adding
details, especially for a single customer and may spend hours working
with a woman to arrive at the right look for her hat.

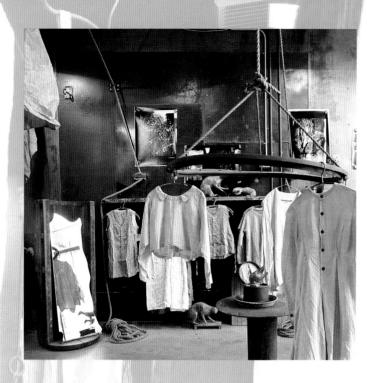

ORGAN PUETT IS A FINE ARTIST WHO WAS CAJOLED, URGED AND PUSHED INTO BECOMING A FASHION DESIGNER. SHE HAS CREATED HER OWN WARDROBE ALMOST ALL HER LIFE. SHE DIDN'T LIKE A MACHINE-MADE STYLE AND PREFERRED TO HAND-STITCH HER CLOTHES. "AT ONE POINT, I DESIGNED ALL MY CLOTHES USING ONLY OLD WHITE BEDDING LINENS AS THE FABRIC," SHE SAYS. THEN SHE WAS FINDING THAT SHE WAS SELLING THOSE VERY CLOTHES "OFF HER BACK.'" SHE GRADUATED FROM THE ART INSTITUTE OF CHICAGO HAVING DEVELOPED A FEEL FOR INDUSTRIAL DESIGN, WOOD-WORKING, FILM AND SCULPTURE—HER STORE IS A REFLECTION OF ALL THESE TALENTS.

IN THE SHOP IN SOHO, I RECALL WALKING THROUGH THE SCREEN DOOR INTO AN ASSEMBLAGE ENVIRONMENT OF RUSTICATED METAL AND PAINTED SURFACES. THE AIR WAS STILL CRISP, AND ON THAT EARLY SPRING DAY I SUDDENLY NOTICED SOME SMALL BUT COLORFUL, QUICK MOVEMENTS IN THE WINDOW. MORGAN HAD PLACED A BOX OF BUTTERFLY LARVAE ON THE SILL AND THESE DELICATE PURPLE AND BLUE FLUTTER-BYS WERE EMERGING FOR THE FIRST TIME, FLOATING IN LAZY CIRCLE EIGHTS FOR ALL THE PASSERS-BY TO ENJOY: MORGAN'S GIFT TO THE STREET TO WELCOME SPRING.

MORGAN IS THE FIRST TO TELL YOU SHE IS A SUCCESS AS A FASHION DESIGNER IN SPITE OF HERSELF. "I'M ACTUALLY A PAINTER IN MY HEART. BUT, AS MUCH AS I HAVE TRIED, THIS IS A BUSINESS THAT WOULD NOT DIE." SHE SELLS MUCH OF HER LINE THROUGH WHOLESALE, AS WELL AS DESIGNED COLLECTIONS FOR INDIVIDUALS. SHE SEES OTHER RETAILERS COMING IN AND TAK-ING NOTES ABOUT HER LINE AND STORE DESIGN—MORGAN IS NOT QUITE SURE WHETHER TO BE COMPLIMENTED OR CONCERNED. AT ANY RATE, NO ONE COULD REALLY IMITATE OR DUPLICATE THE J. MORGAN PUETT STYLE—ONLY MORGAN HERSELF CAPTURES ITS ESSENCE.

A true original, Morgan Puett's store shingle is simply a bronze dress in her classic style. The J. Morgan Puett store is on Wooster Street in Soho.

Puett uses very simple monochromatic line drawings along with two-tone mood photos of non-model friends wearing her clothing.

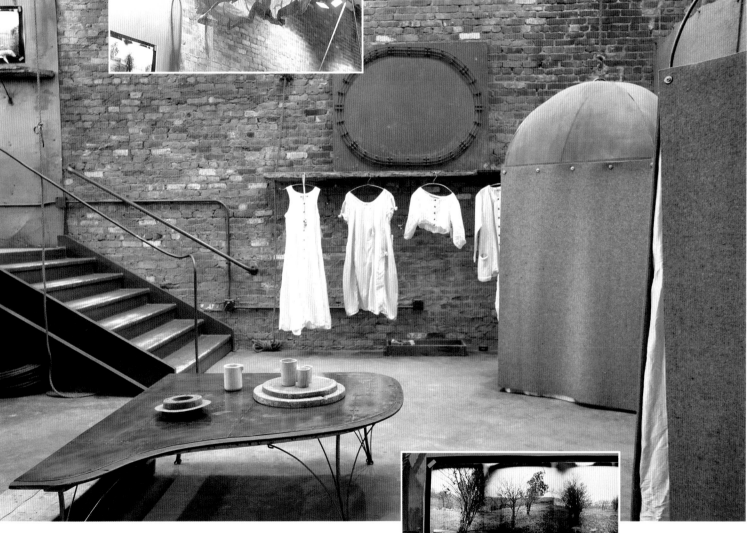

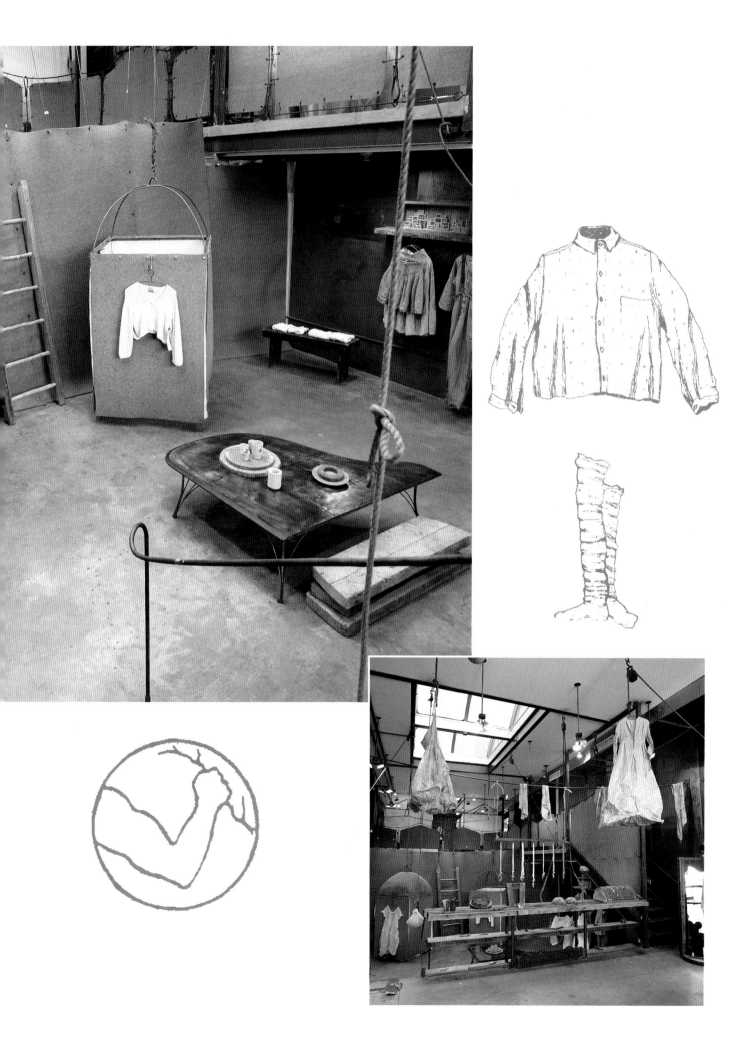

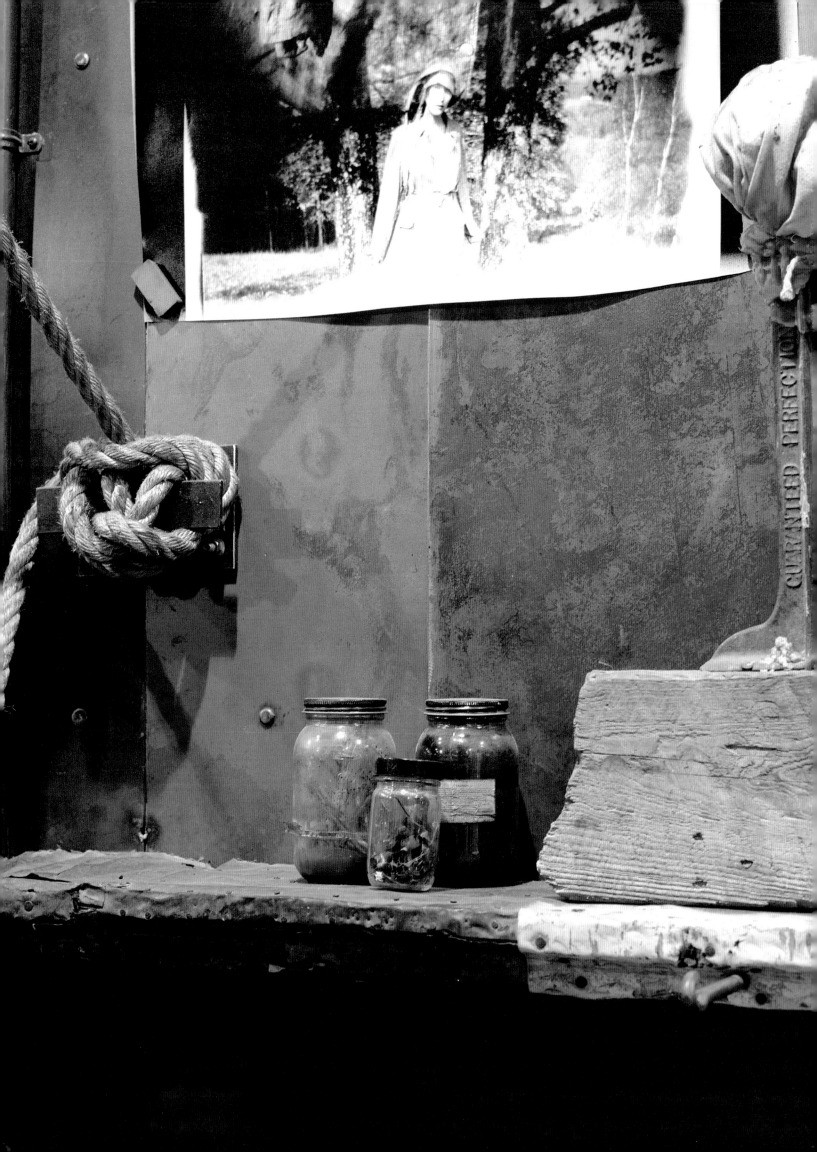

GUARANTEED PERFECTION

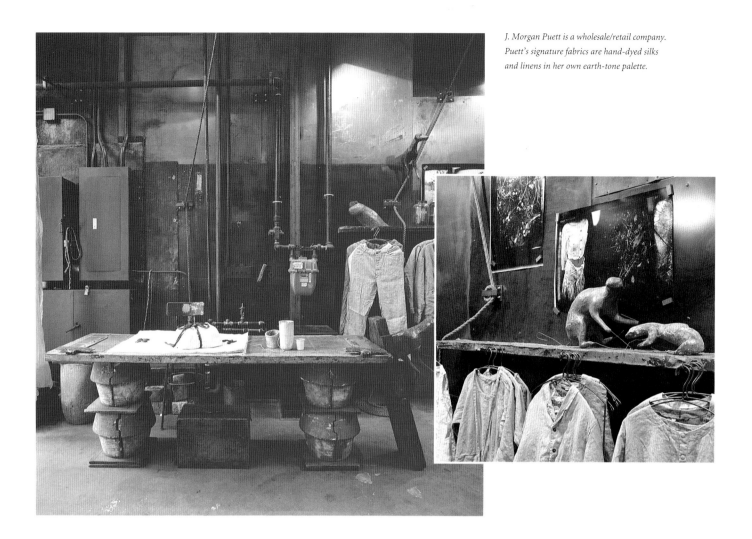

J. Morgan Puett is a wholesale/retail company. Puett's signature fabrics are hand-dyed silks and linens in her own earth-tone palette.

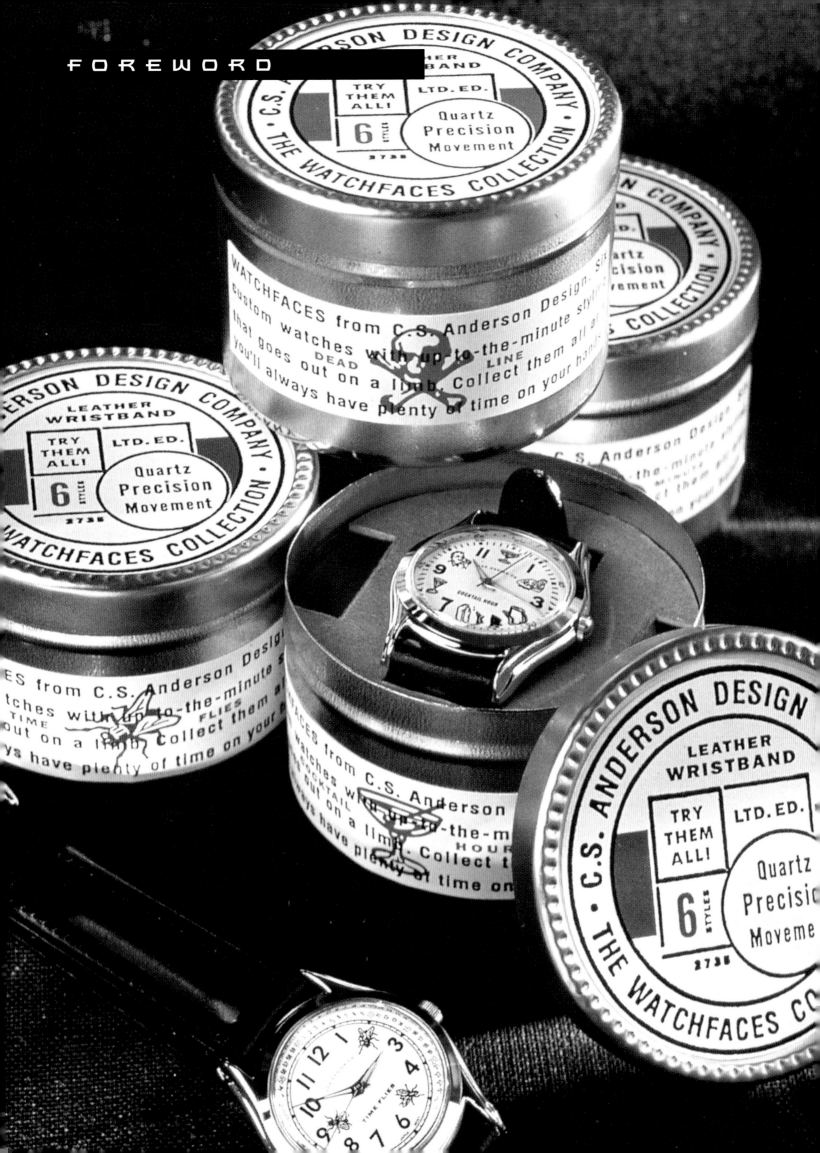

Driven to design

Many entrepreneurs and manufacturers must go outside to find talent that fulfills their merchandising and marketing needs. For many this creates a dilemma: Where do you go? The yellow pages? A good friend with taste? A design school's referral service? Design annuals? These options make designers shutter and cringe because they are all of the hit-or-miss variety. The person or company seeking to find the talent must have a crystal clear idea of what they need, and be able to differentiate between good, bad and just plain ugly in order to end up with a good fit. The reality has been that all these options have brought potential clients knocking on designers doors—big clients to small designers and small clients to big designers.

I assembled a lengthy section of this book in order to help simplify the matching process. This next section is not only great to explore, but it will help put you in touch with a variety of designers and their unique approach to product design, retail store design, packaging design, product identity and promotions. These designers are accessible: a brief profile, addresses and phone numbers are included. Arranged alphabetically, this section is a handy reference guide for those who desire to locate a specific designer they have heard of.

The ways in which these designers work runs the gamut: Charles S. Anderson, Cronan Artefact and M&Co Labs actually create product and market their lines themselves. Bridgid Kavanaugh was the designer-behind-the-scenes for Hue. Hornall Anderson designed many of the product packaging for Starbucks and Desgrippes Gobé was responsible for the new international branding program for Gillette.

When designer Harry Murphy (to whom this book is dedicated) first started with Don Fisher on a store named after the 60s concept of the generation gap, no one had a clue how big the Gap would become. It is through the success and good energy of designers and the strong relationships of entrepreneurs and manufacturing visionaries that such legends may begin to grow.

Can do: Custom wristwatch tins (left) designed by Charles S. Anderson Design, Minneapolis. Co-promotional cans (right) designed by Madeline Corson Design, San Francisco.

A SUCCESSFUL DESIGN IS JUST AS APPARENT TO YOUR CLIENT AS IT IS TO YOU—IF IT'S DEFINED WELL AT THE BEGINNING.

— Brian Collentine

Lisa Billard, Brian Collentine, Richard Parker, and Christian Bentley of AXO design studio.

AXO design studio established merchandising and display standards for United Colors of Benetton. The standards manual was developed for stores in Canada, Mexico and the U.S.

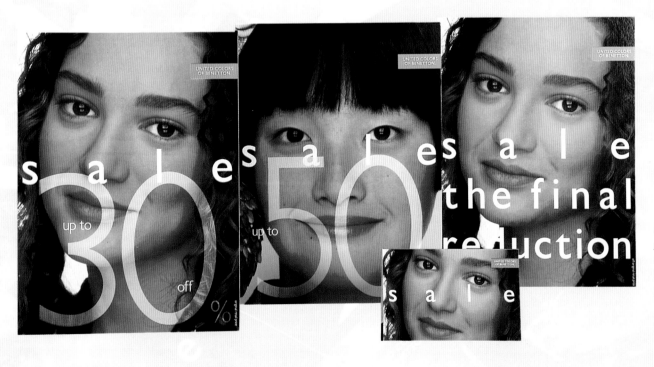

Sale signage and tags for United Colors of Benetton communicate image rather than simply what's on sale.

AXO Design Studio
423 Tehama Street
San Francisco, California 94103
415 543 8712

Starting out in the quintessential retail environment of Macy's, Brian Collentine developed a strong interest and talent for the 2-D/3-D world of consumer environments and promotion. During the mid-eighties, Collentine was Visual Director of Display and Merchandising for Esprit. With Esprit co-founder Doug Tompkins, he developed a rigorous design program for visual presentation.

In 1990, Collentine formed AXO design studio. AXO is derived from the word "axonometric," a two-dimensional drawing of a three-dimensional design. He works with some of the best companies associated with fashion and product design—Nike, United Colors of Benetton, Gap, Banana Republic, Levi's and Apple Computer. His style, active but elegant, complements their marketing savvy.

AXO design studio customized standard gift boxes for Headlines by die-cutting an "H." This solution allowed the tissue to read through and required no printing on the box.

103

Headline's image program is the most recent part of its evolution from a San Francisco "head shop" in the early seventies to four eclectic stores catering to a wonderfully diverse clientele.

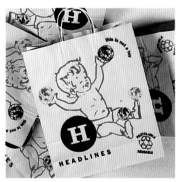

Headline's shopping bags express the free spirit of the owner.

Nancy Bauch, Bauch Design.

PACKAGING IS OFTEN THE SILENT SALESPERSON. THE DESIGN MUST PROJECT NOT ONLY THE CONCEPT OF THE PRODUCT BUT ALSO ITS SPECIFIC POINT OF DIFFERENCE. ONCE THE CUSTOMER HAS IT IN THEIR HANDS, IT IS THE WRITING THAT CLOSES THE SALE. — Nancy Bauch

"Excavating Volumes," a proposed invitation to the grand opening of a new art museum designed by the Swiss architect Mario Botta.

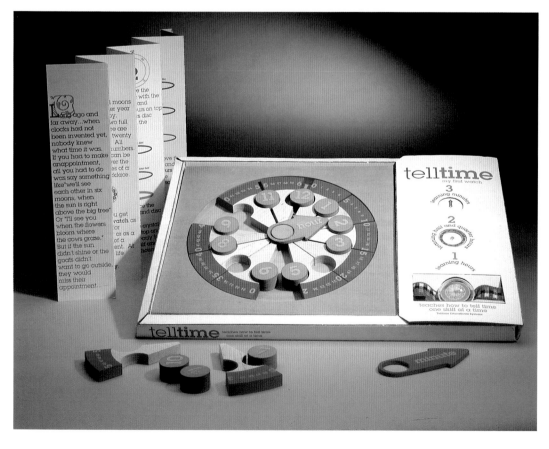

Bauch Design's Telltime Watch is also a puzzle that helps children learn the concepts of time-telling through its interactive layers of removable parts.

BAUCH DESIGN
11 EAST 94TH STREET
NEW YORK, NEW YORK 10128
212 996 6086

Reprinted from MARKETING BY DESIGN.
Printed in Hong Kong.

WHILE IMMERSED IN THE DESIGN OF PACKAGING FOR RANCHO ALEGRE, NANCY BAUCH WEARS JEANS, DONS A WESTERN VEST AND PULLS OUT HER GENE AUTRY 78S. EVEN THOUGH THE ENVIRONMENT IS HER CHIC NEW YORK DESIGN OFFICE, THIS FORM OF METHOD DESIGNING (LIKE METHOD ACTING ONLY THERE'S NO AUDIENCE) ALLOWS BAUCH TO BECOME ONE WITH HER PROJECTS, A FACTOR SHE CONSIDERS EXTREMELY IMPORTANT TO SUCCESS.

WHEN WORKING ON RETAIL PROJECTS, BAUCH REACHES BACK TO HER PAST AND CALLS UPON THE KNOWLEDGE OF 3-D DESIGN THAT SHE GAINED WHILE AN ENVIRONMENTAL DESIGNER FOR GENERAL ELECTRIC IN THE MID SEVENTIES. BAUCH SAYS, "I WENT BACK TO SCHOOL AFTER WORKING AT 3-D PROJECTS FOR SEVERAL YEARS. ART CENTER IN PASADENA PROVIDED ME WITH GREAT TRAINING FROM SOME OF THE BEST PROFESSIONALS IN GRAPHIC DESIGN."

BAUCH SAYS, "MY WORK IS TOTALLY DRIVEN BY THE SUBJECT, THE CONCEPT, THE OBJECTIVES OF MY CLIENT. I NEVER DECORATE." SHE WORKS SOLO BUT

Stationery for The Republic of Tea is printed on paper custom made with tea leaves to stain the pulp. The teapot trademark changes its "steam" on each application, expressing the complexity and range of the tea drinking experience. The stationery system was developed with Clement Mok of Clement Mok designs, Inc.

Packaging for The Republic of Tea creates an imaginary place and time. The writing gives you worthwhile information and the vignetted main image evokes a dream feeling. The texture of the black lid is derivative of a Japanese iron teapot.

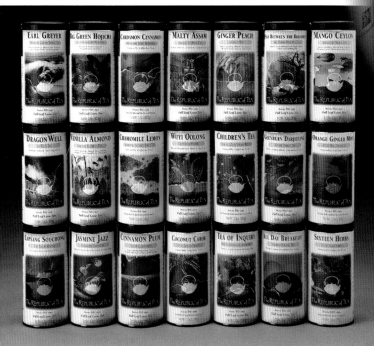

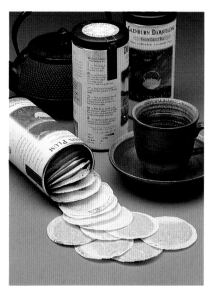

Beyond being designed to stand out among the sea of boxes on the shelf, the packaging had to suggest a higher quality and broader range of tea, common in other cultures, but missing in our own.

MAKES IT A PRIMARY
GOAL TO DIG DEEP TO UNDER-
STAND AND TO INVOLVE THE
CLIENT IN THE PROCESS. BAUCH ADDS,
"I CALL MY FIRST ROUND OF COM-
PREHENSIVES 'DISCUSSION PIECES'
BECAUSE THAT'S WHEN I REALLY HEAR
THE CLIENT'S TRUE
POINT OF VIEW."

This point of purchase display was made from the same plastic tubing used to make shoe cushioning and filled with NIKE-AIR® so potential customers could squeeze it and feel its pressure-absorbing abilities.

The NIKE-AIR® shoe catalog communicates the feeling of air providing comfort through imagery of a woman at peace with herself and of the airbag curved to give it a sensuousness.

This direct mail piece for NIKE-AIR® puts the product's six major features into a form every woman can relate to— the context of a typical day.

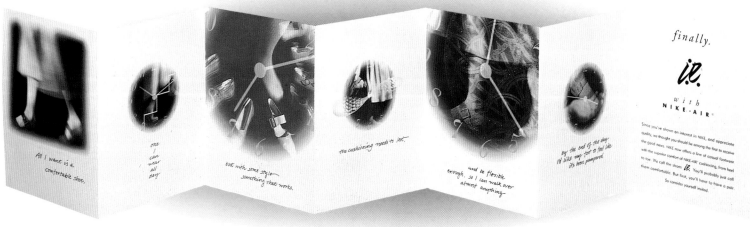

This display, for a new line of men's casual Nikes, (right) showcases the shoe's components in a museum cube, providing a strong central focus to display the products.

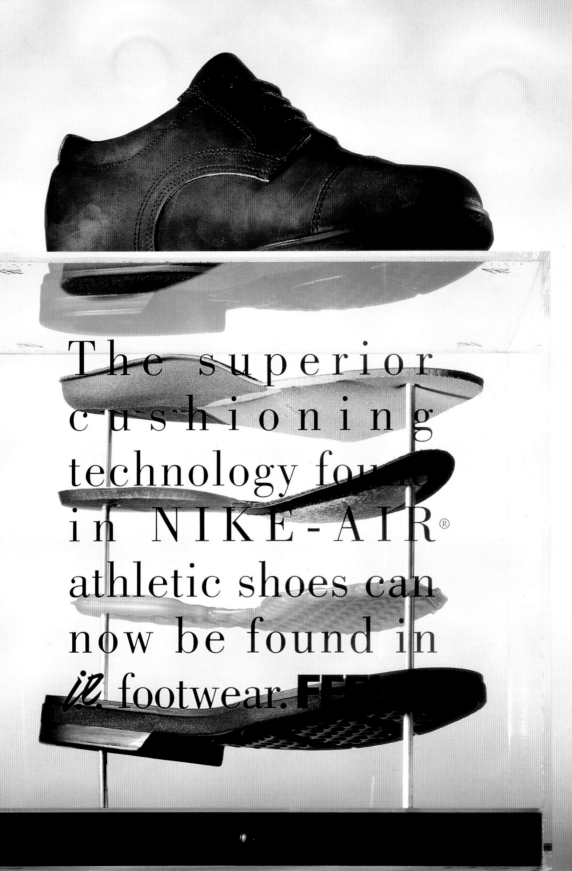

The superior cushioning technology found in NIKE-AIR® athletic shoes can now be found in *ie.* footwear. FEET

"Bewear is the sartorial arm of BlackDog, my design firm," says Mark Fox. *"The target audience is male, 12-21, and interested in alternative music, subculture and the general decline of Western civilization. I want Bewear's appeal to transcend culture and race."* Pictured (from left to right): Rerun, Bewear Clothing Co. and Dogboy.

 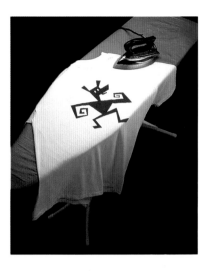

After years of designing shirts for other companies, Mark Fox decided to design and market them for himself under the name Bewear. T-shirt logos (from left to right) are: Xtinkt, Think Global Act Yokel, Xcat and Motoman.

BlackDog principal, Mark Fox.

"CONCEPT, CONCEPT, CONCEPT; BUT IT DON'T MEAN A THING IF IT AIN'T GOT THAT SWING." *– Mark Fox*

BlackDog
239 Marin Street
San Rafael, California 94901
415 258 WOOF

Reprinted from Marketing By Design.
Printed in Hong Kong.

Mark Fox *is* BlackDog. Since 1986, this one man design studio has earned a national reputation for innovative and engaging identity work, including logos for restaurants, the entertainment industry and entrepreneurs. A typical BlackDog logo is characterized by boldness tempered by an idiosyncratic sense of humor. Fox's logo for the Buckeye Roadhouse, located in Mill Valley, California, is a good example: A winking martini sports a pair of antlers. Bill Higgins, a partner of the restaurant, is enthusiastic about the results: "The logo is wonderful; people have a direct relationship with it because of its sense of humor. And the neon martini sign has become a Marin landmark."

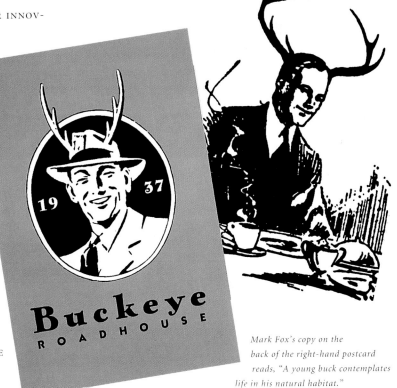

Mark Fox's copy on the back of the right-hand postcard reads, "A young buck contemplates life in his natural habitat."

The seven-foot neon sign blinks in three stages: a buck's head with a winking eye, a martini with an olive, and the actual restaurant logo, a martini with antlers. Two early logo explorations are shown at right.

 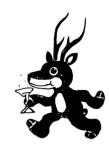

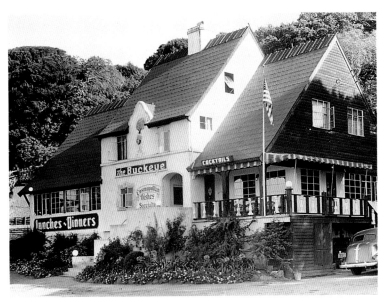 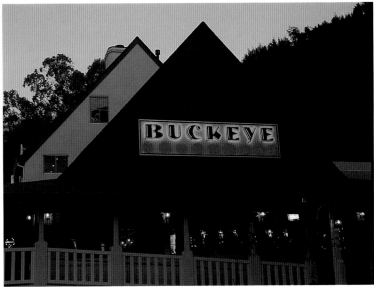

The Buckeye Roadhouse circa 1940 and today. The Mill Valley restaurant originally opened in 1937 and was acquired by Real Restaurants in 1991.

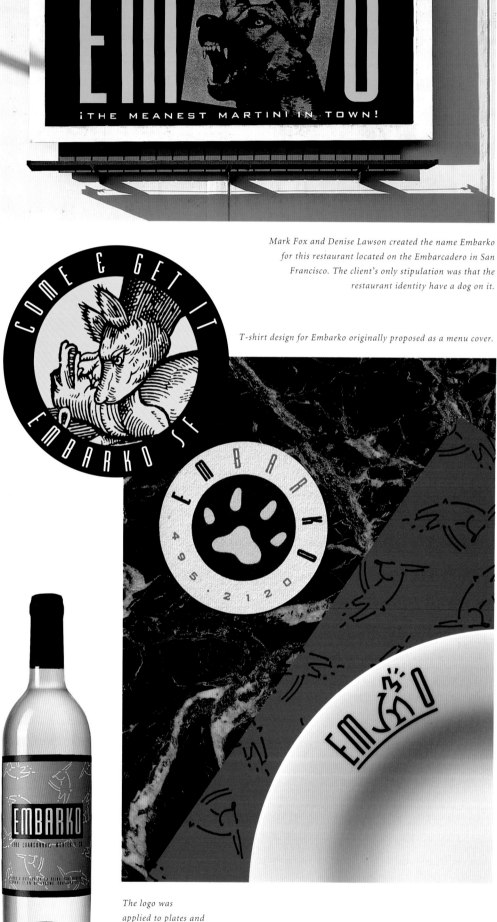

MARK FOX'S FIRST RESTAURANT ASSIGNMENT CAME WHEN HE LEFT A BUSINESS CARD AT A RESTAURANT OWNED BY JOE AND MARNI LEIS. COINCIDENTALLY, THEY WERE IN THE PROCESS OF OPENING A RESTAURANT CALLED TRUDY'S AND THEY NEEDED A DESIGNER. FOX RECALLS, "IN SAN FRANCISCO, WHERE EIGHTY PERCENT OF ALL NEW RESTAURANTS FAIL IN THE FIRST YEAR, A GOOD NAME IS WORTH A LOT. CHANGING THE NAME ALSO MADE THE DESIGN PROCESS A HECK OF A LOT EASIER." THE NEW NAME, EMBARKO, LENT ITSELF TO A REBUS LOGO: A COMBINATION OF TYPE AND A BARKING DOG. "PEOPLE RESPOND TO THE PLAYFULNESS OF THE IDENTITY" SAYS FOX. "MARNI'S ONLY COMPLAINT WITH THE DESIGN IS THAT PEOPLE TAKE MATCHBOXES BY THE HANDFUL."

Mark Fox and Denise Lawson created the name Embarko for this restaurant located on the Embarcadero in San Francisco. The client's only stipulation was that the restaurant identity have a dog on it.

T-shirt design for Embarko originally proposed as a menu cover.

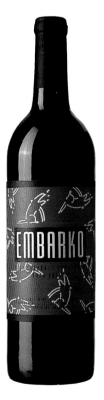

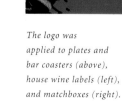

The logo was applied to plates and bar coasters (above), house wine labels (left), and matchboxes (right).

Carson Pritchard, principal, Carson Pritchard Design.

CARSON PRITCHARD'S DESIGN PHILOSOPHY REFLECTS A KEAN AWARENESS OF EXACTLY WHAT IT TAKES TO BRING A PRODUCT OR IDEA TO THE MARKETPLACE.

Carson Pritchard designed a square-format brochure for Angela Cummings to enhance the relationships of her tabletop products.

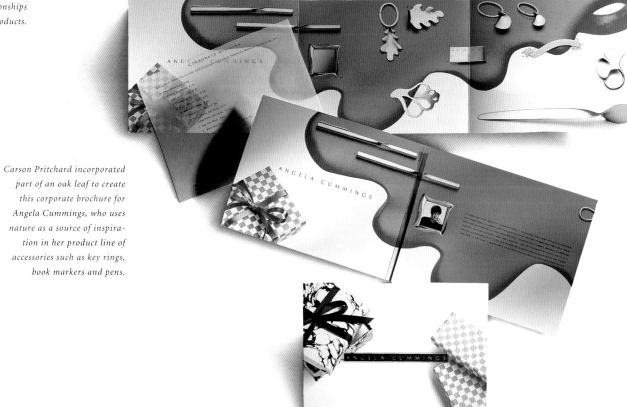

Carson Pritchard incorporated part of an oak leaf to create this corporate brochure for Angela Cummings, who uses nature as a source of inspiration in her product line of accessories such as key rings, book markers and pens.

CARSON PRITCHARD DESIGN

CARSON PRITCHARD DESIGN
4645 RUBIO AVENUE
ENCINO, CALIFORNIA 91436
818 907 7234

Reprinted from MARKETING BY DESIGN
Printed in Hong Kong.

THE LOVE AND JOY OF ENTERTAINING HAS LED CARSON PRITCHARD TO FOCUS HER DESIGN TALENTS ON THE DEVELOPMENT OF PACKAGING, PROMOTION AND PRODUCT FOR AT-HOME ACTIVITIES, INCLUDING HOME FURNISHINGS AND TABLETOP. FOR SASAKI DINNERWARE SHE DESIGNED A TOTAL MERCHANDISING PACKAGE, WHICH INCLUDED THE IDENTITY PROGRAM, LOGO, PACKAGING AND ADVERTISING AS WELL AS THE PRODUCT. AN EDUCATOR AS WELL, CARSON PRITCHARD HAS TAUGHT CONTINUALLY AT ART CENTER COLLEGE OF DESIGN IN PASADENA, CALIFORNIA.

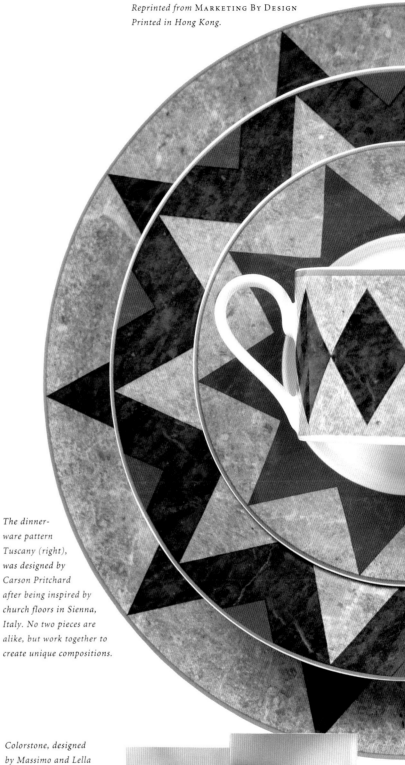

The dinnerware pattern Tuscany (right), was designed by Carson Pritchard after being inspired by church floors in Sienna, Italy. No two pieces are alike, but work together to create unique compositions.

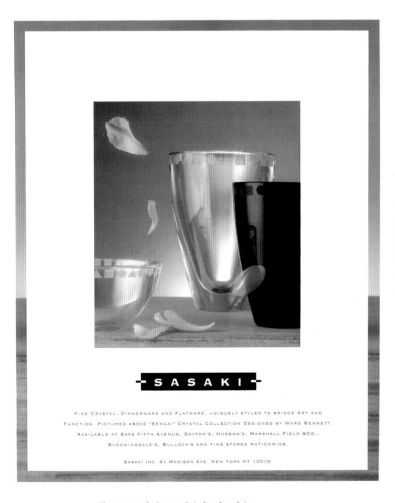

-SASAKI-

FINE CRYSTAL, DINNERWARE AND FLATWARE, UNIQUELY STYLED TO BRIDGE ART AND FUNCTION. PICTURED ABOVE "SENGAI" CRYSTAL COLLECTION DESIGNED BY WARD BENNETT. AVAILABLE AT SAKS FIFTH AVENUE, DAYTON'S, HUDSON'S, MARSHALL FIELD &CO., BLOOMINGDALE'S, BULLOCK'S AND FINE STORES NATIONWIDE.

SASAKI INC. 41 MADISON AVE. NEW YORK NY 10010

The approach Carson Pritchard took in designing this national ad for Sasaki played on the subtle notion of dinnerware as art, framed and collectible.

Colorstone, designed by Massimo and Lella Vignelli, is one of Sasaki's most popular patterns. The packaging, by Carson Pritchard, needed to work as a shipping carton and also have graphic appeal.

Charles S. Anderson Design Company
30 North First Street
Minneapolis, Minnesota 55401
612 339 5181

Reprinted from Marketing By Design.
Printed in Hong Kong.

T O TRANSLATE AN IMPERSONAL PRODUCT, CONCEPT OR ENTITY INTO AN APPROACHABLE, ACCESSIBLE IMAGE WITH A DISTINCT HUMAN QUALITY; TO BEND AND BLEND THESE ELEMENTS TO FIT A MODERN CONTEXT; TO CREATE INTERESTING WORK WITH A VISUAL VOCABULARY—CHARLES S. ANDERSON DESIGN'S WORK REFLECTS THE HUMANISTIC SIDE OF DESIGN. FOUNDED IN 1989, THE FIRM SPECIALIZES IN PRODUCT DESIGN AND DEVELOPMENT, CONSULTING, NAMING, IDENTITY AND PACKAGE DESIGN. HOWEVER, CHARLES S. ANDERSON, HAVING BEEN ON THE MANUFACTURER SIDE HIMSELF, HAS LEARNED TO RESPECT THE GAMBLE THAT ENTREPRENEURS TAKE. "WHEN WE DESIGNED OUR OWN WATCH LINE, DELIVERY WAS COD. ORDERS HAD TO COME IN THE DOOR AS THE CHECK WAS WRITTEN. THIS WAS NOT EASY TO ORCHESTRATE," HE SAYS. "I THINK THAT OUR CLIENTS REALIZE THAT WE'VE SEEN IT FROM BOTH SIDES OF THE TRANSOM, WHICH GIVES US A MORE MATURE ATTITUDE TOWARDS SPENDING THEIR MONEY." ESTABLISHING THIS RELATIONSHIP WITH CLIENTS, AS WELL AS INDIVIDUAL

114

CSA Zippo™ lighters.
A limited-edition collector's
set of four authentic Zippos.
Each features a brushed stainless
steel case complete with a CSA Archive
image, custom logo and lifetime warranty.

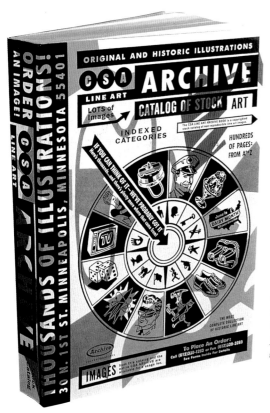

The CSA Archive is a subsidiary company
dealing in original and historic stock
illustrations. This limited-edition hardcover
book is a visual dictionary of everything
from aardvarks to zithers, in hundreds of
indexed categories.

TALENT WITHIN THE FIRM HAS EARNED CHARLES S. ANDERSON DESIGN SPOTS IN NATIONAL AND INTERNATIONAL DESIGN PUBLICATIONS, THE LIBRARY OF CONGRESS' PERMANENT COLLECTION, AND MUSEUMS WORLDWIDE. THE CSA ARCHIVE, A SUBSIDIARY COMPANY, DEALS IN ORIGINAL AND HISTORIC STOCK ILLUSTRATIONS BASED ON ITS COLLECTION OF THOUSANDS OF IMAGES. THE FIRM WORKED MOST RECENTLY WITH TURNER NETWORK TELEVISION TO DEVELOP THE ON-AIR IDENTITY FOR THE TURNER CLASSIC MOVIE CHANNEL, AND HAS DEVELOPED A LINE OF HOME FURNISHINGS AND OTHER PRODUCTS THROUGH A LICENSING AGREEMENT WITH PARAMOUNT PICTURES.

One in a series of CSA watches, this model is called "Cocktail Hour" and takes you from a before dinner cocktail to a well-earned hangover.

Other watches in the series include: "Time Flies," "Deadline," "Watch Dogs" and "New York Minute." The watches come in custom-designed metal tins, each with a top-grade Italian leather band and a one-year limited warranty.

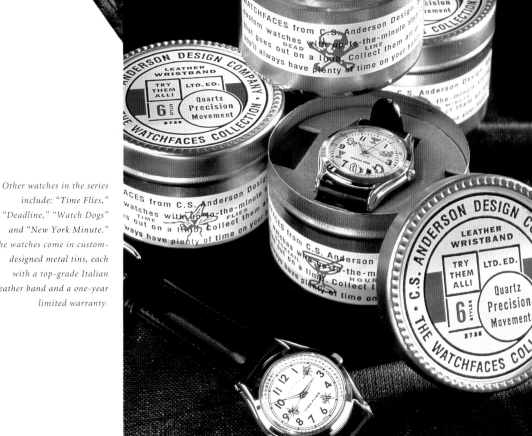

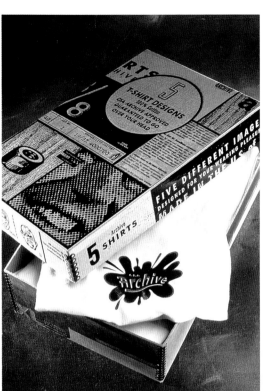

A set of five CSA Archive T-shirts packaged in a limited-edition box, silk-screened in silver and black on heavy-duty paper board with reinforced steel corners, making it great for storage.

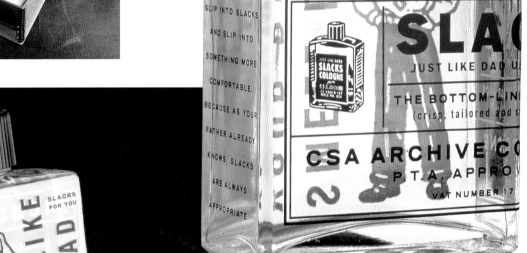

Slacks cologne. "Why wear Chaps™ when you could be wearing Slacks... the bottom line in fragrance, exclusively from CSA Archive." It is a unisex scent and comes in a reusable custom tin.

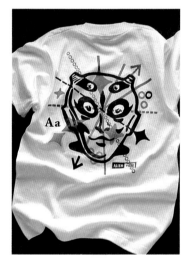

The first-series CSA Archive T-shirts feature Archive images screened in four colors and glow-in-the-dark ink. Other shirts in the series include: "Money," "Smoking," "Insect" and "Dog."

Slacks cologne. "Why wear Chaps™ when you could be wearing Slacks... the bottom line in fragrance, exclusively from CSA Archive." It is a unisex scent and comes in a reusable custom tin.

This CD-ROM disk contains an index for the entire CSA Archive collection as well as 100 royalty-free Archive images and 80 dingbats designed by CSA Design Company. Each black and white images has its own sound effect.

Complementing the CD are mousepads in the form of a mouse trap, T-bone steak and camper trailer.

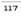

One of a series of porcelain metal tables manufactured from heavy gauge steel like old gas station signs. Based on bad table puns, the series includes: "End Table" and "Under the Table."

Magnetic Personalities is a collection of 15 interchangeable refrigerator magnets that mix and match to create over one hundred different heads.

A boxed set of cloisonné pins—Lumber Jack, Doodle Bug and Roy L. Flush—each in its own reusable steel tin for storage and collecting.

The 3-D Archive In A Drum is a 16-oz. metal drum filled with cheesy plastic toys and trinkets— an assortment of CSA Archive images taken into a whole new dimension.

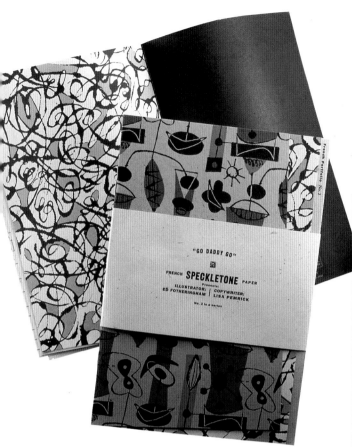

> *OUR DESIGN IS BASED ON OUR IMPRESSIONS OF THE WORLD AROUND US. BITS OF CULTURE—SOMETIMES POPULAR, SOMETIMES OBSCURE. MOST CONSUMERS ARE HUMAN, AND THEY SEEM TO RELATE PRETTY WELL TO WORK THAT APPEARS TO HAVE BEEN CREATED BY OTHER HUMANS.*
>
> *— Charles S. Anderson*

The French Speckletone Illustrator Portfolio, the first in a series of mini-books designed to highlight an illustrator and writer's work on French Paper Company papers.

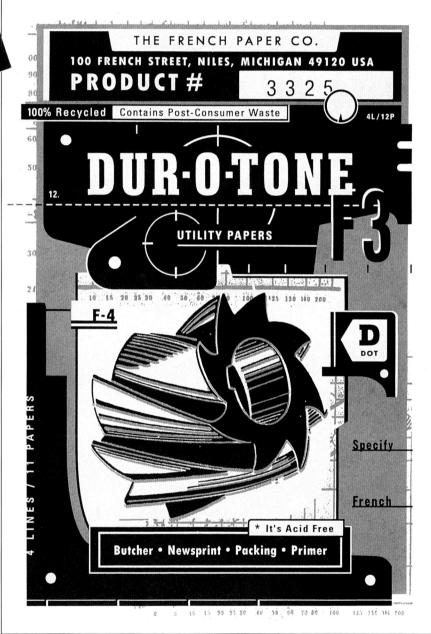

French Paper and Charles S. Anderson Design Company developed a completely new line of paper called Dur-O-Tone, consisting of four categories of utility papers presheeted in usable weights and colors.

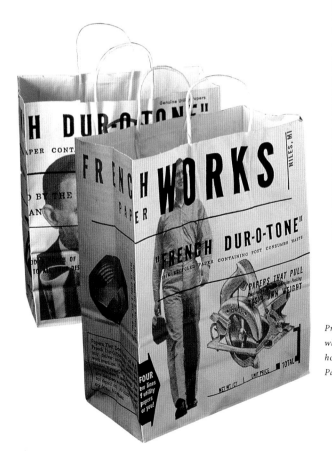

Printed in four colors on French Newsprint white, this bag was designed to help designers hold the many samples they pick up at French Paper tade shows and conferences.

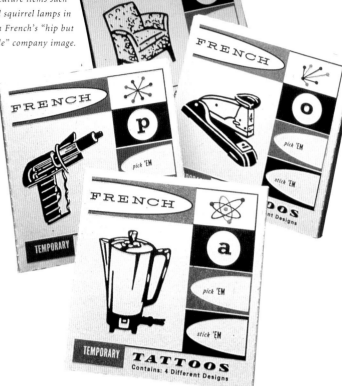

Temporary tattoos to promote French Speckletone paper feature items such as lawn chairs and squirrel lamps in keeping with French's "hip but approachable" company image.

A promotion for French Paper, this 100% unbleached cotton T-shirt reflects French's commitment to both the environment and design.

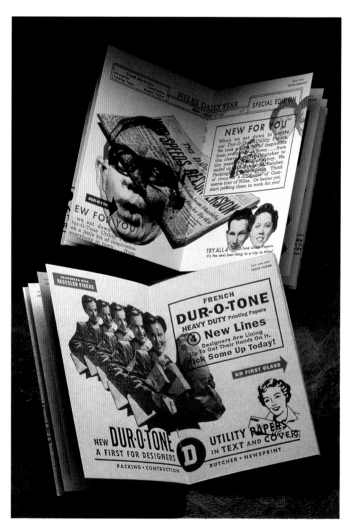

Charles S. Anderson Design created a series of four books to introduce the new French Dur-O-Tone papers. All four books were packaged in a custom-designed slipcover and shipped in a heavy-duty embossed cardboard box.

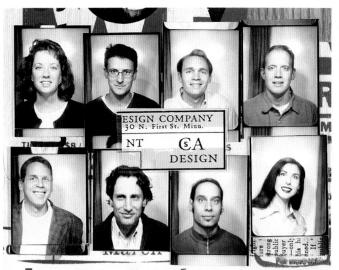

Clockwise from lower left: Charles S. Anderson, Karen Heineck, Erik Johnson, Jason Schulte, Todd Piper-Hauswirth, Lisa Pemrick, David Nadj, John Gross, Charles S. Anderson Design Company.

Chums Clothing Hang Tags feature a mannequin as their "spokes model" to present clothing that is "engineered for comfort."

Each Chums Eyewear Retainer Hang Tag uses color and typography to differentiate product features and convey the company's dedication to engineering and scientific testing.

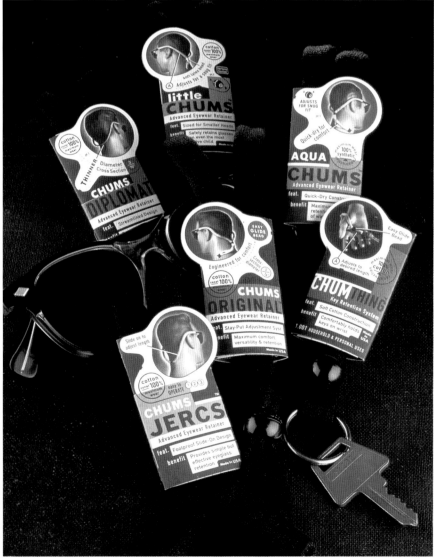

"Tool 'N' Die," one of a series of five T-shirts designed to convey Chum's emphasis on engineering as well as their sense of humor.

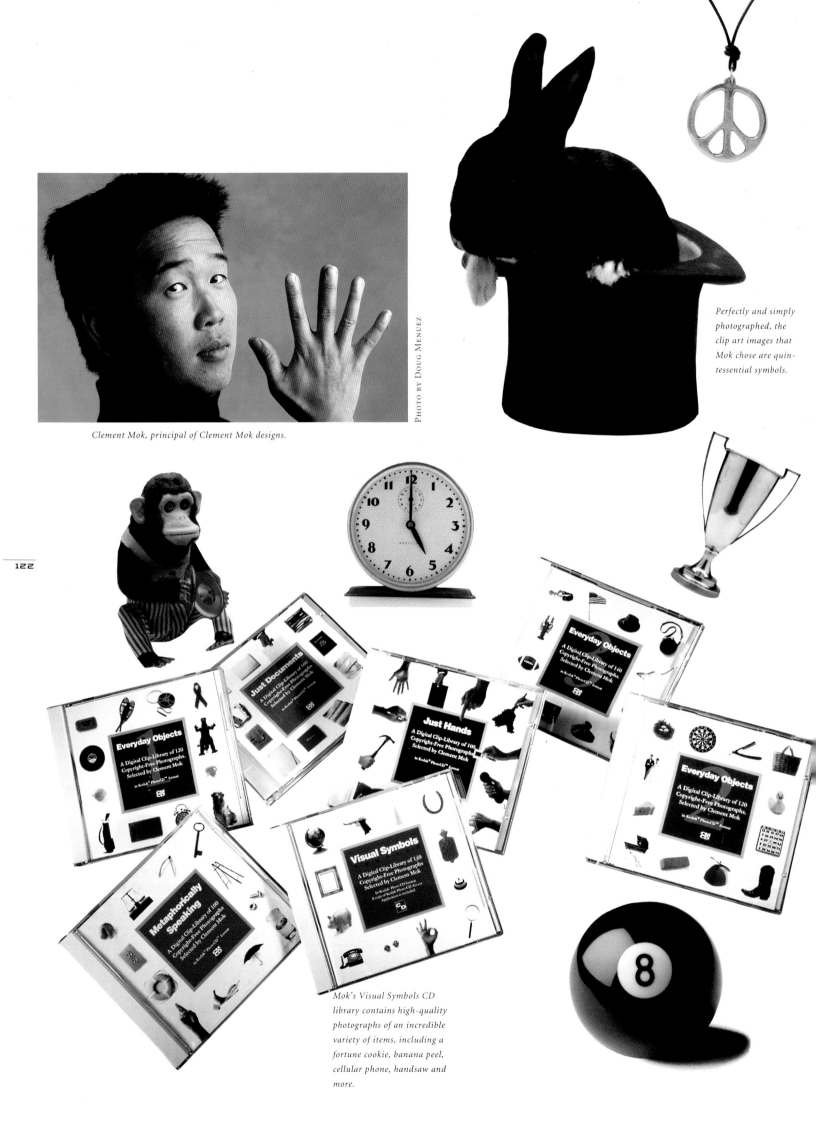

PHOTO BY DOUG MENUEZ

Clement Mok, principal of Clement Mok designs.

Perfectly and simply photographed, the clip art images that Mok chose are quintessential symbols.

Mok's Visual Symbols CD library contains high-quality photographs of an incredible variety of items, including a fortune cookie, banana peel, cellular phone, handsaw and more.

CLEMENT MOK DESIGNS, INC.
600 TOWNSEND STREET, PENTHOUSE
SAN FRANCISCO, CALIFORNIA 94103
415 703 9900

Reprinted from MARKETING BY DESIGN.
Printed in Hong Kong.

Some years ago, a young designer, but a few years out of school, made huge waves in the design industry by embracing what most designers considered a daunting and deadly area—computer technology. That designer was Clement Mok, now known as the designer of many milestone technology launches—including Macintosh and Hypercard for Apple. After Mok left Apple to go on his own, he continued to make many of the next innovations for the computer area—in packaging and in digital product. Soon to realize that the industry was in dire need of

This wafer-thin CD ROM contains hundreds of copyright-free images, like the one above, for designers to access on their computers.

Face it. Most clip art collections look like they were drawn by a five-year-old. Improve your image.

Everyday Objects 1, 2, 3

Just Hands

Just Tools

Just Documents

Metaphorically Speaking

The eyes reveal all—which made movie stars cloak their eyes in dark glass. Perhaps the vanity of Hollywood stars encouraged the variety of designs consumers demand today. But Mok found, when he researched the origins of the sunglass, that they were originally designed in the sixteenth century for Chinese judges who found it necessary to wear sunglasses so as not to reveal their thoughts to lookers-on.

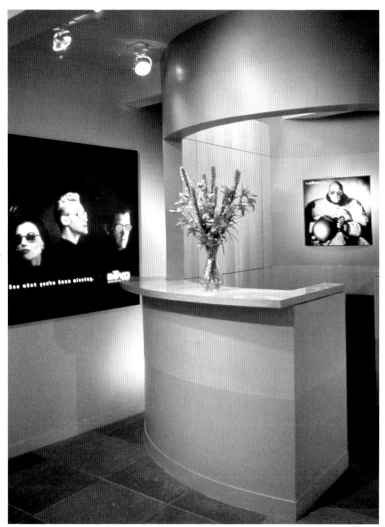

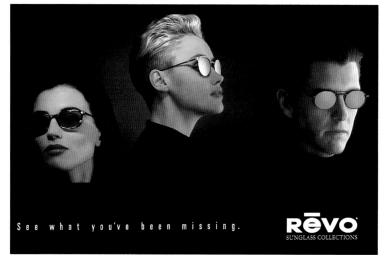

See what you've been missing.

RēVO
SUNGLASS COLLECTIONS

See what you've been missing.

This visual experience brought to you by RēVO
SUNGLASS COLLECTIONS

Revo sells its product in an environment which is part of an overall scheme designed by Mok in conjunction with Holey and Associates, interior designers.

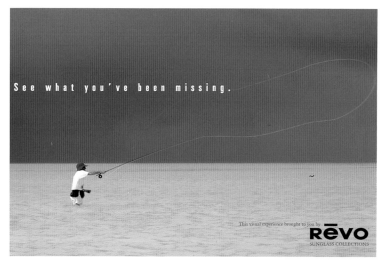

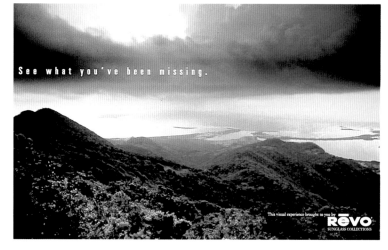

See what you've been missing.

This visual experience brought to you by RēVO
SUNGLASS COLLECTIONS

Before the new marketing approach, Revo was preaching to their choice audience— avid skiers and other nature buffs—who were already aware of the difference Revo's lenses made in their clarity of vision.

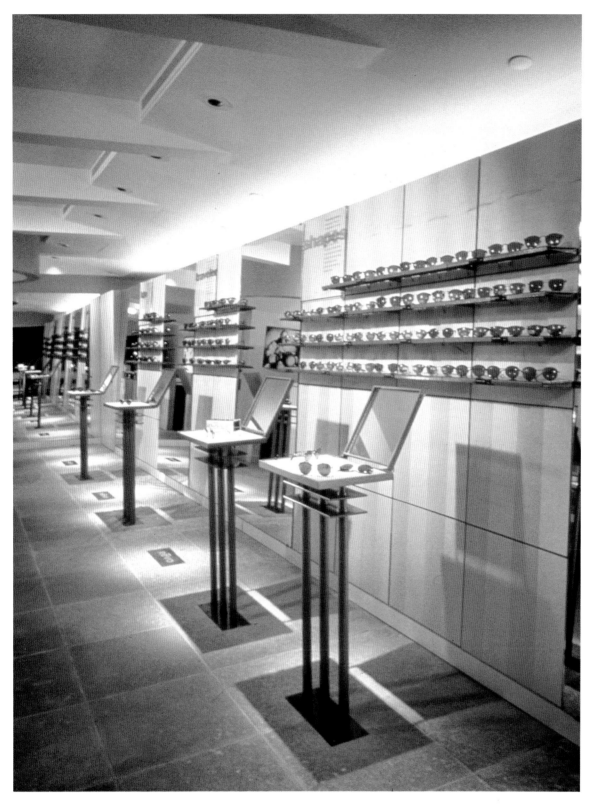

Revo's technology was originally developed as a coating for telescope lenses to protect astronomers' eyes from exposure to UVC rays, which can burn the retina. This high technology, when applied to Revo's sunglasses, differentiated their product from other quality sunglasses but created a need to educate the consumer to the added value of Revo's products.

IMAGES TO MANIPULATE AND ADD TO ITS DESIGNS, MOK CREATED A BRILLIANT SERIES, A LIBRARY OF COPYRIGHT-FREE PHOTOGRAPHIC IMAGES REPRESENTING THE MOST COMMON VISUAL SYMBOLS. WHILE MOST DESIGNERS FEARED THE ADVENT OF "SWIPE" IMAGES, MOK THOUGHT ONLY OF THE NEED AND USEFULNESS OF SUCH A CREATION.

MOK'S CHALLENGE, FOR REVO, WAS TO CREATE AN OVERALL LOOK PLUS PRODUCT GROUPINGS TO APPEAL TO DIFFERENT AUDIENCES. IN ADDITION TO TARGETING A HIGH-END AUDIENCE BY CREATING HIGH-END DESIGN, MOK WAS COPY-SENSITIVE AND COMMUNICATED REVO'S MESSAGE LOUD AND CLEAR.

PHOTO: TOM PAIVA

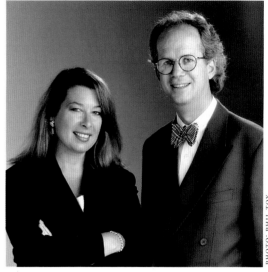

PHOTO: PHIL TOY

The principals of Debra Nichols Design, Debra Nichols, President and William Comstock, Vice-President.

The window graphics for StarBake, a bakery and coffee bar, are clean, bold and reminiscent of a friendly neighborhood bakery.

126

The StarBake logo celebrates pastry-chef Emily Luchetti's famous star-shaped shortbread cookie.

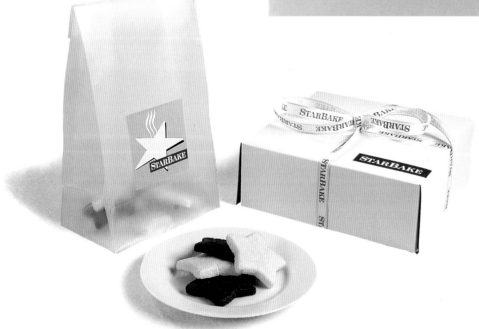

Packaging design, for the range of dessert and pastry items sold at StarBake conveys a sense of delight with a simplicity which is charming and memorable.

DEBRA NICHOLS DESIGN

DEBRA NICHOLS DESIGN
468 JACKSON STREET
SAN FRANCISCO, CALIFORNIA 94111
415 788 0766

Reprinted from MARKETING BY DESIGN.
Printed in Hong Kong.

STARS FOUNDING EXECUTIVE CHEF AND OWNER, JEREMIAH
TOWER, THE "FATHER OF CALIFORNIA CUISINE"— WEARS THIS
IMPRESSIVE MONIKER IN THE WORLD OF GOURMET FOOD WITH
PANACHE. LIKE THREE POINTS ON A SPARKLING STAR, HE CREAT-
ED THREE CAFÉS AS OFF-SHOOTS OF HIS WORLD-CLASS,
RENOWNED STARS RESTAURANT.

TOWER APPROACHED DEBRA NICHOLS TO CREATE
GRAPHIC IDENTITIES FOR THE THREE NEW ENTERPRISES BY INTERPRET-
ING THE LINKS ALONG WITH THE INDIVIDUALITY OF HIS THREE NEW
STARS, EACH OF WHICH HAS BEEN ARTFULLY PLACED IN THEIR OWN
UNIQUE AND VERY SEPARATE LOCALES—A BAKERY/COFFEE BAR IN THE
HEART OF SAN FRANCISCO, A CAFÉ IN THE THEATER DISTRICT, AND A
RESTAURANT OVERLOOKING THE VINEYARDS OF NAPA VALLEY.

NICHOLS WAS CHARGED WITH THE TASK OF ENHANCING A
STRONG CULINARY IDENTITY WITH A STRONG AND APPROPRIATE
GRAPHIC DESIGN SYSTEM.

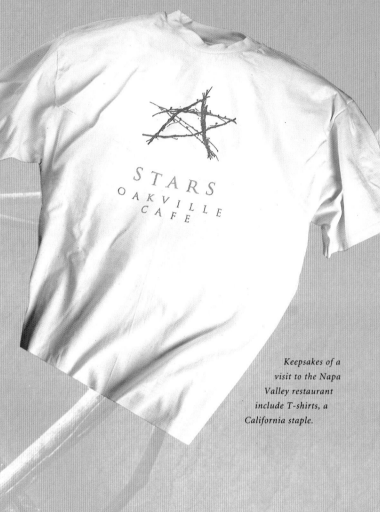

*Keepsakes of a
visit to the Napa
Valley restaurant
include T-shirts, a
California staple.*

*The logo for Stars Oakville Café is made of
clippings of grapevines left over from the har-
vest at the nearby vineyards woven into an
abstract star. It was adopted in two colors
of metallic ink for the menu covers
and stationery program.*

The grapevine star was recreated in metal for the Stars Oakville Café's main highway sign. Redwood supports and rustic copper lettering were designed to match the spirit of the restaurant's Mediterranean-style garden.

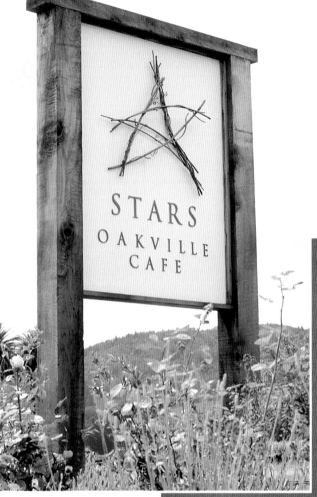

PHOTO: TOM PAIVA

The star is featured on custom labels designed for Napa Valley wine selected by the chef and bottled for the restaurant. Visitors can enjoy the wine in stemware etched with the logo.

PHOTO: PHIL TOY

The chef jacket worn by founding chef and owner, Jeremiah Tower, bears an embroidered version of the restaurant logo.

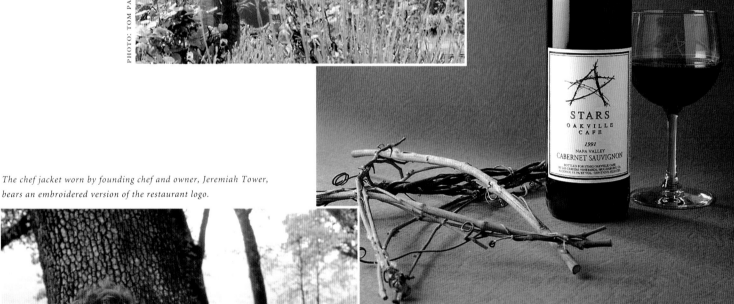

PHOTO: PENNY WOLIN

IN ALL OUR PROJECTS, WHETHER THE ULTIMATE PRODUCT IS SIGNAGE, PRINT OR MARKETING PIECES, WE CHALLENGE OURSELVES TO CAPTURE THE SPIRIT OF EACH SETTING IN A DISTINCTIVE AND ARTFUL SOLUTION.

–Debra Nichols

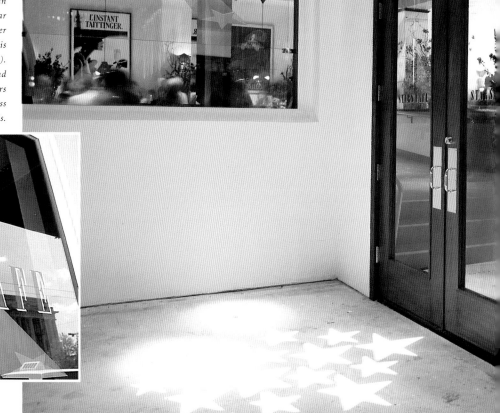

A galaxy of stars is projected onto the entrance area of Stars Café in San Francisco, recalling the star logo and restaurant as theater (right). San Francisco City Hall is reflected against the logo (below). Politicians, theatergoers and restaurant patrons mingle as stars at the café. The etched glass window glows as night falls.

The menu covers and stationery program continue the logo application. Restaurant patrons can carry away the spirit of the place with a signature T-shirt.

DESGRIPPES GOBÉ & ASSOCIATES
411 LAFAYETTE STREET
NEW YORK, NEW YORK 10003
212 979 8900 INTERNET: http://www.dga.com

DESGRIPPES GOBÉ CREATES LOVE STORIES WITH PRODUCTS, ACCORDING TO ITS PRESIDENT, FRENCHMAN MARC GOBÉ. AND WHO BETTER TO EMULATE THE LOVE OF DESIGN THAN THE FRENCH? GOBÉ ADDS, "PEOPLE DON'T BUY PRODUCTS FOR WHAT THEY ARE BUT FOR WHAT THEY REPRESENT." THIS PHILOSOPHY AND THE DESIGN FIRM'S IDENTITY, A SHOOTING STAR, REPRESENT THE CORE OF DESGRIPPES GOBÉ & ASSOCIATES, WHICH HAS CENTERED ITS BUSINESS AROUND PRODUCTS THAT REFLECT THE CONSUMER'S ASPIRATIONS.

THE ROMANCE THAT GOBÉ BRINGS TO PRODUCT DESIGN IS BACKED UP WITH CALCULATED THINKING AND RESEARCH. PRODUCT DEVELOPMENT STARTS WITH THEIR OWN UNIQUE METHODOLOGY, SENSE––SENSORY EXPLORATION + NEED STATES EVALUATION. SENSE IS A PROCESS GOBÉ HAS DEVELOPED TO IDENTIFY A PRODUCT AND ITS COMPETITORS VISUAL EQUITIES. DURING THE PROCESS, DESGRIPPES GOBÉ PROFILES THE TARGET CUSTOMER, ANALYZES THE CATEGORY'S

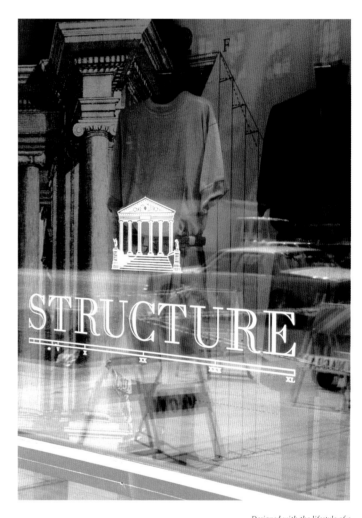

The retail concept for Structure takes its inspiration from classical Italian architecture, in particular Andrea Palladio's design for the Villa Rotunda.

Designed with the lifestyle of a modern Italian man in mind, the store is theater in the sense of animating and engaging people in a retail environment. The architectural motif carries over into imaginative and dramatic details such as oversized Corinthian columns, blueprint backdrops and modular rules as graphic accents.

Desgrippes Gobé's original objective for repositioning Abercrombie & Fitch was to reestablish them as an authority in sportswear.

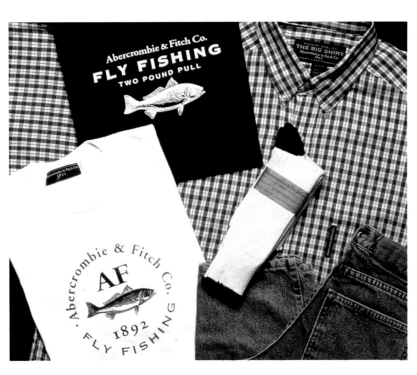

CODES AND CUES, AND DEVELOPS AN EMOTIONALLY-CHARGED VISUAL VOCABULARY THAT SERVES AS THE FOUNDATION FOR THE CREATIVE PROCESS.

DESGRIPPES GOBÉ HAS OFFICES IN PARIS, SEOUL, TOKYO AND, OF COURSE, NEW YORK. THESE STRATEGIC LOCATIONS, COUPLED WITH THE FIRM'S STATUS AS ONE OF THE TOP TEN DESIGN FIRMS IN THE WORLD, POSITION DGA AS IDEAL GLOBAL BRANDERS.

The design developed from being authentically English to having a free-floating nostalgia and outdoor appeal without being locked into any time or place.

Rustic yet refined, the new Abercrombie & Fitch identity and packaging fits the retailer's correspondingly utilitarian line of clothing.

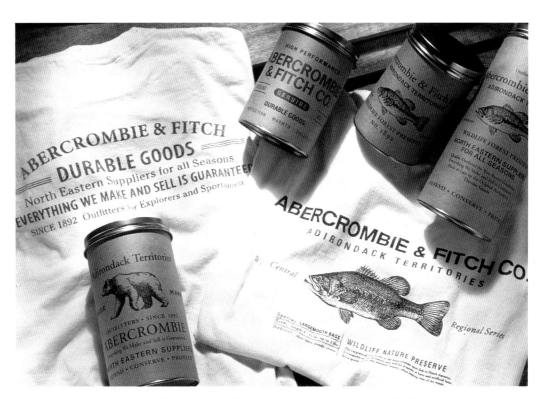

Desgrippes Gobé's most recent creation for Abercrombie & Fitch are T-shirts with bold graphics, layered imagery and an aged look. The strategy was to attract the younger, more active consumer by evolving the outdoor theme to include street fashion appeal.

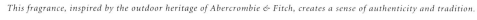

This fragrance, inspired by the outdoor heritage of Abercrombie & Fitch, creates a sense of authenticity and tradition.

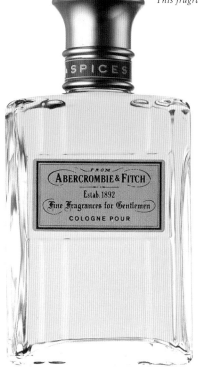

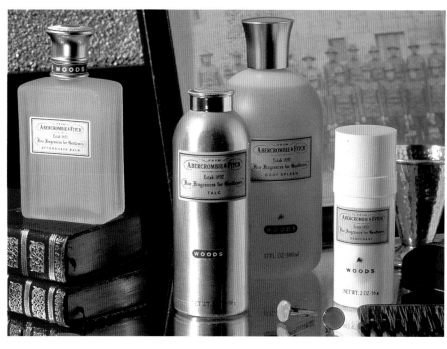

A line of British-inspired men's haberdashery plays on the feel of the age of travel and exploration. The handsome packaging evokes great Edwardian outdoorsmen who enjoyed flyfishing and birdwatching as well as such indoor sports as billiards and chess.

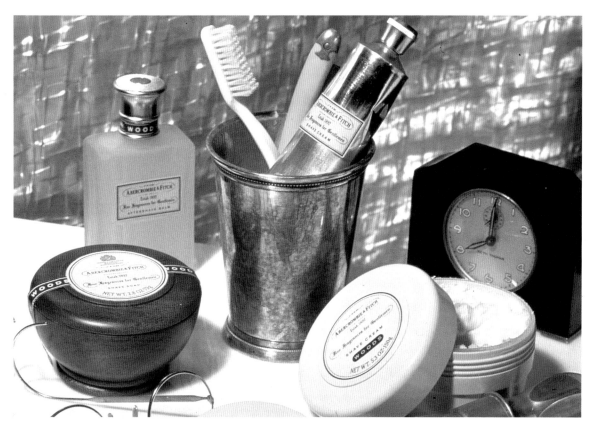

The packaging combines a hint of eccentricity and worldly travels with elements of refinement and pedigree.

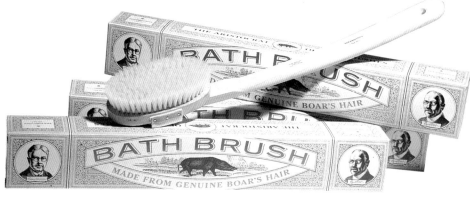

Rather than a drastic makeover, Desgrippes Gobé's objective was to evolve the image of Ann Taylor to regain its place as a cornerstone in the women's ready-to-wear market. A consistency of look and feeling gives the customer's every interaction a sense of completeness and trust that sets the store apart from other retail environments.

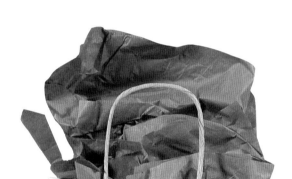

rejoice
ANN TAYLOR.

TODAY, THE RETAIL DESIGN PROFESSION IS IN A STATE OF SHOCK, OF SCLEROSIS. TOO MANY RETAIL DESIGN FIRMS CREATE WITH A FIXTURE CATALOG IN ONE HAND AND A CALCULATOR IN THE OTHER...

The new identity and packaging program has freshened Ann Taylor's image and won back customer loyalty. The 100% recycled paper was custom created for the packaging line to provide texture, a neutral ground and a feeling of authenticity.

ANNTAYLOR.

The new identity communicates the values that are important to the Ann Taylor woman: authenticity, naturalness and simplicity balanced by sensuality, adventure and humor.

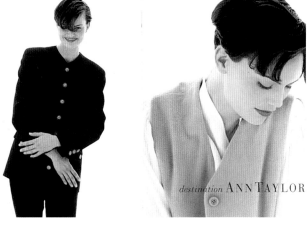

destination ANNTAYLOR

IT STARTED IN THE 1980'S... PEOPLE FORGOT ABOUT IMPORTANT THINGS LIKE THE VALUE OF THEIR BRANDS AND THE QUALITY OF THEIR IMAGE, THE THINGS THAT ORIGINALLY MADE THEIR STORES GREAT. — *Marc Gobé*

The whole question of how to dress a modern career woman is looked at afresh in Desgrippes Gobé's ongoing creative partnership with Ann Taylor.

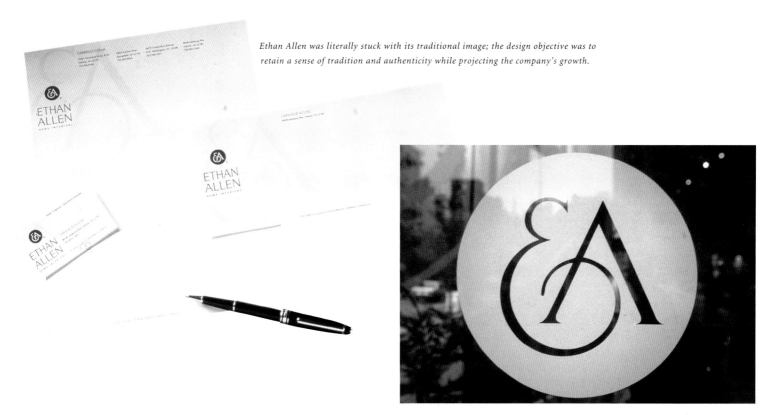

Ethan Allen was literally stuck with its traditional image; the design objective was to retain a sense of tradition and authenticity while projecting the company's growth.

Desgrippes Gobé & Associate's monogram for Ethan Allen evokes a feeling of diversity and change, and communicates the mix of traditional and modern products.

The corporate identity program included interior and exterior applications as well as setting up extensive formats for corporate usage and completing a Retailer Identity Manual, which introduced the new identity and its applications to retailers across the country.

In defining the brand personality, the objective was to suggest the influence of high design without losing the warmth of home.

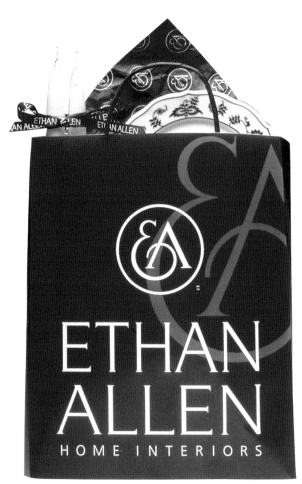

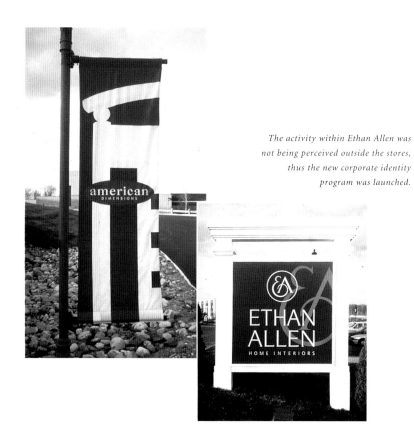

The activity within Ethan Allen was not being perceived outside the stores, thus the new corporate identity program was launched.

Desgrippes Gobé & Associate's strategic design exploration resulted in a logotype, a monogram and a new corporate color. By shifting from green to a deep brilliant blue, the color makes a stronger fashion statement, updates the brand and communicates Ethan Allen's fresh American style.

Employing the new logo and type designs on its store facades, Ethan Allen's strategy is to retain its New England roots while stretching beyond to invite younger customers into the store.

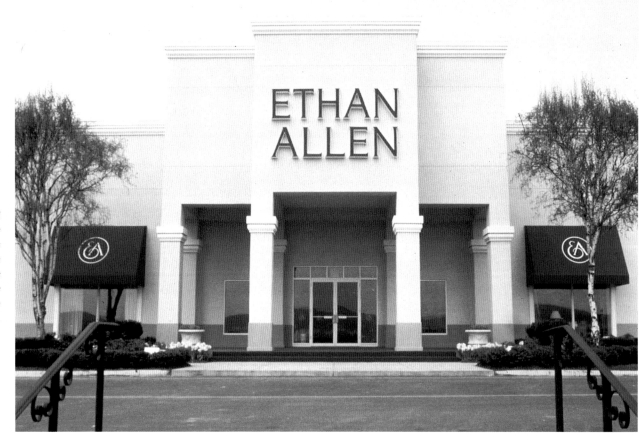

Marc Gobé, president and creative director, Desgrippes Gobé & Associates.

An updated leaf logo for the furniture manufacturer Drexel Heritage is a natural extension of the company's attitude. The leaf refers directly to wood, while its windblown state suggests a freedom consistent with current thinking on home decoration: the freedom to mix styles, periods and tastes, to make choices and personalize your home.

The classic serif typeface reinterprets the Drexel Heritage name to look timeless yet convey a modern feeling. Consistently rich and vibrant, the colors–purple, teal and ochre–have been applied to the total packaging program.

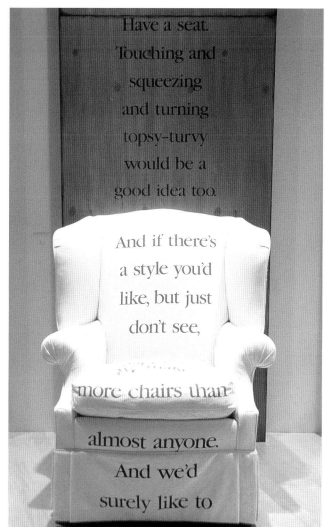

The look is carried over into all corporate identity materials and signage. The objective is to entice the customer to learn more about Drexel Heritage and to encourage repeat visits.

Sandra Higashi and Byron Glaser, Higashi Glaser Design.

Applied Chemistry, a mix-your-own fragrance set, is a package of glass test tubes in a steel box. It comes with a fool-proof Formula Guide that combines aromatherapy with a touch of humor.

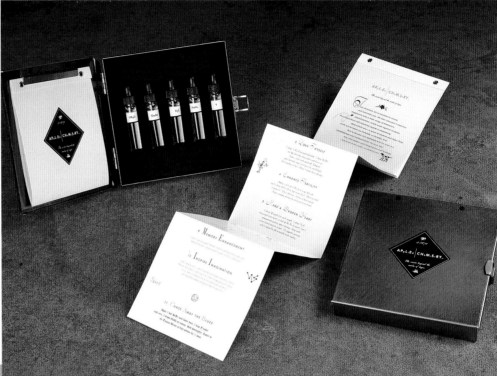

The promotional postcard for Applied Chemistry shows how it works.

Kooky Cutters is a set of eight abstract metal sculpting forms for producing beautifully amorphous cookies. Packaged in a tin, the set includes recipes and decorating tips printed on translucent doily dividers.

HIGASHI GLASER DESIGN

Higashi Glaser Design
822 Caroline Street
Fredericksburg, Virginia 22401
703 372 6440

Reprinted from Marketing By Design.
Printed in Hong Kong.

Zolo consists of 55 handcarved and handpainted wooden pieces that fit together in a infinite number of ways.

Byron Glaser and Sandra Higashi met at Art Center and have been inseparable since. It's curious to see such a perfect blend of such different personalities; yet all Higashi Glaser products radiate the warmth of the familiar, but with a modern twist and hysterically funny a outrageous touches.

Glaser and Higashi were on the typical designer road in the eighties, working for clients in their New York studio. FAO Schwarz was one such client, and it was from observing the low level of children's play products that Glaser and Higashi were led in a totally different direction.

Their first creation, Zolo, seemed like such an obviously great idea to them, that when going the standard route of pursuing funding, they were flabbergasted when toy manufacturers told them Zolo would never sell because its market was indefinable. (Was it for kids? adults? boys? girls?) Undaunted, clever and resourceful

Packaged in a reusable pine storage box with a recycled cardboard band, Zolo can be anything you can imagine. Zolo product information postcards and pricelist are shown above.

Glaser and Higashi manufactured Zolo through self-funding. Within two years Zolo was a major seller and ranked number one in sales at the Museum of Modern Art.

With factories in Indonesia and Virginia, Glaser and Higashi are well on their way to becoming full-time manufacturers. While their main focus is play toys, Higashi Glaser Design also entertains occasional off-beat projects like Hocus Pocus, a watch packaged in a tin, or a children's book (pure Higashi Glaser in conception) for Hyperion.

Glaser and Higashi's personal philosophy is simple: a product's function and design should serve a meaningful purpose—make a social contribution—rather than simply clutter the world.

Store door sign promoting Higashi Glaser's children's book John Jeremy Colton. In keeping with the book's central theme of tolerating difference, each spread was designed to reflect the individual content of that particular part of the text.

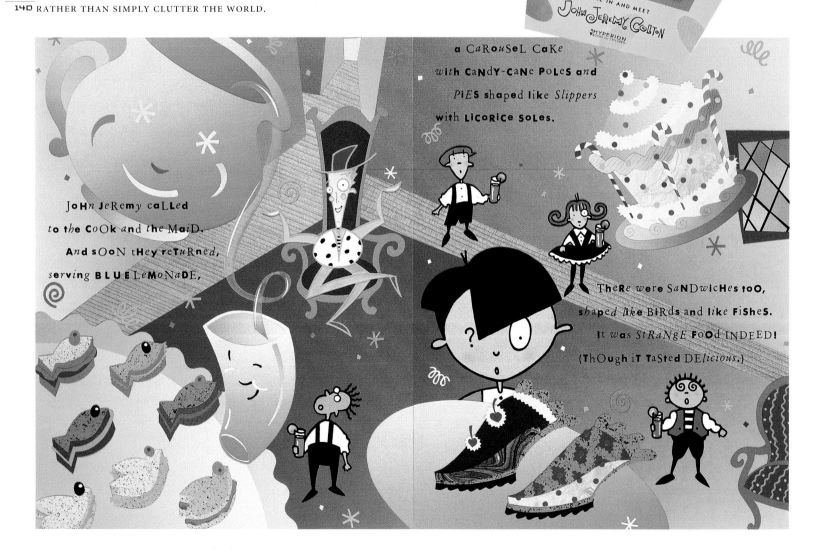

The type for John Jeremy Colton was designed to be an integral part of each illustration.

OUR APPROACH TO PRODUCT DESIGN AND MARKETING LIES SOMEWHERE BETWEEN PRAGMATIC REALISM AND CHAOTIC LUNACY. —Higashi and Glaser

John Jeremy Colton was written by Bryan Jeffery Leech, designed and illustrated by Byron Glaser and Sandra Higashi, and published by Hyperion Books for Children.

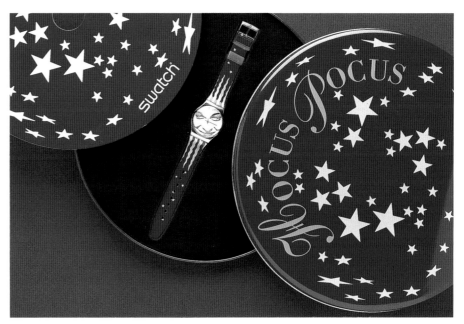

Higashi Glaser's Hocus Pocus Swatch, on which the crystal is a dome, is one of the few exceptions Swatch has allowed to their standard format.

John Hornall and Jack Anderson, principals,
Hornall Anderson Design Works.

IT'S HARD TO HURT OUR FEELINGS. UNHEALTHY
ATTACHMENT TO A SINGLE IDEA, A SINGLE SOLUTION
IS DISCOURAGED. IN RETURN, WE ASK THAT OUR CLIENTS
DON'T HOLD ON TO A PRECONCEIVED SOLUTION OR
APPROACH TO THE PROBLEM THEY MIGHT HAVE
COME TO US WITH. — *Jack Anderson*

Gift boxes for Chateau Ste. Michelle attracted
buyers to sets of lesser known wines when they
otherwise might only buy the traditional
Chardonnay or Cabernet.

The contemporary graphics and typography
create a distinct premium family look for this
Talking Rain beverage.

Other unique bottle elements include the graphics
being applied directly to the bottles' surface, a
graduated frost to add the "ice" effect, and the
black cap. HADW first developed the bottle line,
then applied the graphics to the cans.

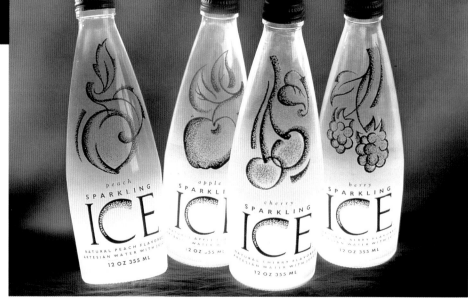

HORNALL ANDERSON DESIGN WORKS, INC.
1008 WESTERN AVENUE
SEATTLE, WASHINGTON 98104
206 467 5800

Reprinted from MARKETING BY DESIGN.
Printed in Hong Kong.

ONE OF THE LARGEST GRAPHIC DESIGN FIRMS ON THE WEST COAST, RUN BY DESIGNERS JOHN HORNALL AND JACK ANDERSON, IS TUCKED IN THE CORNER OF THE UNITED STATES, IN THE CITY OF SEATTLE. WORKING WITH CLIENTS RANGING FROM FORTUNE 500 CORPORATIONS WITH WORLDWIDE MARKETS TO SMALL, START-UP BUSINESSES, HADW CREATES THE BROADEST RANGE OF PROJECTS FOR ITS CLIENTS.

THEIR FOCUS ON MERCHANDISING HAS BROUGHT GREAT SUCCESS TO THEIR CLIENTS INCLUDING NATIONAL BRANDS SUCH AS SEATTLE-BASED STARBUCKS COFFEE, K2 SKIS AND SERVICES GROUP OF AMERICA (THE PARENT COMPANY OF TRADEWELL MARKET, AMERIFRESH). ALL THESE COMPANIES HAVE HAD ENOUGH CONFIDENCE IN HADW'S PROCESSES TO ALLOW THEM TO PUSH THE ENVELOPE FURTHER THAN THEY WOULD HAVE IMAGINED. JACK ANDERSON SAYS, "WE ENCOUNTER CLIENT NERVOUSNESS QUITE OFTEN BECAUSE WE'RE ALWAYS PUSHING TO DO SOMETHING DIFFERENT. IN COMPARISON,

143

For Pane di Paolo, a line
of traditional Italian breads,
Ciabatta and Piatto packaging
are rustic and earthy looking,
creating the feeling of authentic,
old world, Italian products.

The use of kraft paper conveys
the natural ingredients of the
bread, freshness associated with
European products (American
breads are usually packaged in
plastic) and conscientiousness
towards the environment.

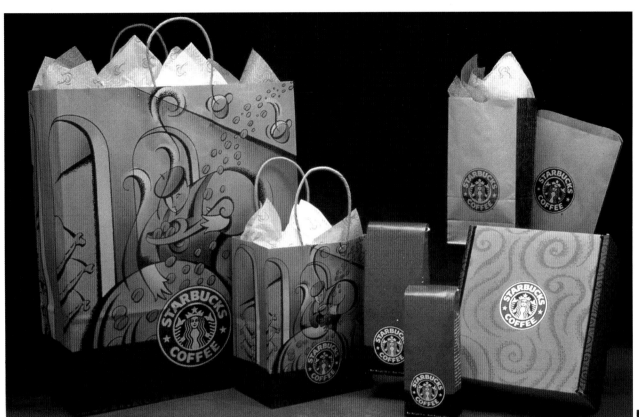

THOSE CLIENTS COULD CHOOSE TO WORK WITH SOMEONE WHO WOULD LEAVE THEM FEELING SAFE AND UNCHALLENGED, BUT THAT'S THE KIND OF WORK THEY'D END UP WITH."

THE ATTITUDE REFLECTED BY THE 30 PERSON COMPANY IS A MIRROR OF BOTH HORNALL'S AND ANDERSON'S PHILOSOPHY. ANDERSON SAYS, "THERE'S A CHINESE PROVERB THAT SAYS THE FISH STINKS FROM THE HEAD, MEANING IF THERE'S AN ATTITUDE PROBLEM, IT'S BECAUSE JOHN AND I HAVE LET IT FILTER DOWN." THIS KEEN AWARENESS OF CONTROL AND RESPONSIBILITY IS JUST ONE OF THE GOOD REASONS FOR THE CONTINUED SUCCESS OF HADW.

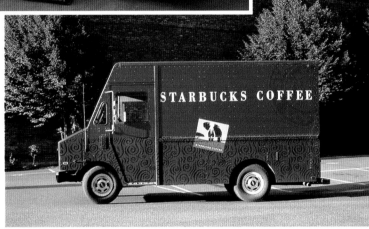

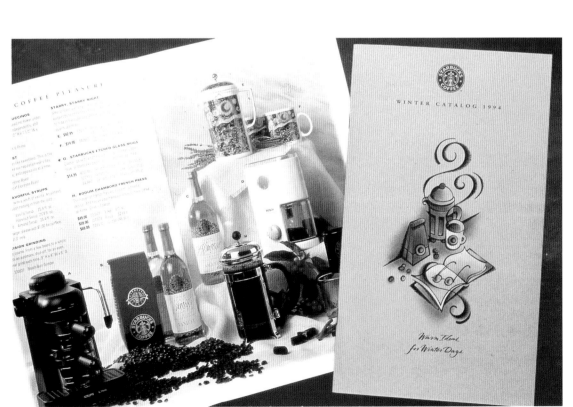

In order to present a strong branded image, while providing a fresh approach with each marketing piece, HADW created a graphic kit-of-parts to communicate the updated Starbucks image. The kit is extended as new projects warrant and includes a rich, earthy color palette; steam patterns; an intimate illustration style; kraft papers; a sun-kissed photographic style and calligraphy.

The design concept focused on the pureness of the outdoors and the company's river rocks origin. In an industry flooded with pristine, crisp images, the Smith materials stand out by using honest, natural materials blended with the actual construction technology and a simple branding treatment of the Smith identity.

The design objective behind the Smith Sport Optics merchandising program was to leverage existing brand awareness established with the company's ski goggles line and to create a strong point of differentiation for its new line of sunglasses.

HADW created this three-dimensional direct-mail piece for the Russell Retirement Planning division at Frank Russell, which contains a workbook, brochures and informational videos.

This collateral piece for the Frank Russell Company, demonstrates HADW's ability to present financial investment material in a user-friendly, creative way.

New identity to signify the merger of long-time printer, Print Northwest, and a new company, Six Sigma, a provider of software and printed products.

Based upon the Greek sigma symbol, the identity depicts the company's flexible relationship with its clients which allows them to use Six Sigma's services from beginning to end or at any point during a project.

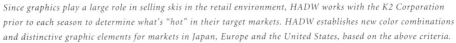

Since graphics play a large role in selling skis in the retail environment, HADW works with the K2 Corporation prior to each season to determine what's "hot" in their target markets. HADW establishes new color combinations and distinctive graphic elements for markets in Japan, Europe and the United States, based on the above criteria.

The 1995 product catalog focuses on the excitement of bicycling—whether a recreational activity or in a competitive atmosphere.

Newly designed helmet graphics help reinforce Giro's brand strength in the retail marketplace.

Strong visual images and a distinct color palette, lets Giro packaging stand out among a strong competitive environment.

When pricing points and ski technologies are relatively similar, the graphics are a significant factor in the consumer's decision to purchase one ski over another. The graphics continue to play a role on the slopes by maintaining and extending brand and product awareness.

HADW was selected to create an identity and apply it to a variety of materials for Italia, an Italian restaurant, art gallery, caterer and deli. A significant challenge was to develop a high impact, versatile image within a very conservative budget.

A successful look was achieved for a small budget by creating a design that is just as effective in one color as in three or four. A rich tapestry of "edible" colors were carefully selected including eggplant, tomato red, olive and ochre.

The resulting identity is based on a contemporary renaissance concept, keeping both progressive and classical concepts in mind. In addition to encouraging gift and souvenir purchases, the packaging and T-shirts function as decor throughout the restaurant.

HADW created a mark from which elements can be extracted to be used individually or in groups for variety in application on separate program components.

KAVANAGH DESIGN
561 FOURTH STREET
BROOKLYN, NEW YORK 11215
718 768 8358

Reprinted from MARKETING BY DESIGN.
Printed in Hong Kong.

B RIGID KAVANAGH IS AT PEACE WITH A SOLID DESIGN SOLUTION WHICH IS POWERFUL IN ITS PURITY. KAVANAGH APPROACHED THE NEW PACKAGE DESIGN FOR HUE WITH THIS PHILOSOPHY IN MIND. SHE SAYS, "THE BOTTOM LINE FOR THE RETAIL CLIENT IS THEIR PERFORMANCE ON THE SELLING FLOOR. LEGWEAR IS OFTEN AN IMPULSE PURCHASE AND THE SIMPLE, BOLD PACKAGING SYSTEM I DEVELOPED HELPS TO SELL HUE'S PRODUCT BY CREATING INTEREST AT THE 'POINT-OF-PURCHASE.' IT PERFORMS DOUBLE-DUTY BY ADVERTISING ITSELF AS WELL. THE FORMAT IS EXTREMELY FLEXIBLE AND ALLOWS A WIDE RANGE OF PHOTOGRAPHIC APPLICA-TIONS ACROSS A BROAD PRODUCT RANGE."

FROM HER HOME STUDIO, KAVANAGH CONFESSES, "WITH STAFF POSITIONS IN THE PAST, I WOULD BRING CREATIVE WORK HOME TO CONTINUE IN RELATIVE PEACE AND QUIET. DESIGN PROJECTS TEND TO CONSUME ME, AND WITH CREATIVE WORK, YOU MUST UNDERSTAND THE CONDITIONS IN WHICH YOU WORK BEST."

150

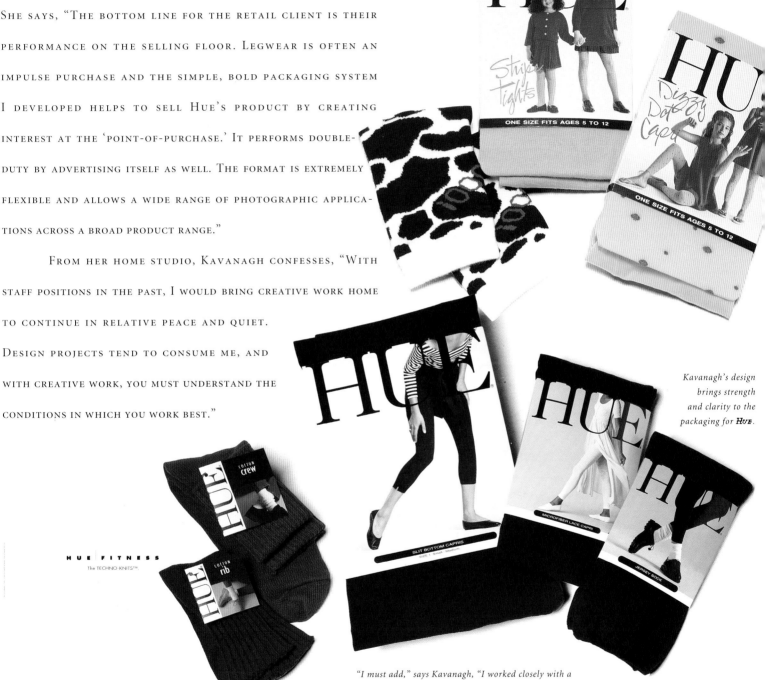

Kavanagh's design brings strength and clarity to the packaging for HUE.

HUE FITNESS
The TECHNO-KNITS™.

"I must add," says Kavanagh, "I worked closely with a wonderful photographer, Dorothy Handelman, and in this sort of project, teamwork is everything."

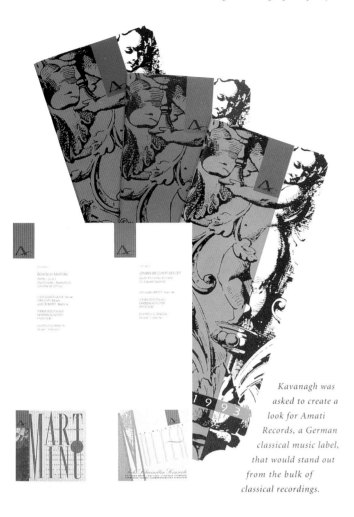

Kavanagh was asked to create a look for Amati Records, a German classical music label, that would stand out from the bulk of classical recordings.

Designing an image for a client is always an individual process. That is what keeps the 'business' of design so interesting. I try to make the process something they'll look forward to and not just a problem to be dealt with.

—*Brigid Kavanagh*

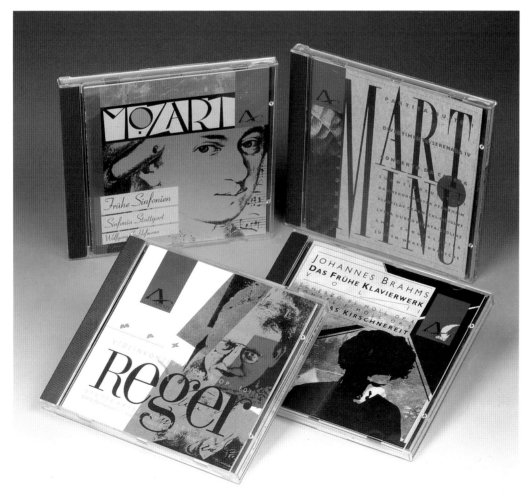

The strong and non-traditional Amati CD packaging uses paper collage, prominent type, color and texture. Listening to the music when considering the layout, helped Kavanagh find the appropriate direction for the design. She says, "I've always respected the work of type designers and I don't like to disrupt the intrinsic nature of a typeface unless I'm absolutely sure it works."

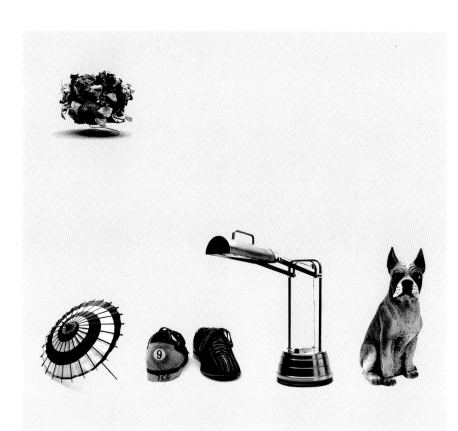

The M&Co designers pose for a studio portrait. Left to right: Emily Oberman, Scott Stowell, Tibor Kalman, Dean Lubensky, and Maira Kalman as the hat.

A Mystery. It looks just like a book, but it's not. It contains everything you need to write a novel or run a major corporation: 12 cedar pencils, a brass sharpener, paper clips, rubber bands, a 7-inch steel ruler, a good eraser with a dodo bird on it, and breath mints from Italy... as well as an abundance of wisdom and wit.

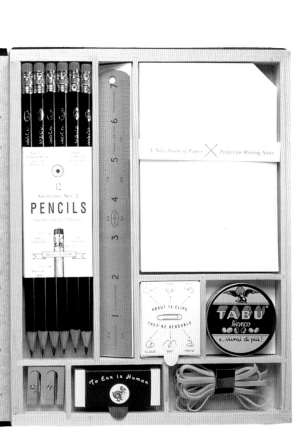

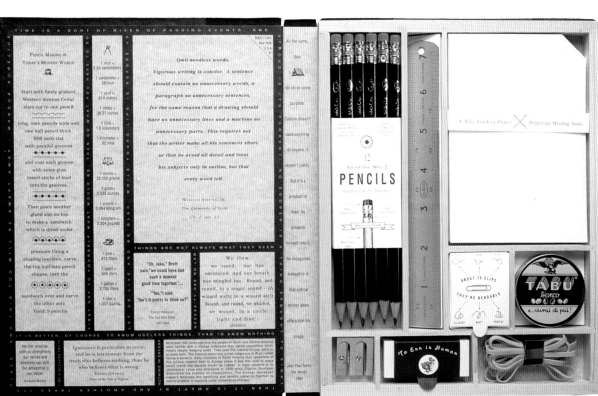

M&Co Labs
225 Lafayette Street
Suite 904
New York, New York 10012
212 343 2408

Reprinted from Marketing By Design.
Printed in Hong Kong.

*I*nscribed on the back of the M&Co Labs' watches are words that epitomize its approach—"Waste Not A Moment." M&Co was always M&Co's favorite client. While the design firm had achieved success in record covers, corporate graphics, magazines, and film titles, its self-promotional holiday gifts were an opportunity to explore industrial design and product development. Some of the gifts were baffling (an indecipherable metal ruler wrapped in a semaphore flag), some social (a boxed lunch—similar to those distributed to the homeless—with a $20 bill and a list of places to contribute it); some turned out to be actual products. One particularly desultory, idea-flinging, paper-crumpling, design session resulted in the now-classic Paper Weight—still sold in museum and design stores after a decade. M&Co Labs gradually added watches, clocks, children's blocks and a string of other objects that have quirky, intelligent and humanistic qualities. Many of the products have been recognized with various awards and publications, including inclusion in the permanent design collection at the Museum of Modern Art, New York, and other design collections.

M&Co is a small design studio in New York City. We usually work for 'clients' who tell us what the public (you) will or won't like. This is okay. But it turns out that the things *we* like best are things that the clients say *you* won't like.

So we decided to take matters into our own hands...

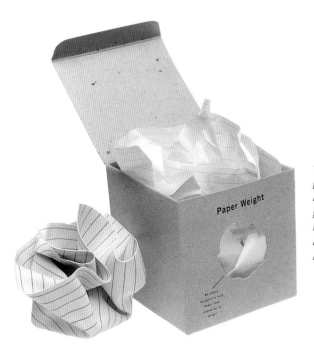

This screened vinyl and steel paper-weight is packaged in a chip-board box with stuffing paper of matching style-ledger paper, stock quotations, and architectural blueprint are also available.

Included in the permanent
design collection of the
Museum of Modern Art,
New York, Ten One 4
(right) tells time with
elegance, minimalism
and humor. Bang (below)
plays with the notion of an
intentional misprint.

M&Co.

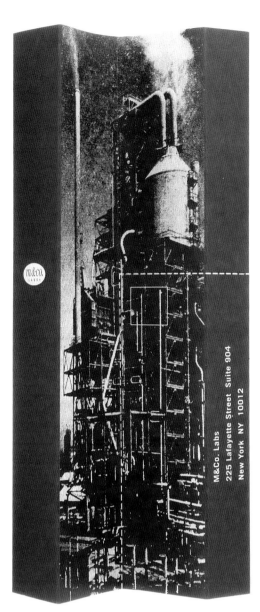

M&Co. Labs
225 Lafayette Street Suite 904
New York NY 10012

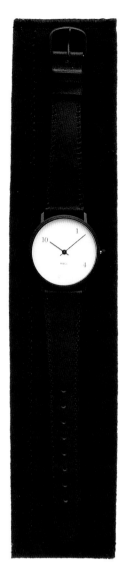

As plastic packaging lives forever, M&Co watches are packed in recycled chipboard. Made in Switzerland, they come with a one-year warranty, (three years for silver). The size is mid-range—appropriate for both men and women.

THE IDEA IS TO BELIEVE IN THE INTELLIGENCE OF THE PUBLIC AND THEN TRY TO MINIMIZE THE NUMBER OF LAYERS OF FRIGHTENED IDIOTS BETWEEN YOU AND THEM.

— *Tibor Kalman*

Scratch: Made without computers or typesetting—thus very popular among architects and designers.

Stubby: Like many M&Co designs, it is intended to look like a mistake. Sometimes what is considered "wrong" is more beautiful than what is considered "right."

Until the 16th-century all clocks used to look like this. It takes a day to get used to it, but Solo is precise and easy to read. Hash marks represent five minute increments.

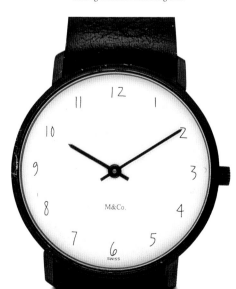

*The Zoot pocket watch (left)
is shown with its black anodized
chain. The pocket watches are
packaged with a maple stand,
making them ideal for night
stands and desktops.*

Badges of distinction. Some new points-of-view in solid sterling silver and enamel (above). The badges are packaged in re-usable aluminum storage containers.

Fuzzy (right): Designed years ahead of the current craze for blur—it was created for those those who hate the brutal precision of numbers and time.

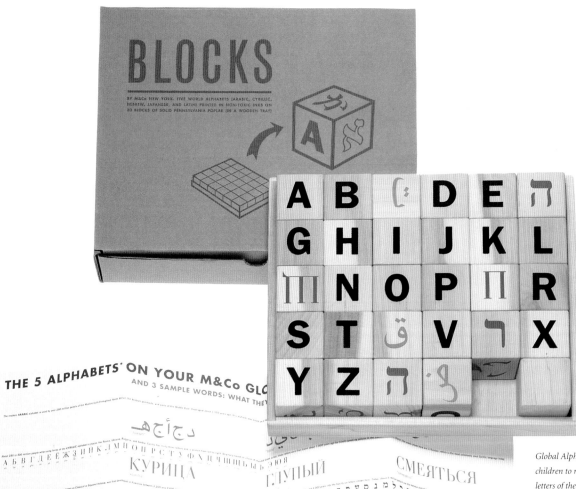

BLOCKS

BY M&Co NEW YORK. FIVE WORLD ALPHABETS (ARABIC, CYRILLIC, HEBREW, JAPANESE, AND LATIN) PRINTED IN NON-TOXIC INKS ON 30 BLOCKS OF SOLID PENNSYLVANIA POPLAR (IN A WOODEN TRAY)

THE 5 ALPHABETS ON YOUR M&Co GLO
AND 3 SAMPLE WORDS: WHAT THE

The modern ARABIC alphabet is used by over 200 million people of the Modern (with Persian/and Arab dthis). For Arabians provinces, and parts of the Middle East. Developed from 1,500 years ago, it's written right to left.

ذ ج إ أ هـ

КУРИЦА

Modern HEBREW, the official language of Israel, otherwise known as Classical or Biblical Hebrew.

תרנגולת

あいうえおかきくけこさしすせそたちつてとなにぬねのはひふへほまみむめもやゆよらりるれろわをん

ひよこ

まぬけ

ΕΙΝЫЙ

פרשת

טפשי

わらう

СМЕЯТЬСЯ

צחוק

The LATIN or Roman alphabet is used by several hundred million people around the world, making it the most

A B C D e f G H I J K L M N O P Q R S T U V W X Y Z

CHICKEN

STUPID

LAUGH

Global Alphabet Blocks encourage children to recognize and pronounce letters of the Arabic, Cyrillic, Hebrew, Hiragana (Japanese), and Latin alphabets. Using poplar, they are made by hand on an Amish farm and screened with non-toxic inks. They help children and adults to understand that the world is too big and interesting for a single alphabet. A wooden storage tray is provided.

Five O'clock (far right). For truly dedicated clock-watchers. Packaging for M&Co clocks (right), is simple, obvious and ecologically sound.

HERE'S YOUR
CLOCK
Cheers from M&Co.

Madeleine Corson, principal, Madeleine Corson Design.

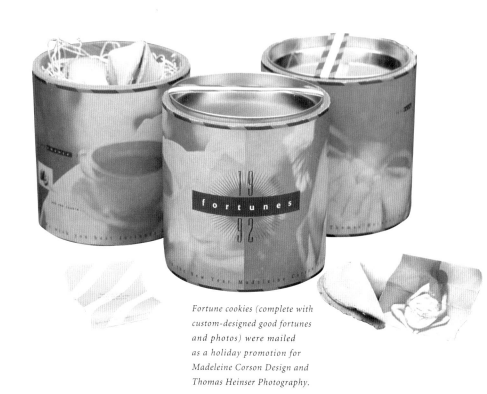

*Fortune cookies (complete with
custom-designed good fortunes
and photos) were mailed
as a holiday promotion for
Madeleine Corson Design and
Thomas Heinser Photography.*

*Promotional notepads
were designed integrating
a simple poetic line of type
and a photo, and were
printed on recycled paper.*

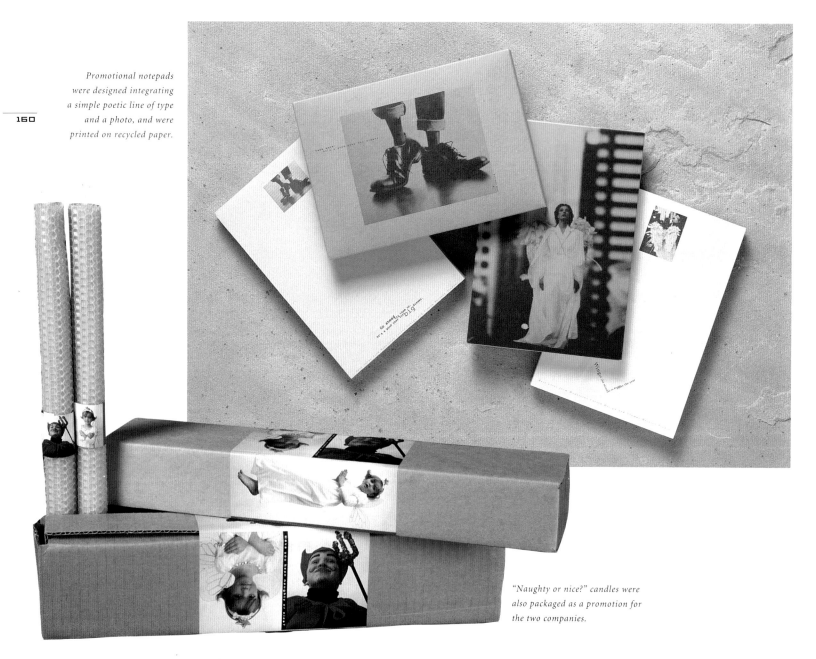

*"Naughty or nice?" candles were
also packaged as a promotion for
the two companies.*

Madeleine Corson Design
25 Zoe Street
San Francisco, California 94107
415 777 2492

Reprinted from Marketing By Design.
Printed in Hong Kong.

*I*ntegrated—that's the best way to describe Madeleine Corson's approach to design. By maintaining her home and design studio under one roof in downtown San Francisco, her philosophy manifests itself in a very physical way.

Finding herself equally intrigued by product packaging for large retailers as well as identity and collateral projects for small companies, Corson's range is exceptionally broad. But no matter what the project, Corson likes to handle things from the ground up. This means finding out as much as possible about her client's business and goals, so that the resulting design is wholly engaging. The best solutions, feels Corson, must be both visually and emotionally moving.

Madeleine Corson Design designs and produces marketing pieces, direct mail brochures and packaging for Natural Wonders, a national retailer of nature and science related products.

Natural textures and spot illustrations are used in these package designs for products available in Natural Wonders' geology department.

Recycled chipboard was used to package a wooden toy truck carrying tumbled stones.

Christmas Collection

Natural Wonders holiday collection featuring
piano, guitar, flute, harp & chamber.

NATURAL
WONDERS™

NATURAL WONDERS CHRISTMAS COLLECTION

Natural Wonders
offers a variety of gift items including garden and
geology products, juvenile games, music selections and jewelry.

Bold typography emphasizes discovery and
excitement for these Natural Wonders chemistry kits

AN AVID READER, CORSON COMBINES HER LOVE OF THE WRITTEN
WORD WITH HER SENSE OF VISUAL DESIGN. "IT'S WHEN I'M READING,"
SHE SAYS, "THAT IDEAS MOST OFTEN COME TO ME. THE IMAGES PRAC-
TICALLY PAINT THEMSELVES." WHEN SHE'S NOT WORKING IN HER
DOWNSTAIRS STUDIO, CORSON ENJOYS WALKING HER DOG.

SOAPSTONE
CARVING KIT
CREATE SCULPTURES USING THE INDIAN CRAFT OF SOAPSTONE CARVING

NATURAL
WONDERS

Packaging designs are customized to
reflect the nature of each product.
Madeleine Corson Design oversees
copywriting, design directions and
production of the product packaging.

TERRA COTTA
CERAMIC BIRDBATH
Natural terra cotta ceramic birdbath to use in your garden.

NATURAL
WONDERS

Natural Wonders' ceramic birdbath
is revealed through the die-cut
window of its package.

For the garden department products, recycled paperboard and corrugated packaging materials are used to create a natural look. Illustrations are used to communicate how each product works.

A discount coupon and pencil designed to be given to Natural Wonders customers as they shop.

Book covers were designed as courtesy gifts for young Natural Wonders customers during the back-to-school season.

EILEEN WEST

Gardenia

Net. Wt. 10 oz.

EILEEN WEST

Wisteria

4 Soap Cakes Net Wt. 10 oz.

EILEEN WEST

Tuberose

4 Soap Cakes Net Wt. 10 oz.

EILEEN WEST

Eileen West has created

this gift box of palest pink soap

with the delicate romantic scent of tuberose.

Each French Milled bar

is made from the

finest ingredients available.

Hangtags were designed to represent the actual lace sewn into Eileen West velvet dresses and sleepwear.

I ENJOY THE PROCESS OF DEVELOPING PACKAGING FOR THE RETAIL SHELF—IT'S A WONDERFUL OPPORTUNITY TO INTRODUCE A DIFFERENT VIEW OF THE WORLD TO SHOPPERS... ONE THEY CAN TAKE HOME WITH THEM.

— *Madeleine Corson*

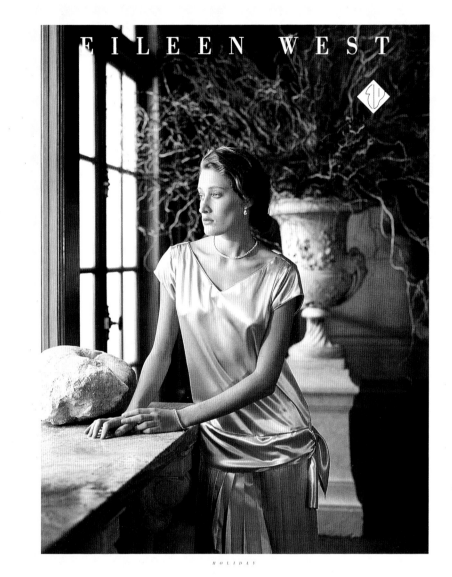

HOLIDAY

Direct mail catalogs for Eileen West, a manufacturer of women's apparel and home furnishings, embody a light, romantic style.

The packaging for a line of gift soaps (left) uses florals related to bath and bedding products.

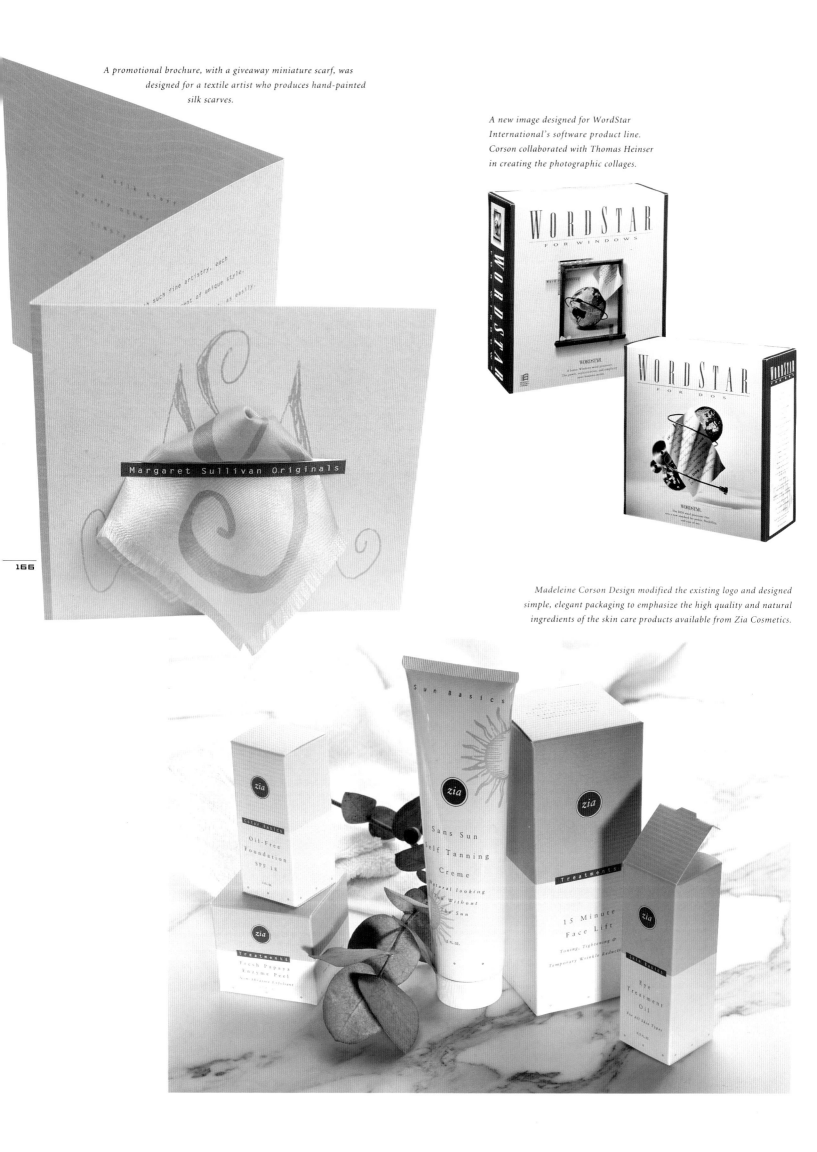

A promotional brochure, with a giveaway miniature scarf, was
designed for a textile artist who produces hand-painted
silk scarves.

A new image designed for WordStar
International's software product line.
Corson collaborated with Thomas Heinser
in creating the photographic collages.

Margaret Sullivan Originals

Madeleine Corson Design modified the existing logo and designed
simple, elegant packaging to emphasize the high quality and natural
ingredients of the skin care products available from Zia Cosmetics.

Warmly toned images were art directed to complement the line of handmade, organic bedding products featured in The Natural Bedroom direct mail catalog.

The Layered Bed

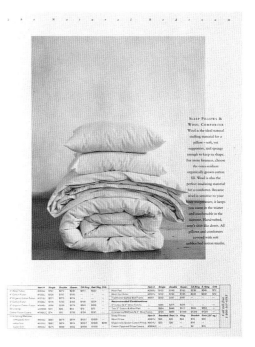

The Natural Bedroom

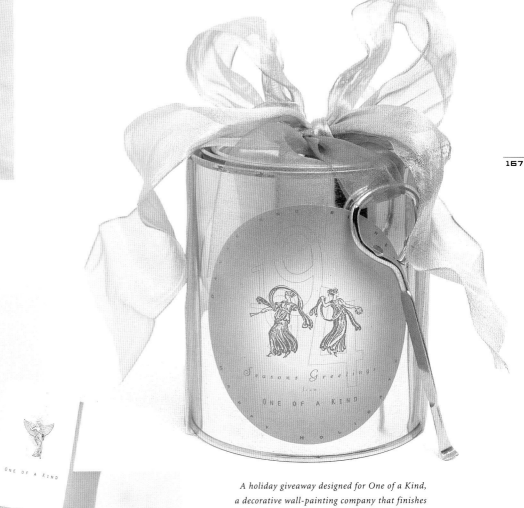

A holiday giveaway designed for One of a Kind, a decorative wall-painting company that finishes interiors for hotels. The "paint" can comes with a can opener and is filled with chocolate.

Madeleine Corson Design created the elegantly engraved letterhead system for One of a Kind.

Maddocks & Company.

For Philips Interactive Media, Maddocks & Company created an impactful group of packages, discs and brochures that gave the consumer a taste of the nature of their innovative multimedia product, CDi or compact disc interactive.

Warner Bros. asked Maddocks & Company to create a packaging system adaptable to a line of accessories and clothing that would have a Looney Tunes feel and style—nostalgic but with a nineties attitude.

MADDOCKS & CO.
2011 PONTIUS AVENUE
LOS ANGELES, CALIFORNIA 90025
310 477 4227

Reprinted from MARKETING BY DESIGN.
Printed in Hong Kong.

MADDOCKS & COMPANY TAKES A CIRCUMSPECT VIEW WHEN IT COMES TO ACCOMMODATING CLIENTS' NEEDS, PROVIDING ALL ASPECTS OF DESIGN FROM IDENTITY, PRODUCT AND PACKAGE DESIGN TO CORPORATE LITERATURE. THE FOCUS CAN BE STRATEGICALLY TARGETED OR BROAD-BASED. AS FOUNDER FRANK MADDOCKS SAYS, "WE JUST DID A SUPERMARKET PRIVATE LABEL PROGRAM STARTING WITH THE COFFEE WHICH HAS SINCE BECOME THE BEST-SELLING COFFEE IN THE STORE. THAT'S WHAT WE LIKE TO HEAR. OF COURSE, IT'S EQUALLY EXCITING TO DESIGN A PRESTIGIOUS FRAGRANCE LINE WHICH INVARIABLY INCLUDES A COMPLETE DESIGN PROGRAM—FROM BOTTLE, PACKAGE, POINT OF PURCHASE, TO PROMOTIONAL SUPPORT MATERIALS."

FRANK MADDOCKS, WHOSE LOS ANGELES-BASED FIRM RECENTLY OPENED ITS NEW YORK OFFICE, HANDLES MANAGEMENT AND SALES. CREATIVE DIRECTOR, MARY SCOTT, FEELS THAT, "GOOD DESIGN IS BASED ON A SIMPLE IDEA THAT EVOKES AN HONEST RESPONSE." DAVID STERN, MARKETING DIRECTOR, SAYS, "WE'VE CREATED AN ENVIRONMENT THAT ENCOURAGES OUR STAFF TO PUSH FOR UNEXPECTED CREATIVE SOLUTIONS THAT ARE BASED ON A SOLID FOUNDATION OF RESEARCH AND ANALYSIS."

Packaging for the Wings fragrance line is designed in elegant shapes reminiscent of natural forms like seed pods or a water smoothed stones, creating a feeling of upscale environmental awareness and appealing to the variety of lifestyles pursued by women in the nineties.

169

WINGS

Wings for Men was conceived as a companion to Wings for Women. It's masculine form complements and enhances its partner while having an edge of pride, gentle strength and stature.

Hiram Walker came to Maddocks & Company to create a holiday package for Beefeater's gin (left) that was more festive and exuberant than before. The Beefeater character had always been used in the past, but the design team took a new approach, resulting in a dynamic package that billboarded into a successful holiday display.

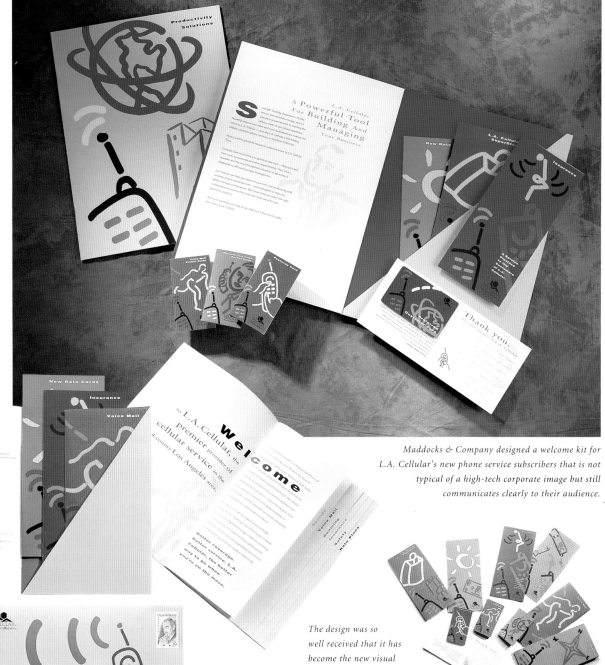

Maddocks & Company designed a welcome kit for L.A. Cellular's new phone service subscribers that is not typical of a high-tech corporate image but still communicates clearly to their audience.

The design was so well received that it has become the new visual identity for L.A. Cellular, used in all print graphics and on billboards throughout Los Angeles.

Dino A. Maniaci, principal, Mani Graphics & Co.

*HAVING AN IDEA, RESOURCES AND THE MARKETING SAVVY TO
SEE IT THROUGH HAS SET THE TONE FOR THE TYPE OF DESIGN
SOLUTIONS THIS AGENCY IS NOTED FOR.* — Dino A. Maniaci

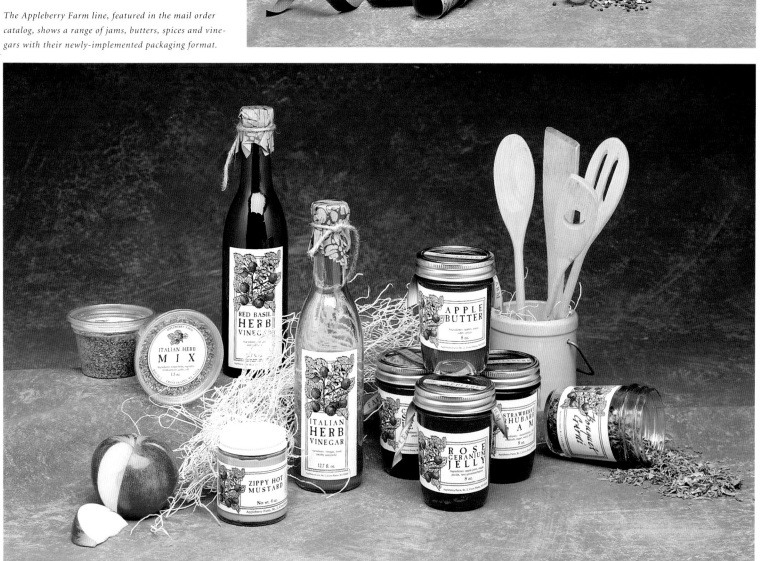

*Packaging materials for Appleberry Farm create a clean,
fresh look and a "home grown" sensibility. Standard
corrugated boxes are imprinted with a logo graphic on
the inside, creating a giftbox/shipper. Custom printed
papers, cotton-thread ribbons and straw sisal
provide a unique wrap alternative.*

*The Appleberry Farm line, featured in the mail order
catalog, shows a range of jams, butters, spices and vine-
gars with their newly-implemented packaging format.*

MAN1 GRAPHICS

Mani Graphics & Co.
303 South Paterson Street
Madison, Wisconsin 53703
608 255 5300

Reprinted from Marketing By Design.
Printed in Hong Kong.

Mani Graphics & Co., named after founder and creative director Dino A. Maniaci, has a diverse client base and an approach that stretches way beyond the design of clients' retail products.

Mani Graphics & Co., which has designed proprietary lines of gift wrap for companies like Williams Sonoma, Inc., has also developed product packaging lines for Godiva Chocolatiers, Bloomingdales, Revlon and Cadbury Schweppes. Maniaci's style is distinctively identifiable as Mani Graphics, and Maniaci, who has a true entrepreneurial spirit, realized an opportunity in the gift wrap area. The result was the formation of Mani Graphics' subsidiary, Mani G 'Raps & Co., which has developed a very successful gift wrap and accessory line.

173

Originally positioned as "graphic hip-hop," Mani G 'Raps plays off industrial-looking papers and an environmental sensibility. Unique color effects were created by working with printers to test soy-based inks on kraft papers.

The Mani G 'Raps line began with twelve designs printed in one and two colors on brown or white kraft papers.

A complete line of tags, stickers and ribbons were designed to complement the papers and build a base as a giftwrap resource.

Mark Randall

Love Peace Happiness and Prosperity. The mainstay of the E.G. Smith philosophy.

SMITH WOULD COME TO RANDALL WITH KERNELS OF IDEAS. IT WAS ESSENTIAL TO SMITH'S SUCCESS THAT RANDALL "GET" THE SINCERITY AND ORIGINALITY OF SMITH'S PHILOSOPHY ACROSS, IN ALL OF HIS GRAPHIC REPRESENTATIONS. THE PACKAGING WAS ESSENTIAL TO DIFFERENTIATING E.G. SMITH FROM OTHER SOCK LINES. ALL THIS WHILE MAXIMIZING IMPACT ON A LOW BUDGET COUPLED WITH THE NEED FOR HIGH VISIBILITY. RANDALL WAS THE RIGHT MAN FOR THE JOB.

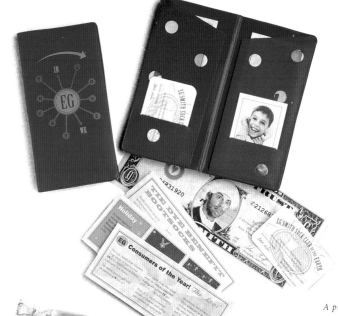

A promotional wallet was sent to store buyers and customers. Inside, E.G. family photos, an E.G. club membership card and a variety of "bills" provided information on the season's offerings.

A selection of accordion-folded, perforated postcards in a self-mailer further developed the E.G. Smith philosophy by emphasizing the theme— communication—as opposed to the product. A special postcard was sent to the President of the United States requesting more funding for AIDS research.

WORLD STUDIO
NEW YORK, NEW YORK
212 366 1317

Reprinted from MARKETING BY DESIGN.
Printed in Hong Kong.

E.G. SMITH IS A CHARACTER. A LAWYER CUM SOCK-DESIGNER, SMITH HAS DEVELOPED A WORLD VISION OF PEACE AND LOVE AND MADE THIS MESSAGE A COMPONENT OF HIS BUSINESS. THE DESIGNER THAT WORKS WITH A MAN LIKE SMITH MUST BE HAVE AN INNATE ABILITY TO TRANSLATE, INTERPRET AND COLLABORATE. SUCH IS MARK RANDALL, WHO, WORKING WITH SMITH FOR SEVERAL YEARS, DEVELOPED A LINE OF PACKAGING, PROMOTION AND POINT OF PUR-CHASE DISPLAYS THAT HELPED BRING THE MESSAGE OF WORLD LOVE TO MACY'S AND OTHER RETAIL SPACES. TOGETHER, THEY TOOK HUMOR, WARMTH AND INTELLIGENCE AND STARTED CUSTOMER COM-MUNICATION PROGRAMS LIKE "SOCK THERAPY." WHEN A CONSUMER PURCHASED A PAIR OF E.G. SMITH SOCKS, THE PACKAGING INCLUDED A QUESTIONNAIRE INTENDED TO PROBE THE MIND AND SPIRIT OF THE WEARER. IN REACTION, SMITH WOULD READ EACH RESPONSE SENT HIM AND, IN FACT, APPLY HIS AMATEUR THERAPEUTIC—AND QUITE HILARIOUS—ADVICE, COMMUNICATING BACK (CONNECTING, BONDING) WITH THE SOUL OF THE SOCK-WEARER.

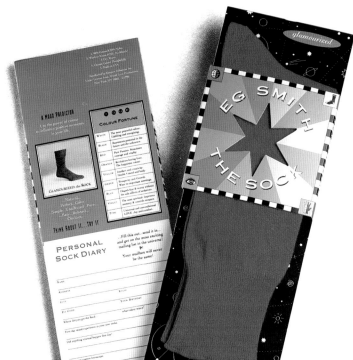

A simple cotton sock (top) was "glamourized" by creating a custom package on the theme of Change Your Mood by Wearing Socks. A Color Fortune Chart advised the customer on the appropriate color to affect his or her mood for the day. A wrap-around label for women's tights(above). Large foil-stamped words were used to highlight the various styles.

This Color Game was sent to retail buyers in place of a traditional catalog. Playing cards with the different sock and tight styles are placed in the center of the board, arrows on the cards point to the colors in which each style is available.

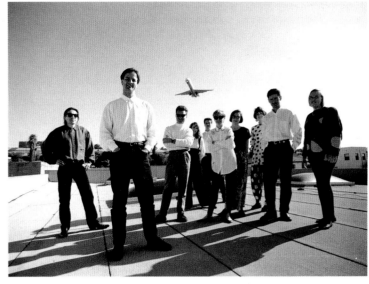

This T-shirt was used to introduce a new line of Hawaiian tiles.

Mires Design is located in an airy 4,000 square-foot loft, just north of downtown San Diego, and five minutes from the San Diego International Airport.

Advertising for Deleo Bella Tiles highlights the natural, hand-made quality and old-world crafts-manship of the product.

So beautiful, Italian roofers have used it for over 2000 years.

Bella clay tile. In Italy it's been a classic since the first Caesar. Now it's made in America by Deleo. While carefully reproducing the long, trim, elegant shape, Deleo uses modern methods to enhance durability and quality. The result is a beautiful blend of old world charm and new-era craftsmanship. Bella tiles come in any color imaginable. Mediterranean Sea blue. Venetian palazzo pink. Any color on earth, including the earthy tones of natural clay. Also attractive is the fact that these sleek 18 inch tiles give any roof a clean, uncluttered look. Indeed, the main reason for specifying Bella clay tile is, as the Italians say, per la bellezza. For the sheer beauty of it. Bella clay tile from Deleo. • Deleo Clay Tile, 600 Chaney Street, Lake Elsinore, California 92330, 714.674.1578 or 800.237.9461 (Inside CA) 800.654.1119 (Outside CA).

DELEO CLAY TILE

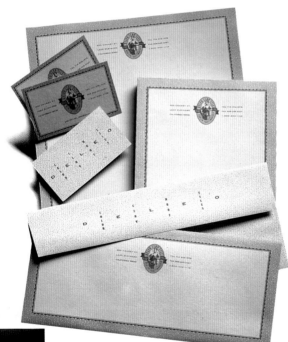

The Deleo Stationery System (above) was produced with natural colors and paper stock to convey a feeling of quality, old-world craftsmanship.

A page from the Deleo General Store Calendar (left). The Deleo General Store Calendar (left).

MIRES DESIGN, INC.
2345 KETTNER BOULEVARD
SAN DIEGO, CALIFORNIA 92101
619 234 6631

Reprinted from MARKETING BY DESIGN.
Printed in Hong Kong.

AN DIEGO DESIGNERS SCOTT MIRES, JOSE SERRANO AND JOHN BALL HAVE DEVELOPED A STRONG, BOLDLY-ILLUSTRATED STYLE FOR THEIR CLIENTS. IN FACT, FEW DESIGN FIRMS HAVE MASTERED THE DIVERSITY OF STYLES THAT MIRES HAS WHILE RETAINING THE ORIGINALITY AND INTEGRITY OF THE WORK ITSELF.

PERHAPS THIS IS WHY MIRES IS ABLE TO BOAST OF HAVING OVER 50 PERCENT OF ITS CLIENTS COME FROM OUTSIDE SAN DIEGO. SURPRISINGLY SAN DIEGO, HARDLY A CENTRALLY-LOCATED CITY, PLAYS HOST TO SEVERAL GOOD DESIGN OFFICES OF WHICH MIRES IS ONE OF THE LARGEST AND FASTEST GROWING.

MIRES HAS AN UNUSUAL AND CHALLENGING BUSINESS PHILOSOPHY—UNLIKE MANY DESIGN OFFICES AND AD AGENCIES, THEY WILL NOT WORK ON RETAINER FOR A CLIENT. MIRES SAYS, "I THINK THAT KEEPS OUR WORK SHARP, BECAUSE WE'RE CONSTANTLY FOCUSED ON THE PROJECT AT HAND. AND IN THIS BUSINESS, YOU'RE ONLY AS GOOD AS YOUR LAST PROJECT."

Mires' "Light Gear Man" was so well liked by LA Gear/Light Gear, that they rejected the look they had and recreated everything, using it as the new identity. The "Light Gear Man" appears on promotional materials for the illuminated footwear line like T-shirts (left) and point of purchase displays (below).

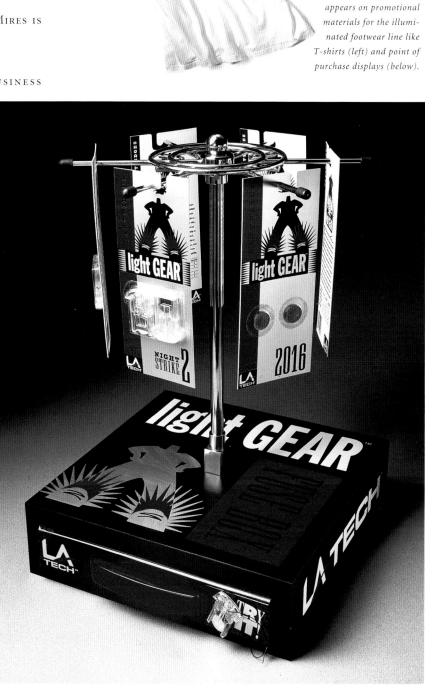

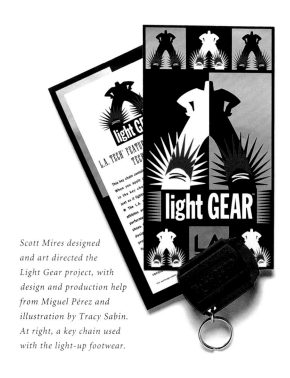

Scott Mires designed and art directed the Light Gear project, with design and production help from Miguel Pérez and illustration by Tracy Sabin. At right, a key chain used with the light-up footwear.

WE USE NATURAL INGREDIENTS AND NO ARTIFICIAL COLORING.

OUR COLOR SPECIALIST HAS BEEN PERFECTING HER ART FOR BILLIONS OF YEARS.

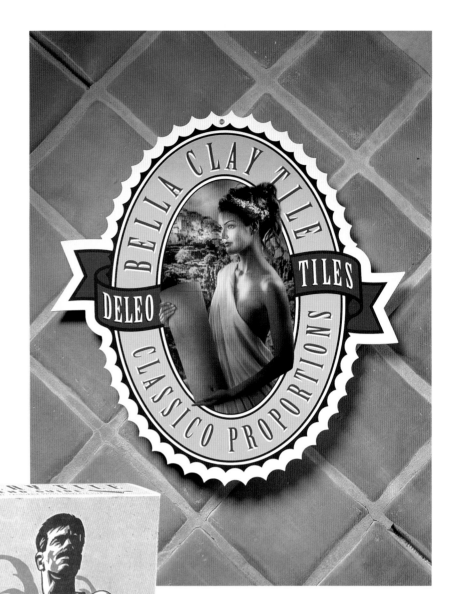

Deleo promotional items, like the postcards above, use color photography to stress the product's range and modernity, while packaging for support materials (right) employs thirties-style graphics to convey quality and workmanship.

Designed with the same quality craftsmanship as the Deleo Clay Tile packaging, the Color Blend Guide lets the consumer see different styles, shapes and colors.

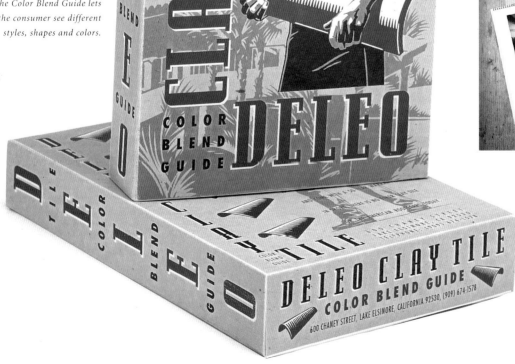

Every year, Mires creates a calendar for each line of Deleo Clay Tile to give away as a promotion to architects, distributors and consumers.

This Bella Point of Purchase Display (left) helps the distributors showcase the Bella Clay Tile Line.

Mires developed packaging for the Deleo Clay Tile that could be shipped economically to customers. The earthy yet detailed design conveys the fine craftsmanship and natural qualities, just like the products it holds.

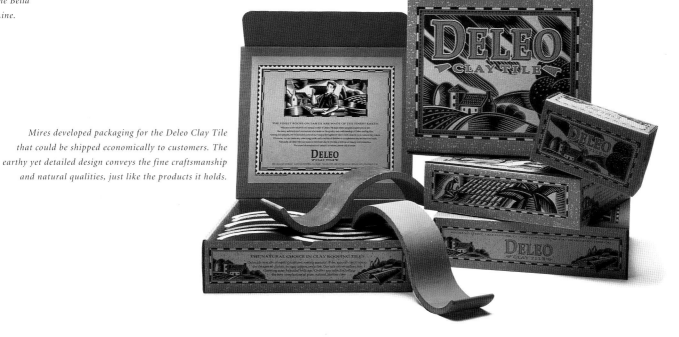

D E L E O C L A Y T I L E

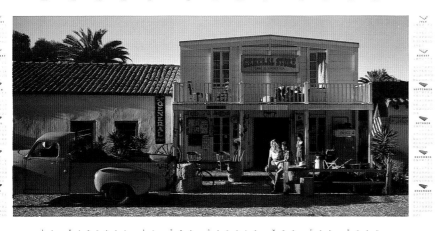

GREAT WORK DOESN'T JUST HAPPEN —IT TAKES DEDICATED EFFORT BY THE ENTIRE TEAM. WE EXPECT A LOT OUT OF EVERYONE, ESPECIALLY OURSELVES. —Scott Mires

179

Mires designed support materials for users of the tile which include installation and spec requirements.

This package, including Deleo Chameleon T-shirt, notepad, pencils and tape measure, was a summer promotion to introduce consumers to the wide color selection offered by the manufacturer.

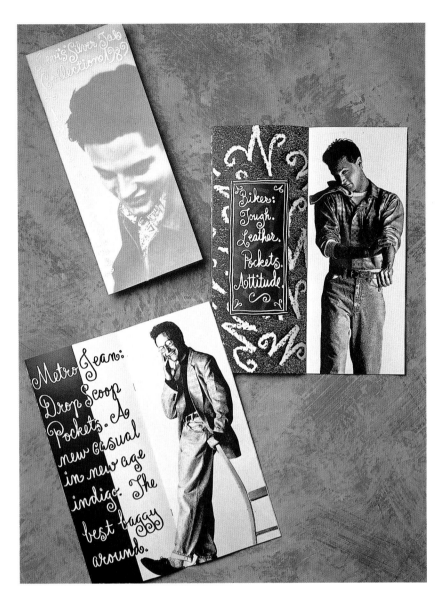

This early Silver Tab Brochure established the current vocabulary of black, white and silver imagery for the collection. The distinctive style is enhanced through the use of hand-drawn type and mezzotint photographs.

Fit Identifiers for the Jean Shops.

Jennifer Morla is president and creative director of Morla Design. She has been honored internationally for her ability to pair wit and elegance on everything from annual reports to music videos. Morla Design's work has received over 500 awards for excellence in graphic design and was recently featured in a solo exhibition in Osaka, Japan.

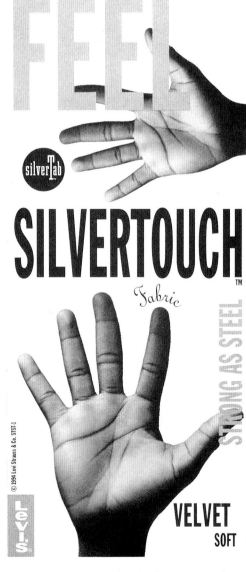

This Silver Tab hangtag utilizes hand imagery to reinforce the introduction of a new, softer fabric.

MORLA DESIGN

Morla Design, Inc.
463 Bryant Street
San Francisco, California 94107
415 543 6548

Reprinted from Marketing By Design.
Printed in Hong Kong.

Jennifer Morla responded to Levi Strauss & Co.'s need to permeate the East Coast market with the 501 Jean by introducing life-size, duotone portrait photography in the now-classic 501 Jeans poster. This bold, new approach worked significantly to reposition the Levi's 501 Jean.

Morla Design's refreshing vision in design has accompanied the evolving corporate image and diverse product lines of every Levi Strauss & Co. division, for over 15 years. "The challenge of working with a company as diverse as Levi's," says Morla, "has been identifying each product group, from Dockers, to Men's Jeans, to Youthwear and developing creative solutions that target the marketing goals of each division while maintaining the integrity of the Levi Strauss & Co. name."

Levi's Old Favorites hangtag was designed to tie-in with Levi's historic trademarks and convey a natural, worn-in feeling.

Levi's Jean Catalog (below) features 501 jeans. Morla Design worked with Albert Watson in creating the impactful black-and-white photography.

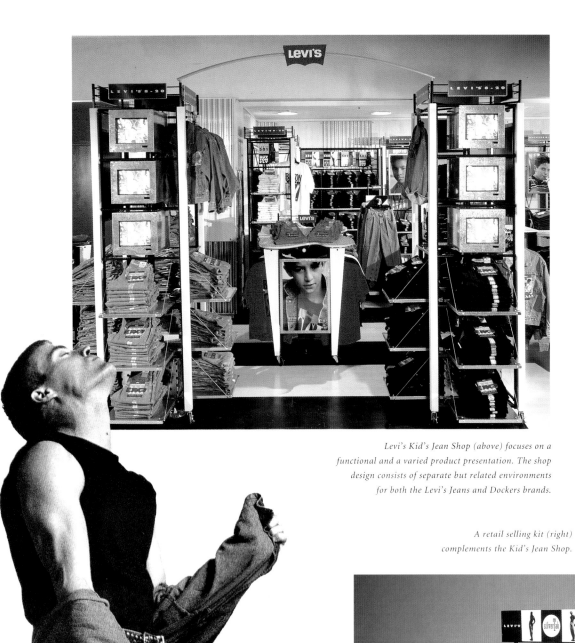

Levi's Kid's Jean Shop (above) focuses on a
functional and a varied product presentation. The shop
design consists of separate but related environments
for both the Levi's Jeans and Dockers brands.

A retail selling kit (right)
complements the Kid's Jean Shop.

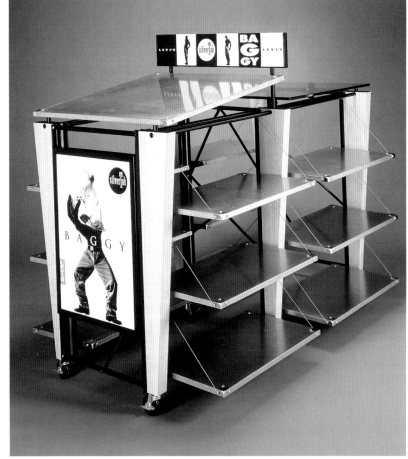

A folding jeans fixture from the Levi's Jean
Shop. Criteria included a very cost-conservative
plan and high-volume inventory capabilities.

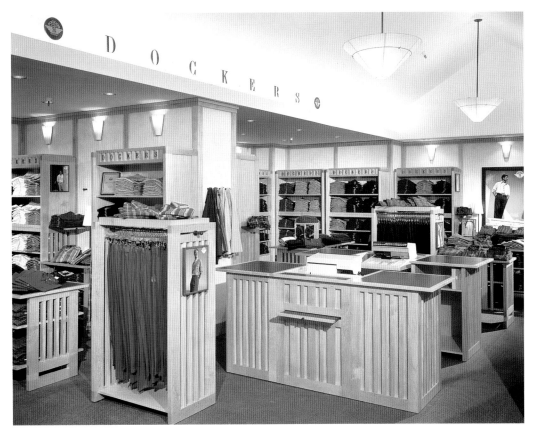

The Levi's Dockers Shop
uses classic American design
to create a sophisticated
environment that responds
to the demographics of the
Dockers consumer.

*Levi's Girls pocket flasher and hangtag (below) and
Fashion Brochure (right) were designed to appeal to 7-14
year olds and to position the line as a contemporary, yet
authentic Levi's product.*

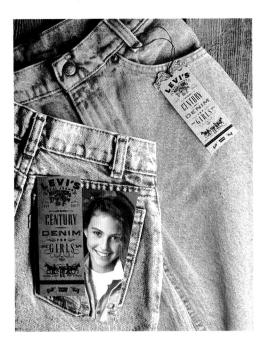

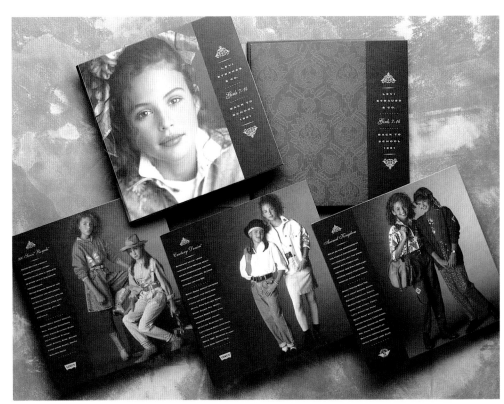

A series of sell-in materials was created for eyewear retailers to announce and distinguish the arrival of the Guess? Collection (below). Hand craftsmanship and the flavor of a limited edition are conveyed in the materials which allow sales personnel to hand write and personalize brochures for specific accounts.

The corrugated "pillow" (above), a single loop of material, is used both for protection during shipping and as an inventive display prop.

Parham Santana created a series of collectible tins (left): packaging which doubles as a point-of-sale display and helps distinguish Guess? in a mature and crowded eyewear market.

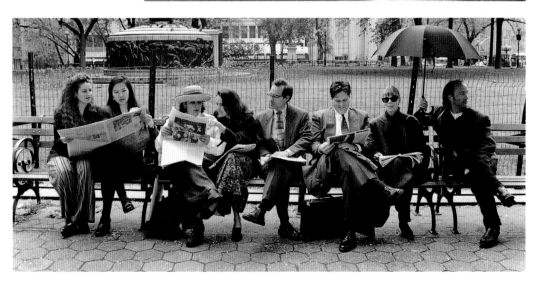

Parham Santana Inc. relaxing in the park. Left to right: Lori Ann Reinig, Millie Hsi, Maruchi Santana, Katherine Inglis, John Parham, Jerald M. Berkowitz, Mary Louise Chatel and Richard Tesoro.

PARHAM SANTANA

Parham Santana Inc.
7 West 18th Street
New York, New York 10011
212 645 7501

Reprinted from MARKETING BY DESIGN.
Printed in Hong Kong.

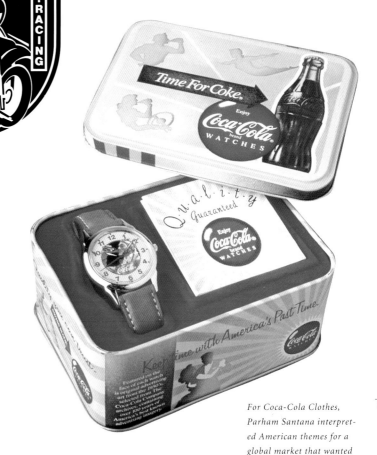

\mathfrak{M}ARUCHI SANTANA AND JOHN PARHAM ARE AN INTRIGUING PAIR WHO ON FIRST BLUSH APPEAR TO BE DIAMETRICALLY OPPOSED PERSONALITIES. THEY MET AT PRATT INSTITUTE WHERE THEY BOTH RECEIVED MASTER'S DEGREES IN COMMUNICATION DESIGN WITH UNDERGRADUATE DEGREES IN FINE ART. SANTANA IS A FLAMBOYANT CUBAN, AND PARHAM IS INTROSPECTIVE, SERIOUS-LOOKING AND ANALYTICAL. "JOHN IS VERY LATIN," SANTANA WILL TELL YOU WITH A KNOWING TWINKLE IN HER EYE. AND YOU MUST BELIEVE HER BECAUSE THEIR DESIGN IS CONSISTENTLY INTELLIGENT, GUTSY AND INTUITIVE. THE FINE-ART BACKGROUND OF PARHAM AND SANTANA HAS CREATED A MARKET FOR THEIR TALENTS, IN SURFACE DESIGN AS WELL AS PROMOTION MATERIALS AND PACKAGING, WITH MANUFACTURERS LIKE SWATCH, COCA-COLA AND GUESS?—WORKING WITH PARHAM SANTANA TO CREATE ENTIRE LINES OF WATCHES, APPAREL AND BEDDING. WITH A COMMITTED STAFF OF NINE, PARHAM SANTANA IS GROWING AT A HEALTHY RATE. AS SANTANA SAYS,

185

For Coca-Cola Clothes, Parham Santana interpreted American themes for a global market that wanted the taste of original themed graphics. The watch (above) uses Coca Cola's image as an American standard to project quality.

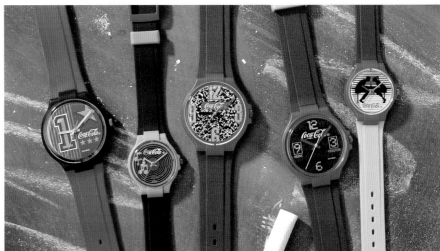

Parham Santana designed clothing and accessories using Coke's association with leisure as a link to American sports with an exciting or glamorous edge.

"WE USE THE STREETS OF NEW YORK AS A BAROMETER FOR THE TIMES. WE ARE OUT THERE, AT ANY TIME, FOR EVERY CLIENT, WE KNOW WHAT'S HAPPENING IN COLOR, FASHION, LINE, STYLE, IN THE MOST TRENDSETTING ARENA IN THE WORLD. WE TRANSLATE WHAT WE SEE INTO DESIGN FOR THE YOUTH MARKET AND THAT'S WHAT SETS PARHAM SANTANA APART." AND THE GENERATION NAMED FOR THE VOID—X—LOVES THE WORK, BECAUSE THE MESSAGE IS HONEST. THE LOOK IS ORIGINAL.

Packaging for the Swatch Watch includes "Switch Swatch," a line of gift boxes holding watches with mix-and-match watch bands and guards.

Parham Santana was the first firm outside of Switzerland to design a Swatch Watch. Their "Pink Camouflage" is an international best seller. The group of watches (right) were auctioned at Sotheby's.

For Swatch Fun Wear (right), Parham Santana developed themes like Nefertiti, an Egyptian comic book; Check Point, a Viennese-inspired collection featuring Sigmund Freud and "Dare to be Square" graphics; and the tropically-inspired Bora Bora, a collection of prints with tropical leaf and eye motifs.

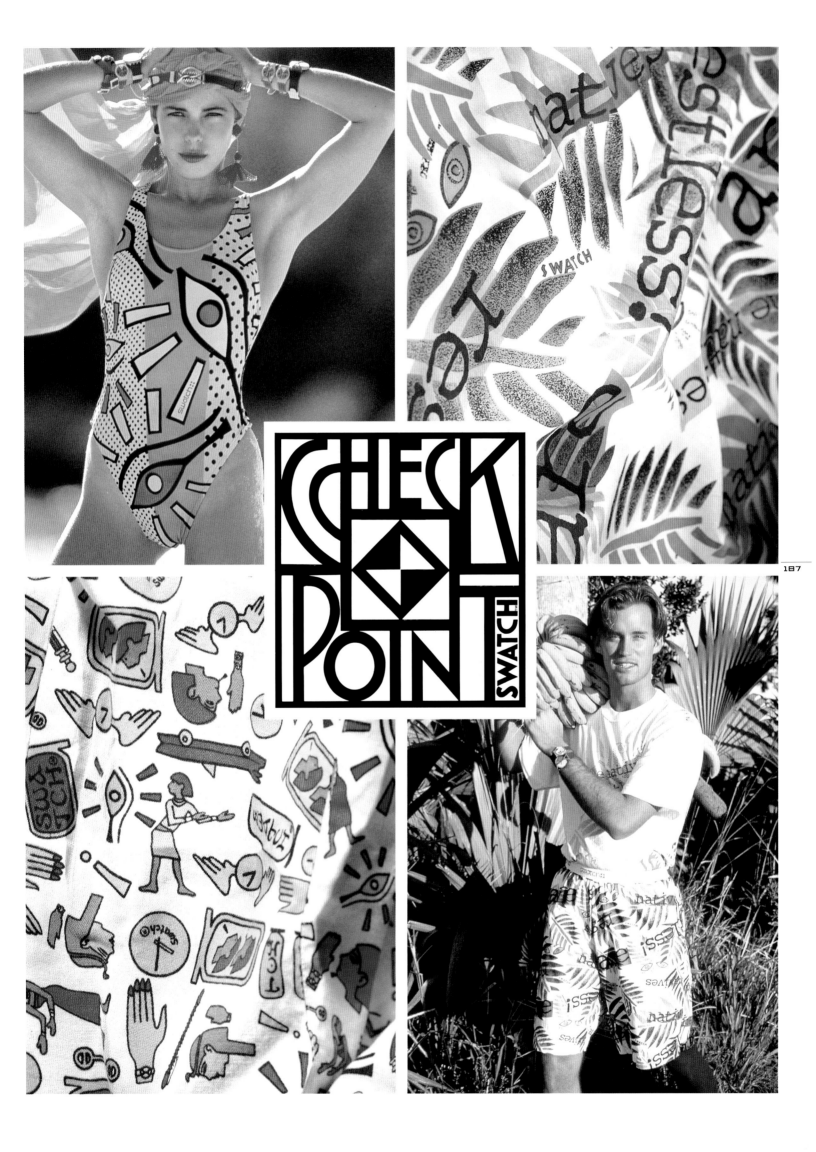

The Pentagram partners boating on the Thames.

When Boots, the largest chemist in Britain, made a major move into the optician market, Pentagram's John McConnell was asked to prepare a graphic house style encompassing packaging, point of sale and in-store promotional material.

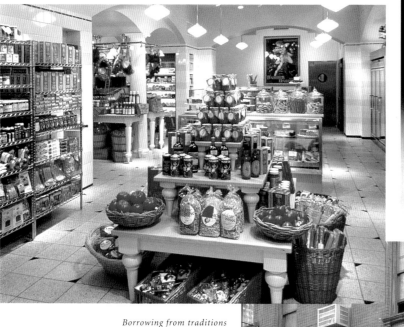

Borrowing from traditions of the local American deli, the French charcuterie and the elegant English food hall, the interior for Neuman Bogdonoff is a stage on which foods are displayed to their best advantage. Bold graphics were designed for the storefront and awning to increase the shop's presence at street level. Partners for this project were: James Biber (architecture) and Paula Scher (graphics).

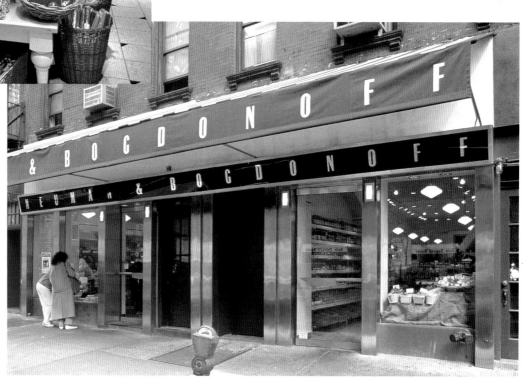

PENTAGRAM

PENTAGRAM DESIGN INC
204 FIFTH AVENUE
NEW YORK, NEW YORK 10010
212 683 7000

Reprinted from MARKETING BY DESIGN.
Printed in Hong Kong.

WHILE IT'S EXPECTED THAT A FIRM WILL HAVE ONE STRENGTH THAT STANDS OUT ABOVE ALL OTHERS, PENTAGRAM IS A RARE EXCEPTION. PENTAGRAM'S ABILITY TO PUT TOGETHER POWERFUL TEAMS WORLDWIDE FROM ITS 14 STAR-QUALITY PARTNERS IS UNIQUE IN THE DESIGN WORLD. WITH OFFICES IN LONDON, HONG KONG AND THREE IN THE UNITED STATES, PENTAGRAM HAS GROWN TO BECOME ONE OF THE WORLD'S LARGEST DESIGN FIRMS. EACH PARTNER HAS A HIGHLY-DEVELOPED SENSE OF STYLE, REPUTA-TION AND, THEREFORE, INDIVIDUAL STRENGTHS. PENTAGRAM HAS FOSTERED A SENSE OF CAMARADERIE SINCE ITS START IN 1972, WHICH ALLOWS FOR SEVERAL OF THE PARTNERS TO COMBINE THEIR FORCES AND GENIUS WITHOUT A SENSE OF TERRITORIAL IMPERATIVE THAT IS COMMON IN CREATIVE ENDEAV-ORS. EACH PARTNER JOINED PENTAGRAM LONG AFTER THEIR OWN STYLE, REPUTATION AND CONFIDENCE HAD BEEN ESTABLISHED, AND

Television
Video Cards (by partner
Paula
Scher for CBS Fox Video) were packaged
in boxes that double as Christmas cards. All the
materials, including wrapping paper, buttons and posters,
were designed in attention-grabbing red and green to assure

Pentagram partner Kit Hinrichs' marketing identity for Clarks of England employs images of its founders, Cyrus and James Clark, in nineteenth-century scratch-board style drawings.

The Good Diner was conceived by partners James Biber (architecture), Michael Bierut (graphic design) and Woody Pirtle (illustration), as a somewhat excessive celebration of the ordinary "vernacular" materials used in diner construction.

In keeping with the unpretentious theme, stools and banquettes are upholstered with Naugahyde in bright primary colors, and floors and tabletops are covered with three types of linoleum.

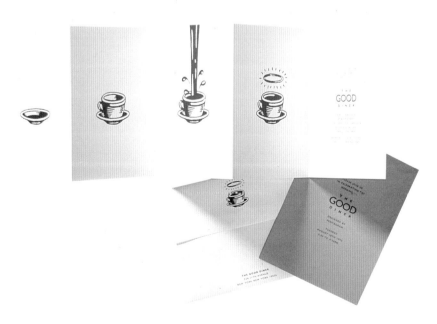

M A N Y

(IN FACT, MOST) OF THE PROJECTS THEY WORK ON ARE

RADIANT EXAMPLES OF THEIR INDIVIDUAL STYLES.

CLIENTS BENEFIT FROM PENTAGRAM'S STRENGTH

AS A LARGE, BROAD-BASED COMMUNICATIONS FIRM, BUT

THE PARTNERS, AS INDIVIDUALS WITHIN THE FIRM, PROVIDE

THE SAME CLIENT WITH A SENSE OF INTIMACY THAT IS USU-

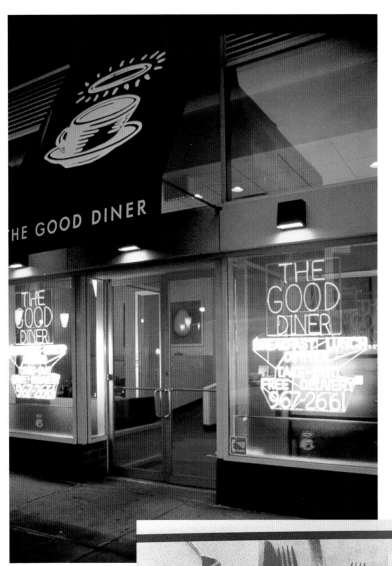

The logo, a coffee cup elevated to sainthood, is part of a graphic program that extends to menus, announcements, signage, stationery and matchbooks.

The clients wanted an unpretentious restaurant that wasn't retro or trendy, which offered good, honest food at a fair price.

The restaurant's art program features huge, framed photocopies of archetypal diner objects.

Based on the success of the catalogue design, The Nature Company commissioned Pentagram to develop the company's identity. The rabbit featured on the first catalogue cover was chosen as a visual personification of the company's philosophy. Here it serves as an oversized logo on gift boxes.

An unconventional approach allowed Pentagram's Kit Hinrichs to highlight the most interesting rather than the most expensive products in The Nature Company catalogue (left), giving it intrinsic value beyond being a mere sales tool.

Pentagram's projects for The Nature Company include poster packaging (below) and a calendar (below right). Packaging for inflatable animals (right) was designed to read like a museum label with type large enough for a child to read.

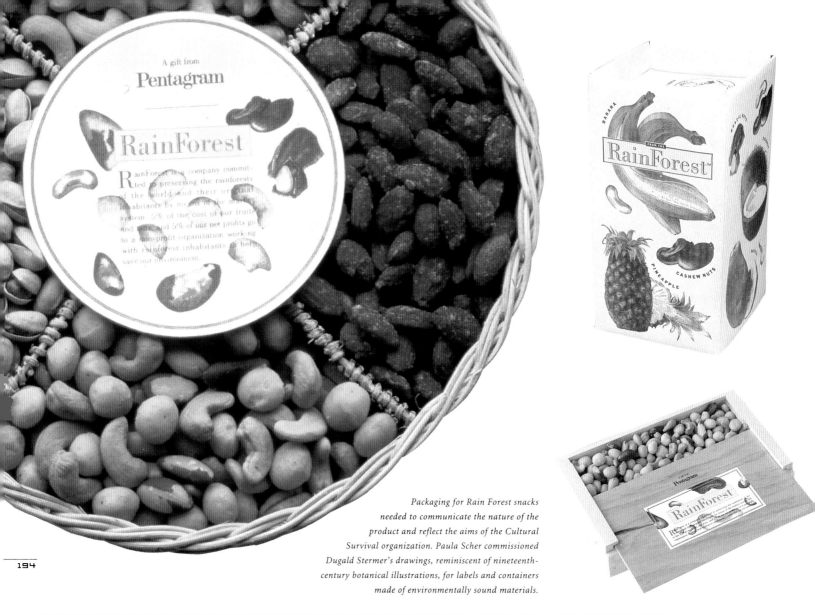

Packaging for Rain Forest snacks
needed to communicate the nature of the
product and reflect the aims of the Cultural
Survival organization. Paula Scher commissioned
Dugald Stermer's drawings, reminiscent of nineteenth-
century botanical illustrations, for labels and containers
made of environmentally sound materials.

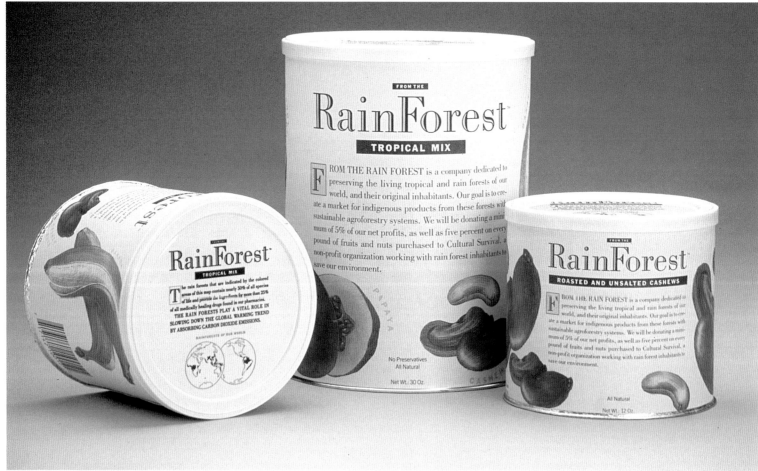

*PACKAGING TRANSMITS THE
SPECIAL SPIRIT OF A PRODUCT
TO THE CONSUMER. IT MAY BE
ELEGANT, IRREVERENT, COLD,
WHIMSICAL, RADICAL OR CON-
SERVATIVE. WHEN NO PERSON-
ALITY IS TRANSMITTED AT ALL,
IT IS THE SIGN OF A PRODUCT
THAT IS AFRAID OF ITS MARKET.*

— *Paula Scher, Pentagram*

*Ronnybrook Farm Dairy,
a small family-run business,
switched from selling in bulk
to packaging their milk in
bottles and selling it directly
to an upscale market.
Pentagram partner Neil
Shakery developed a design
scheme that extended to
ice cream, yogurt and
promotional materials.*

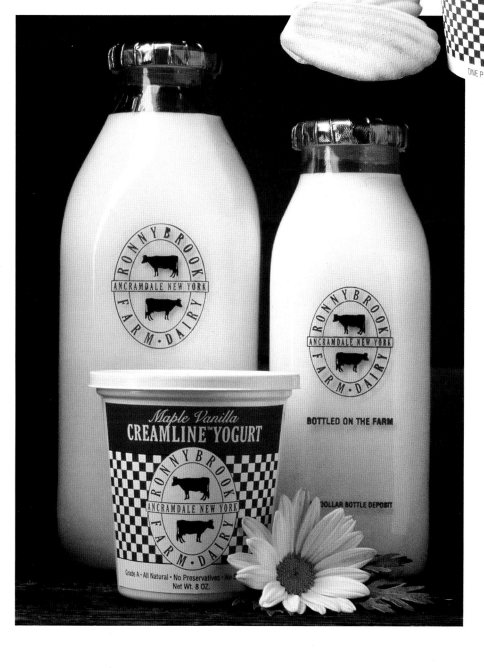

*The combination of tradi-
tional glass bottles and
Pentagram's logo—designed
to convey a wholesome,
home-grown image—
creates associations with
an earlier era.*

Along with client agency Foote, Cone & Belding, Primo Angeli worked to develop a name, brand identity, label graphics and bottle structure to capture the character of Zima, a uniquely flavored malt beverage and alternative to traditional alcohol.

Zima successfully projects the "personality" of a drink that's clean, new, pure and refreshing.

Primo Angeli Inc.
590 Folsom Street
San Francisco, California 94105
415 974 6100

Reprinted from Marketing By Design.
Printed in Hong Kong.

Computer technology has created a sort of heaven for Primo Angeli, who develops—in a fraction of the time it used to take—packaging prototypes that look like they were taken right off the supermarket shelf.

Certain kinds of products are flexible in the way they can be packaged. Indeed, these products may rely entirely on packaging to get consumer attention, respect and, ultimately, dollars. A revolutionary process, called Rapid Access™, features the development of the packaging before the product is determined. Says Angeli, "We design packages that match our fantasies. Forget the consumer focus groups, at least for the moment. They can get too focused, too narrow in their thinking, too soon. Give me a fantastic package design and, assuming we've done our homework, we can help come up with a whole bunch of fantastic products to fill it."

Primo Angeli's objective
was to develop a high-end
packaging design that would
establish Harden & Huyse
as a major international
brand of luxury chocolates.
While the packaging has a
distinctive, sophisticated
look, the modular containers
can be "nested" into a perfect
cube for effective retail
display and shipping safety.

MANUFACTURERS SPEND TOO MUCH
TIME IN DEVELOPMENT ONLY TO SEE 80-90%
OF ALL PRODUCTS FAIL. ONE FACTOR, ANGELI
BELIEVES, IS THAT CONSUMER RESEARCH
SMOTHERS INTUITION. AFTER THE DESIGN
TEAM NARROWS DOWN THE TYPES
OF PRODUCTS THAT ARE PRACTICAL, THEY
CONVENE AN EXTENDED IDEATION SESSION
ATTENDED BY THE ENTIRE DESIGN/MAN-
AGEMENT TEAM AND MODERATED
BY AN EXPERT FACILITATOR. THEN
THEY TAKE EVERYTHING BACK TO THE
PROVERBIAL DRAWING BOARD (THESE DAYS,
AN APPLE QUADRA 650) TO REFINE THE PRO-
TOTYPES. THREE OR FOUR OF THE BEST PACK-
AGE DESIGNS ARE CHOSEN FOR CONSUMER
RANKING. THE CONCEPT WITH THE HIGHEST

ACCEPTANCE RATING GOES TO PRODUCT
DEVELOPMENT. THE CLIENT RECEIVES A
REALISTIC AND HIGHLY-FINISHED, THREE-
DIMENSIONAL, FULL-COLOR CATALOGUE OF
PRODUCT SPECIFICATIONS—FAR MORE
COMPREHENSIVE THAN A TYPEWRITTEN
PRODUCT SPECIFICATION.

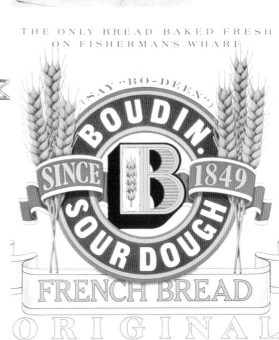

*Angeli's design for Boudin
sourdough French bread
capitalizes on the product's
long local history.*

*Established in 1849,
Boudin is the oldest
French bread bakery
in San Francisco.*

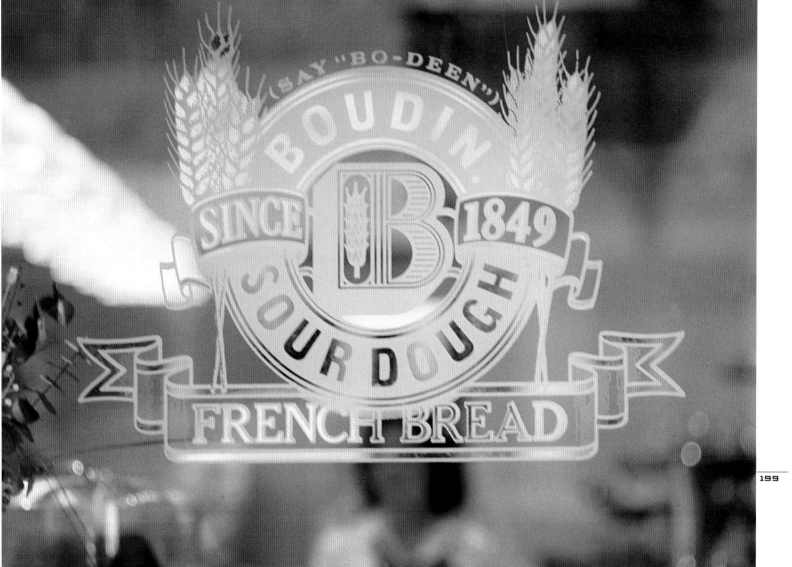

The bread wrappers feature a short history of sourdough French bread and a recipe drawn from a selection of San Francisco's noted French restaurants. Not altogether French, the label emphasizes the local by instructing the reader to "Say 'Bo-Deen.'"

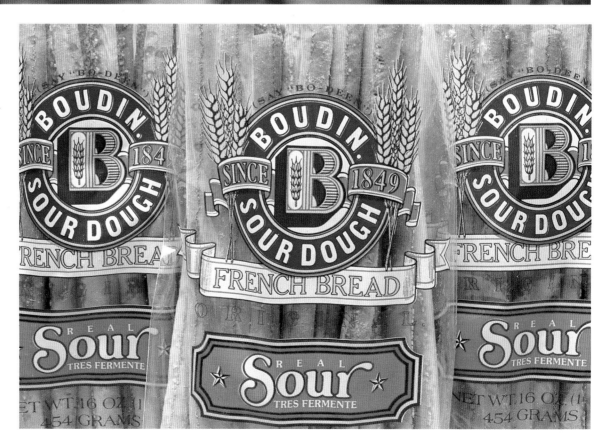

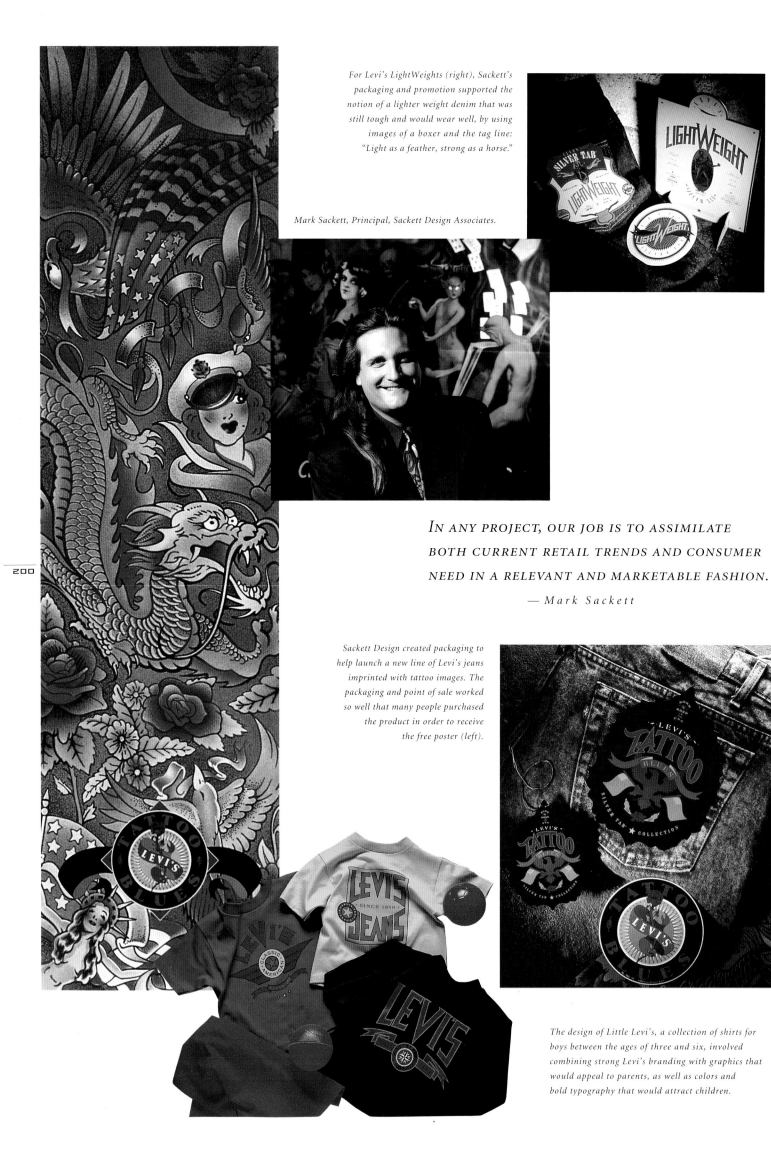

For Levi's LightWeights (right), Sackett's packaging and promotion supported the notion of a lighter weight denim that was still tough and would wear well, by using images of a boxer and the tag line: "Light as a feather, strong as a horse."

Mark Sackett, Principal, Sackett Design Associates.

IN ANY PROJECT, OUR JOB IS TO ASSIMILATE BOTH CURRENT RETAIL TRENDS AND CONSUMER NEED IN A RELEVANT AND MARKETABLE FASHION.
— Mark Sackett

Sackett Design created packaging to help launch a new line of Levi's jeans imprinted with tattoo images. The packaging and point of sale worked so well that many people purchased the product in order to receive the free poster (left).

The design of Little Levi's, a collection of shirts for boys between the ages of three and six, involved combining strong Levi's branding with graphics that would appeal to parents, as well as colors and bold typography that would attract children.

SACKETT DESIGN ASSOCIATES
2103 SCOTT STREET
SAN FRANCISCO, CALIFORNIA 94115
415 929 4800

Reprinted from MARKETING BY DESIGN.
Printed in Hong Kong.

ᴀʀᴋ Sᴀᴄᴋᴇᴛᴛ's ʟᴏᴠᴇ ᴏꜰ ᴅᴇꜱɪɢɴ ᴍᴀʏ ʙᴇ ꜱᴇᴇɴ ɪɴ ʜɪꜱ ᴇʟᴀʙᴏʀᴀᴛᴇ ᴄᴏʟʟᴇᴄᴛɪᴏɴ ᴏꜰ ᴀɴᴛɪQᴜᴇ ᴛᴏʏꜱ, ʙᴏᴀʀᴅ ɢᴀᴍᴇꜱ ᴀɴᴅ ᴘᴀᴄᴋᴀɢɪɴɢ. Hᴏᴜꜱᴇᴅ ɪɴ ᴛᴡᴏ ʙᴜɪʟᴅɪɴɢꜱ ɪɴ ᴛʜᴇ Pᴀᴄɪꜰɪᴄ Hᴇɪɢʜᴛꜱ ɴᴇɪɢʜʙᴏʀʜᴏᴏᴅ ᴏꜰ Sᴀɴ Fʀᴀɴᴄɪꜱᴄᴏ, Sᴀᴄᴋᴇᴛᴛ's ᴄᴏʟʟᴇᴄᴛɪᴏɴꜱ ᴀʀᴇ ᴀ ᴛʀɪʙᴜᴛᴇ ᴛᴏ ᴛʜᴇ ᴇɴᴅᴜʀᴀɴᴄᴇ ᴏꜰ ɢᴏᴏᴅ ᴅᴇꜱɪɢɴ ᴡʜɪᴄʜ ɪɴꜱᴘɪʀᴇꜱ ʜᴇ ᴀɴᴅ ʜɪꜱ ꜱᴛᴀꜰꜰ ᴛᴏ ᴄʀᴇᴀᴛᴇ ᴛʜᴇɪʀ ᴏᴡɴ ᴍᴇᴍᴏʀᴀʙʟᴇ ꜱᴏʟᴜᴛɪᴏɴꜱ.

Tʜᴇ ᴜɴꜰᴏʀɢᴇᴛᴛᴀʙʟᴇ ɪᴍᴘʀᴇꜱꜱɪᴏɴ ᴛʜᴀᴛ ᴡᴇʟʟ ᴛʜᴏᴜɢʜᴛ-ᴏᴜᴛ ᴅᴇꜱɪɢɴ ᴍᴀᴋᴇꜱ ɪꜱ ᴊᴜꜱᴛ ᴏɴᴇ ᴀꜱᴘᴇᴄᴛ ᴏꜰ Sᴀᴄᴋᴇᴛᴛ's ᴄᴏɴᴄᴇʀɴꜱ. "Wᴇ ꜱᴇᴇᴋ ᴏᴜᴛ ᴀꜱꜱɪɢɴᴍᴇɴᴛꜱ ɪɴ ᴡʜɪᴄʜ ᴡᴇ ᴄᴏʟʟᴀʙᴏʀᴀᴛᴇ ᴡɪᴛʜ ᴄʟɪᴇɴᴛꜱ ɪɴ ᴛʜᴇ ᴄʀᴇᴀᴛɪᴏɴ ᴏꜰ ᴅʏɴᴀᴍɪᴄ ꜱᴏʟᴜᴛɪᴏɴꜱ ᴛᴏ ɪɴᴄʀᴇᴀꜱᴇ ꜱᴀʟᴇꜱ, ᴍᴀʀᴋᴇᴛ ꜱʜᴀʀᴇ ᴀɴᴅ ᴠɪꜱɪʙɪʟɪᴛʏ." Sᴀᴄᴋᴇᴛᴛ Dᴇꜱɪɢɴ ʀᴇꜱᴇᴀʀᴄʜᴇꜱ ᴛʜᴇ ᴄᴏᴍᴘᴇᴛɪ-ᴛɪᴏɴ ᴀɴᴅ ᴄʟᴇᴀʀʟʏ ᴜɴᴅᴇʀꜱᴛᴀɴᴅꜱ ʜɪꜱ ᴄʟɪᴇɴᴛ's ᴏʙᴊᴇᴄᴛɪᴠᴇꜱ, ᴀɴᴅ ɪɴ ᴛᴜʀɴ ᴘʀᴏᴠɪᴅᴇꜱ ᴅᴇꜱɪɢɴ ꜱᴏʟᴜᴛɪᴏɴꜱ ᴛʜᴀᴛ ᴍᴀᴛᴄʜ ᴛʜᴏꜱᴇ ᴏʙᴊᴇᴄᴛɪᴠᴇꜱ.

For the DFS Group in San Francisco, Sackett Design created "Texas" Destinations, a line of clothing that would appeal to tourists within the Texas market. Sackett knew that classic western and Texas imagery would attract customers from outside the United States, and therefore designed the shirt graphics to have a rough, aged and decidedly "Texas" look. The entire line captures the authentic, dusty, cowboy feel that tourists wanted in a Texas memento.

Sackett Design created a logo and symbols for "Taiwan" Destinations, a product line for DFS Group's duty free stores in Taiwan. Both logo and symbol were used on a wide variety of products, allowing for a unified look.

The Taiwan "chop" typography, created by Sackett Design, allowed products that could not be completely redesigned to be easily assimilated into the overall look.

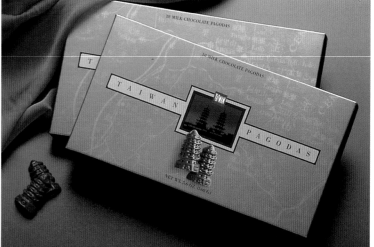

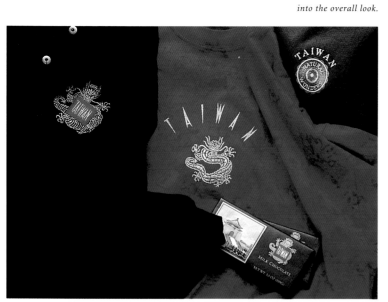

The packaging and product design use images taken from culturally significant icons and destinations within the region.

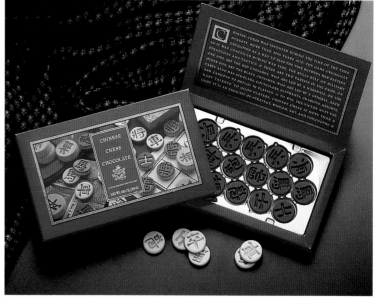

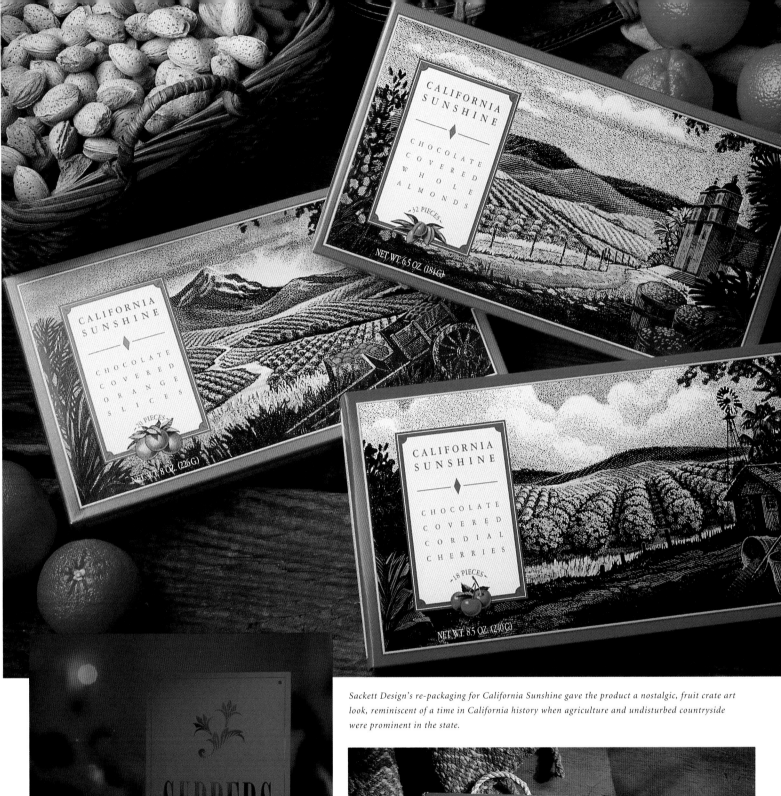

CALIFORNIA
SUNSHINE

CHOCOLATE
COVERED
WHOLE
ALMONDS

· 32 PIECES ·

NET. WT. 6.5 OZ. (184 G)

CALIFORNIA
SUNSHINE

CHOCOLATE
COVERED
ORANGE
SLICES

· 20 PIECES ·

NET. WT. 8 OZ. (226 G)

CALIFORNIA
SUNSHINE

CHOCOLATE
COVERED
CORDIAL
CHERRIES

· 18 PIECES ·

NET. WT. 8.5 OZ. (240 G)

Sackett Design's re-packaging for California Sunshine gave the product a nostalgic, fruit crate art look, reminiscent of a time in California history when agriculture and undisturbed countryside were prominent in the state.

SUPPERS

Sackett Design's identity for Suppers Restaurant suggests the restaurant's comfortable ambiance, "homecooked" feeling and warm dining experience.

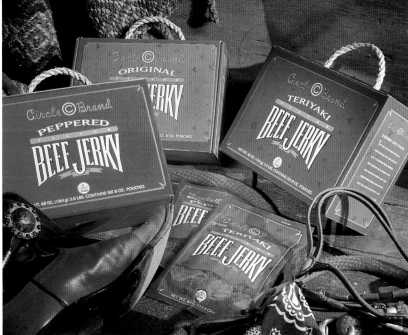

Sackett's redesign of the Circle C Brand Beef Jerky included traditional Old West icons and handlettering to create an authentic western look for the Japanese market.

The Santa Monica series includes fabric designs built up of small photographs of natural patterns occurring at the beach.

Sam Smidt (right) took the photographs he used for the Santa Monica fabrics and wall coverings.

The textured pattern of the wall coverings is from greatly-enlarged photographs of sand.

A Californian through and through, Smidt created a collection of fabric designs that used photographs of the beach at Santa Monica as the graphic. The result is a classic textile design using photography, a totally unconventional approach to illustration.

Will there be a New York or Paris collection? Probably only if Smidt has the passion to pursue it, for everything from Sam Smidt comes from the heart.

Sam Smidt, Inc.
666 High Street
Palo Alto, California 94301
415 327 0707

Reprinted from Marketing By Design.
Printed in Hong Kong.

*Sam Smidt has created
product and packaging for
Natural Wonders with the
same sense of fun and
humanity that he instills
in his class assignments.*

S AM SMIDT IS A DESIGNER'S DESIGNER. THE GOAL OF HIS LIFE, OF THE PROJECT, OF THE CLIENT, ARE ALWAYS SIMULTANEOUSLY FOREMOST IN SMIDT'S THINKING. DAUGHTER BECCA AND WIFE MARLENE ARE MAJOR CONTRIBUTORS TO THE COMPANY. SMIDT KEEPS HIS OVERHEAD MINIMAL SO HE CAN PICK AND CHOOSE THE PROJECTS THAT ARE MOST APPROPRI- ATE FOR THE STUDIO. THIS HARMONIOUS APPROACH TO PROBLEM-SOLVING LED THE CITY OF PALO ALTO TO SELECT CITIZEN SMIDT TO DESIGN ITS NEW IDENTITY. PALO ALTO IS A SOPHISTICATED, SMALL, DESIGN-CONSCIOUS CITY NEAR STANFORD, CALIFORNIA. A TENURED PROFESSOR OF DESIGN AT SAN JOSE STATE UNIVERSITY, SMIDT INJECTS HIS ENTHUSIASM AND CURIOSITY INTO HIS CLASSES. A FINAL EXAM, ONE YEAR, REQUIRED EACH STUDENT TO THROW A PARTY. SMIDT SAYS, "THINGS HAVE GOTTEN TOO SERIOUS SINCE THE SIXTIES."

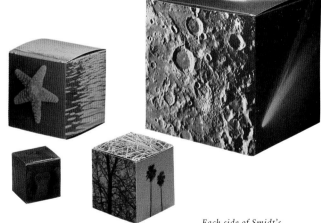

*A national chain that
sells products related to
the outdoors, the look that
Sam Smidt has developed
for Natural Wonders is
not static; Sam Smidt
looks at each new project
with a fresh eye.*

*Each side of Smidt's
Natural Wonders gift
boxes show different
natural objects or textures.
As a group, the boxes
descend through the
natural order: the largest
is the Universe, followed
by the Earth, the Sea,
Vegetation and Animals.*

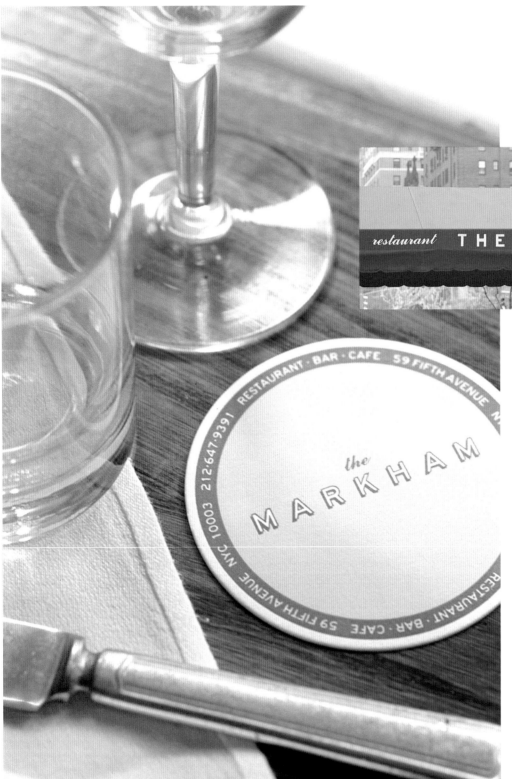

Stretching out onto Manhattan's chic lower Fifth Avenue, The Markham's awning was an opportunity to broadcast a simple, elegant image to passers-by. Niski wanted the signage to be a welcome neighbor to the surrounding residents.

The Markham ID was created by Paul Niski and designer Mona Kim. This included menus, matches, coasters and signage.

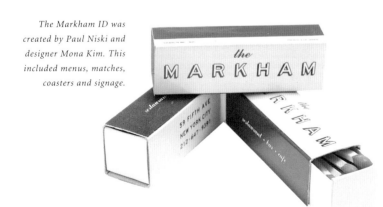

Paul Niski, principal, Studio N.

STUDIO N
225 LAFAYETTE STREET,
NEW YORK, NEW YORK 10012
212 219 9572

Reprinted from MARKETING BY DESIGN.
Printed in Hong Kong.

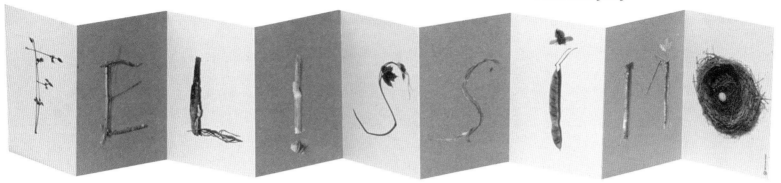

*The new, naturalistic logo is
applied to a store brochure.
After the new logo was created,
Niski proposed that Studio N
create an entire alphabet
and numeral set.*

HEN THE JAPANESE, FAMILY-OWNED SPECIALTY STORE
FELISSIMO WAS SEARCHING FOR ITS IDENTITY, THEY CHOSE
THE DESIGN STUDIO OF PAUL NISKI, STUDIO N.

NISKI FELT THAT HE UNDERSTOOD IMMEDIATELY WHAT THE
PRESIDENT OF FELISSIMO WAS LOOKING FOR. "IT WAS INTUITION,
REALLY, NOT AN EASY THING TO ESTABLISH WHEN SPEAKING THROUGH
A TRANSLATOR. THE JAPANESE SHARE THE SAME LOVE OF THE CRE-
ATIVE PROCESS THAT WE HAVE. THEY SAID THAT THEY CHOSE ME
BECAUSE I WAS AN ARTIST, WHICH MEANS A GREAT DEAL TO ME."

FELISSIMO'S GOAL WAS TO CREATE AN UPMARKET PRESENCE
IN THE UNITED STATES. NISKI EXPLAINS, "FELISSIMO IS A CATALOG
COMPANY IN JAPAN; SO OPENING A RETAIL STORE IN NEW YORK CITY
DEMANDED A NEW APPROACH. WE CONCEIVED A LOOK AND FEEL FOR
THE IDENTITY BY DISCUSSING THE CONCEPTS OF NATURE, HARMONY,
ART AND COMMERCE, AND THE STORE SIMPLY DEVELOPED OUT OF
THOSE DISCUSSIONS."

*Studio N used wild posting of the new Felissimo logo all over the
city—interjecting nature into an urban landscape—as a way
to stir up interest prior to opening. Here, it appears on top of a
storefront rolldown grill. Above, the design team created a store
directory signage system employing a series of universal icons.*

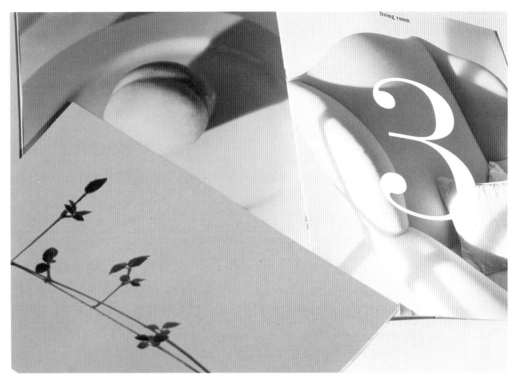

The Felissimo spirit is summed up on the opening spread of their mail-order catalogue, which was designed by Studio N.

STUDIO N ALSO DESIGNED THE IDENTITY FOR THE MARKHAM, A RESTAURANT ON MANHATTAN'S LOWER FIFTH AVENUE. THE OWNERS, CLARK WOLF AND ANSEL HAWKINS, SOUGHT A SIMPLE, ELEGANT, ALMOST CLASSICAL LOOK—PICKING EXACTLY THE RIGHT SHADE OF CREAM FOR THE WALLS, SELECTING EXACTLY THE RIGHT TABLE SETTINGS AND RECREATING THE ORIGINAL DETAILS OF THE BUILDING'S INTERIOR. THIS LED NISKI TO PURSUE AN UNDERSTATED LOGOTYPE, APPROPRIATELY HISTORICAL WITHOUT BEING RETRO. WOLF AND HAWKINS WANTED TO ATTRACT AN AUDIENCE THAT WOULD UNDERSTAND THAT SOMETIMES, THE LESS YOU TAMPER WITH SOMETHING, THE BETTER IT IS.

The brochure was created to give a preview of the store prior to its opening, conveying the environment and mood of the store itself, without showing products. Studio N also collaborated with Felissimo to develop a home concept, choosing specific floors to represent a room: the bedroom, the foyer, the dining room, each symbolized by the use of carefully-developed photographic icons.

The Studio N design team was headed by Paul Niski, creative director and designer; and designers Jennifer Waverek and Steven Toriello; along with contributions by Judy Lee and Jose Gomez. Principal photography was done by Don Freeman, with additional photography provided by Callahan and Kevin Reardon.

The art of wrapping is particularly honored in Japanese culture. Studio N chose a birch twig––taken from trees already felled in the woods of upstate New York––as a natural closure. The die-cut holes are repeated for both the bags and the boxes, creating a unique signature for wrapping. The tissue bore the new Felissimo identity while incorporating the existing logotype (designed by Pentagram). Studio N worked in collaboration with the architects to produce a wrap desk with exposed elements, which are not only functional, but also produce a beautiful still life.

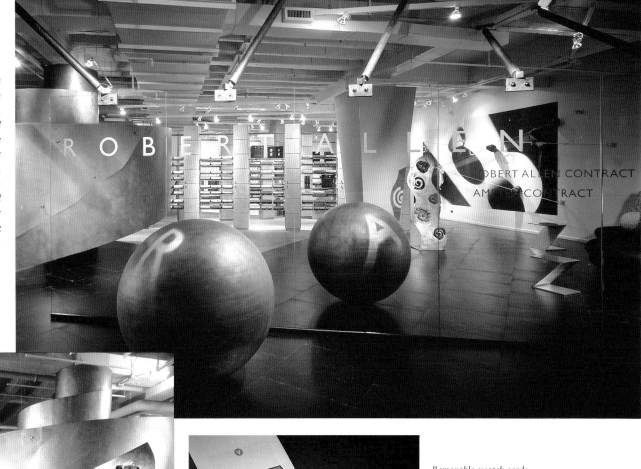

Susan Slover Design has moved fluidly through dimensions one and two, all the way to 3-D retail environments. For the Robert Allen Contract Showroom in Chicago, they created an innovative environment to aid architects and interior designers specifying contract textiles.

Removable swatch cards housed in Tyvek pockets save Robert Allen approximately $250,000 each year in book replacement costs. Slover Design created textile boxes, books and chainsets.

"We conversationalize copy to talk with the consumer; and we always press for proprietary substrates and production techniques that increase visual impact. Admittedly, our processes are intentionally seductive."
— Susan Slover

Left to right: Melinda Slover and Susan Slover, Susan Slover Design.

Susan Slover Design
584 Broadway, Suite 903
New York, New York 10012
212 431 0093

Reprinted from Marketing By Design.
Printed in Hong Kong.

Asymmetrical bags for Takishimaya (left). "We excel at packaging systems that don't feel systematic. Our packaging architecture appeals to the senses, drawing the hand to hold the product. We merge functionality with curiosity."

Bottle designs for Perrier flavored waters (right). Susan Slover Design created three distinctly different labels for testing in focus groups.

Partners Susan Slover and Melinda Slover speak fluent retailese. After all, "We grew up in Southern five and dimes where products—stacked top to bottom and end to end—beckoned us from one aisle to the other. We're consummate and astute consumers. So when retail clients buy our design intelligence, they also get a unique consumer's perspective in the process."

They define their design intelligence in humanistic terms: "We take the idea of the product into our hands, turn it around, upside down and inside out. But what's most critical, we explore the market where our clients and their products compete." Then they separate and sort—to help clients "see" the product and consumer in a different light. "That's when we break through to authentic graphic differentiation."

Sales jumped dramatically six months after Susan Slover Design's up-dated and up-scaled packaging for Isotoner Gloves was introduced.

211

Fragranced Bath Soap
with cold cream

total net
(8

Fragranced Bath Soap
with cold cream

six cakes

total net wt. 31.5 oz.

(891 grams)

made exclusively

for Saks Fifth Avenue

New York, NY 10022

Rose

Honeysuckle

nced Bath
with cold cream

six cakes
total net wt. 31.5 oz.
(891 grams)

made
for S
New

Baby's

Fragranced Bath Soap
with cold cream

six cakes
total net wt. 31.5 oz.
(891 grams)

made exclusively

for Saks Fifth Avenue

New York, NY 10022

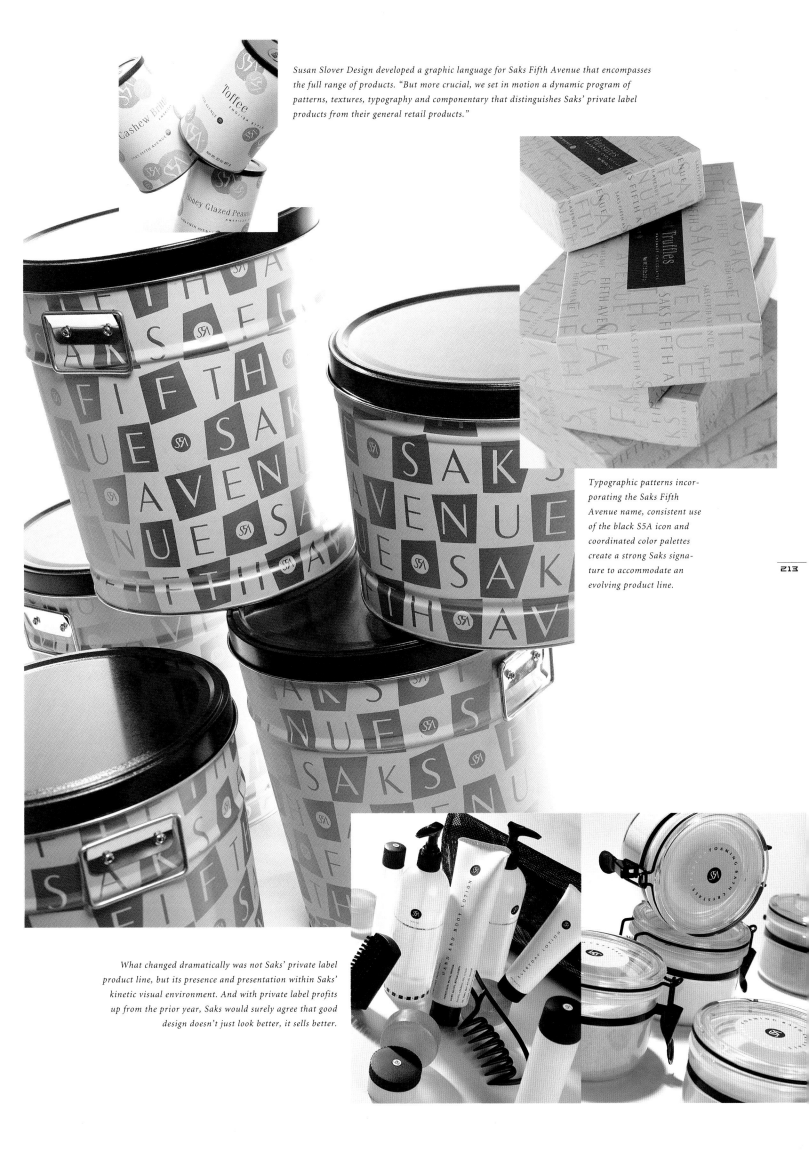

Susan Slover Design developed a graphic language for Saks Fifth Avenue that encompasses the full range of products. "But more crucial, we set in motion a dynamic program of patterns, textures, typography and componentary that distinguishes Saks' private label products from their general retail products."

Typographic patterns incorporating the Saks Fifth Avenue name, consistent use of the black S5A icon and coordinated color palettes create a strong Saks signature to accommodate an evolving product line.

213

What changed dramatically was not Saks' private label product line, but its presence and presentation within Saks' kinetic visual environment. And with private label profits up from the prior year, Saks would surely agree that good design doesn't just look better, it sells better.

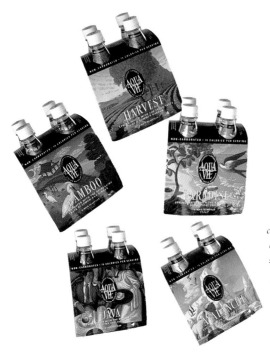

For the last 20 years,
TGD has been a key consultant
to many national and international
consumer product companies for
comprehensive brand management
strategies, new products, packaging
programs, name creations, and
brand-product evolutions.

Tim Girvin, and his mighty sword.

Specializing in consumer product-brand strategy and design, to date, TGD has launched over 2,500 software products and 5,000 food and beverage products.

TIM GIRVIN DESIGN

Tim Girvin Design, Inc.
1601 Second Avenue
Seattle, Washington 98101
206 623 7808

Reprinted from Marketing By Design.
Printed in Hong Kong.

TIM GIRVIN'S FASCINATION WITH THE WRITTEN WORD LED HIM TO BECOME ONE OF THE WORLD'S GREATEST CALLIGRAPHERS. EXPANSIVE IN HIS THINKING, GIRVIN'S VISION GREW TO EMBRACE THE LARGER IDENTITY OBJECTIVES OF HIS CLIENTS WHILE INCORPORATING, IN MANY CASES, HIS EXQUISITE AND VERY PERSONAL TALENT FOR EXPLORING LETTERFORMS. GIRVIN SAYS, "I'VE ALWAYS BELIEVED THERE IS A MAGIC LINK BETWEEN SPEECH AS COMMUNICATION AND WRITING." IN FACT, CAREFULLY EXECUTED "WRITING" (I.E. TYPOGRAPHY, LETTERING, CALLIGRAPHY) IS A KIND OF ILLUSTRATION OF LANGUAGE.

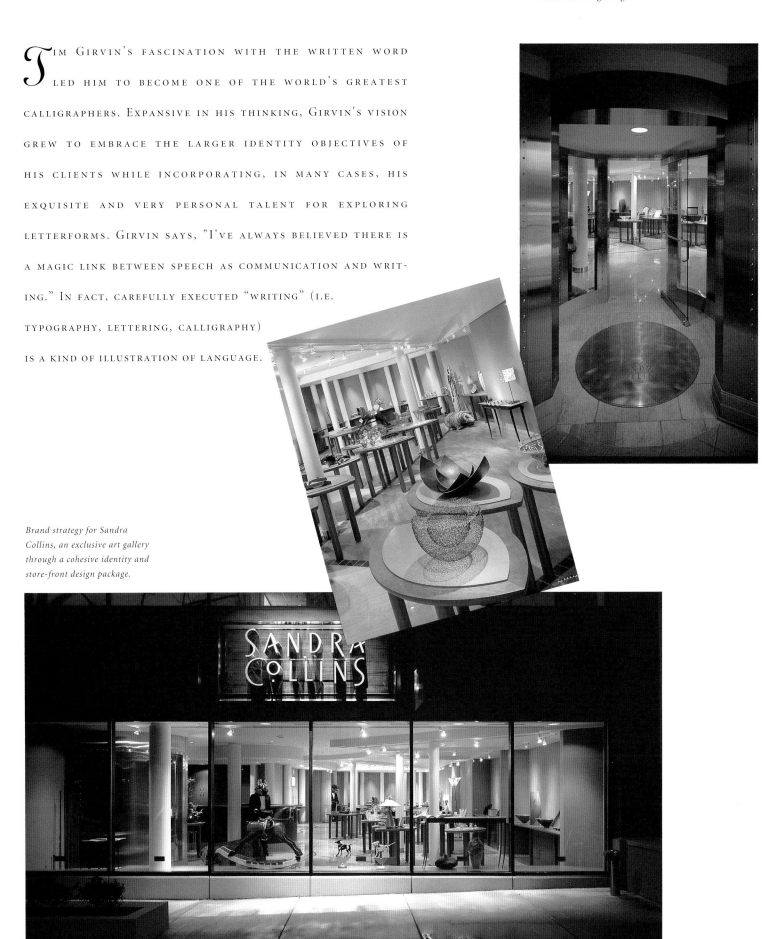

Brand strategy for Sandra Collins, an exclusive art gallery through a cohesive identity and store-front design package.

GIRVIN ENVISIONED AN OFFICE THAT BROUGHT TOGETHER MANY DIVERSE TALENTS IN ONE ARENA. IN FACT, HE HAS ACHIEVED THIS BY HIRING DESIGNERS WHO ARE ALSO TRAVELERS, CHEFS, MOUNTAIN CLIMBERS, MAGICIANS AND POETS. GIRVIN SAYS, "OUR WORK IS THUS ENRICHED BECAUSE WE BRING FORCEFUL VIEW-POINTS TO THE PROJECT; WE ARE EXPLORERS, DREAMERS."

THE OFFICE IS A REFLECTION OF THE MAGIC OF WHICH GIRVIN SPEAKS. THE SPACE IS INFUSED WITH FOUR ANCIENT CHINESE PRINCIPLES: YUGEN, A QUIET MYSTERIOUSNESS; WABI, A MELLOWING WITH AGE; SABI, RUSTIC SIMPLICITY, AND FINALLY; SHIBUI, ELEGANT SIM-PLICITY. THIS CAREFUL ATTENTION TO ENVIRONMENT IS ESSENTIAL TO GIRVIN: THE PEOPLE AND PLACE CREATE THE BALANCE NECESSARY FOR CREATIVITY.

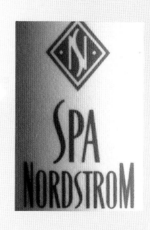

Names, identities and structural packaging for a complete line of personal body care products. It was developed by TGD as a component of the SPA NORSTROM brand strategy.

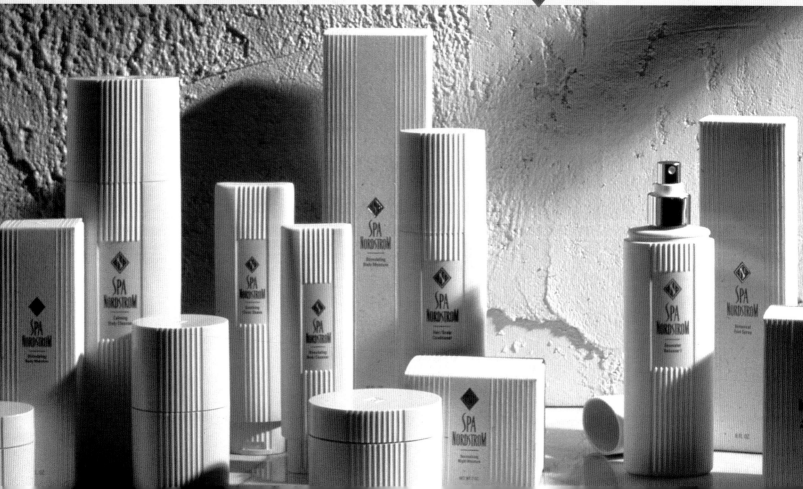

For exclusive clothier Logan Drive, TGD created the name, identity and store design. The brand was crafted to give a relaxed as well as socially interactive atmosphere in order to encourage a wider consumer/customer base from an extremely competitive market.

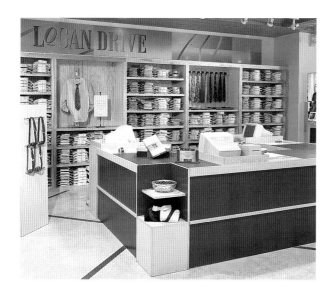

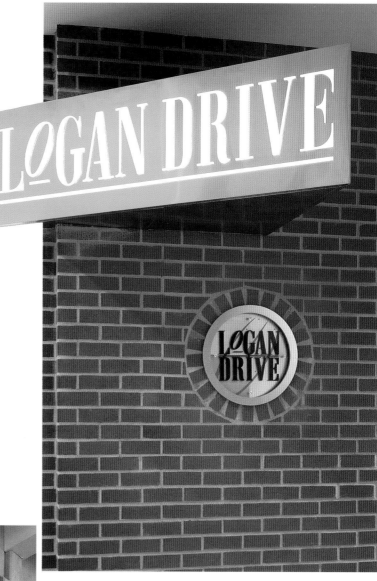

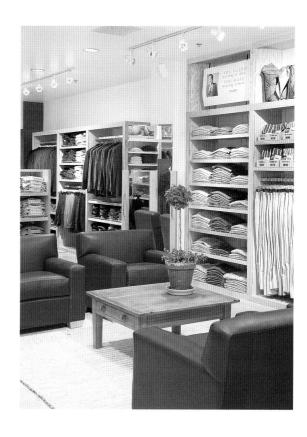

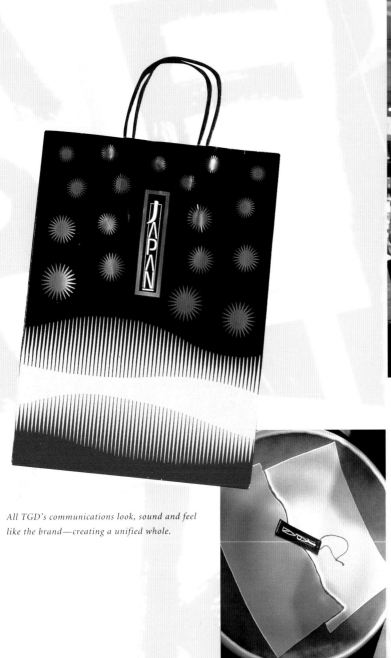

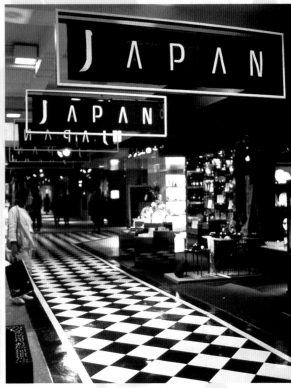

Whether the project is a corporate identity, a packaging system, a product design, an interactive screen interface, or a trade show exhibit, the design promotes the attributes, imagery and strengths of the core brand concepts.

All TGD's communications look, sound and feel like the brand—creating a unified whole.

OUR BUSINESS IS TO CREATE A CONSTANT AND CONSISTENT MESSAGE THAT BOTH MAXIMIZES BRAND EQUITY AND EMPOWERS THE CONSUMER AUDIENCE TO REACT AND RESPOND.

— Tim Girvin

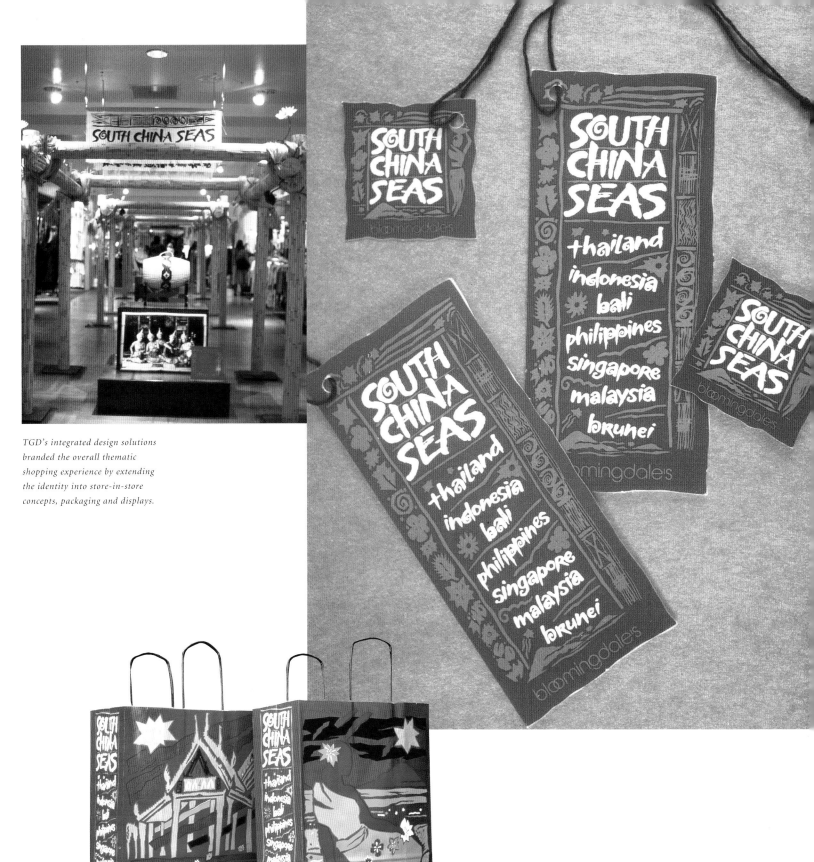

TGD's integrated design solutions branded the overall thematic shopping experience by extending the identity into store-in-store concepts, packaging and displays.

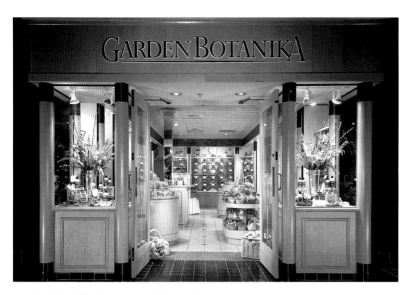

Complete brand development—including architectural intent and definition—was part of Garden Botanika's requirement challenge that was successfully achieved.

Ongoing retail merchandising strategies are a continual part of TGD's brand-building partnership with Garden Botanika.

When the founding executives of Garden Botanika presented their business plan to TGD, they required a total package. Within months the store was named, store-front realized, and packaging achieved—all on a short launch schedule. Sub-brands, such as Botanikids, were successfully developed to serve all demographic consumer segments.

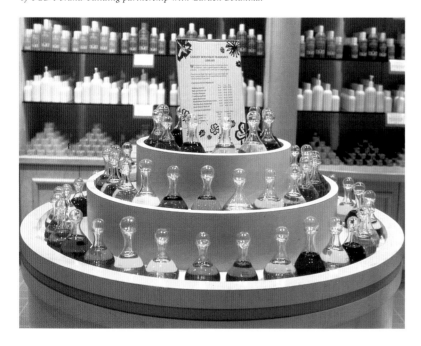

Cucina! Cucina! represented a sterling opportunity in brand development for TGD, as designers of record for Schwartz Brothers restaurateurs.

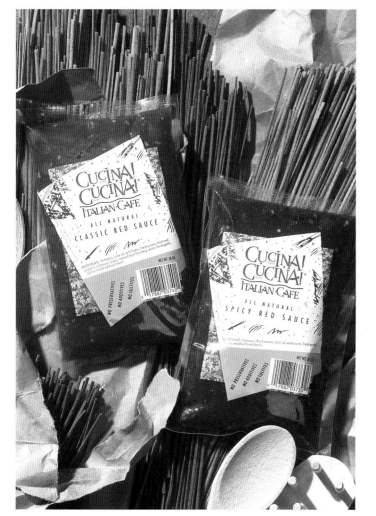

As team members in the expansion of the brand concept, colors and materials, and opening promotions, TGD has been instrumental in the expansion of this venue throughout the western United States.

Left to right, front row: Stan Church, Rob Wallace; second row:
Suzanne Welker, Wendy Church, Ophilia Lopez, Susan Wiley;
third row: Corine Skolnick, Cheryl Swanson, Terri Goldstein,
Paula Patricola, Phyllis Chan; fourth row: Tangerine Clark,
Christine Campbell, Joe Cuticone, Janet Willemain, Lesslie
Tucker; back row: Howard Jackson, Jeff Tyson, John Waski,
Craig Swanson, Brien Wood, Darren Capik.

LIKE GOOD MARKETING, GOOD DESIGN IS NOT A MATTER
OF OPINION OR TASTE, BUT A SKILL COMBINING STRATEGIC
GROUNDWORK WITH CREATIVITY. — *Stan Church*

A promotional piece
utilizing one of the tools of
the trade, the loupe is
necessary to read the
miniature holiday greeting
from Wallace Church.

The hand arrived in the black cylindrical
mailer, a peace message during Desert Storm.

Modern jazz renditions of classic holiday
tunes—packaged as jam. This holiday
greeting showcased Wallace Church's
design integrity while communicating the
firm's personality and humor. The jar's
label was designed by Stan Church and
illustrated by Marilyn Montgomery.

WALLACE CHURCH ASSOCIATES, INC.
330 EAST 48TH STREET
NEW YORK, NEW YORK 10017
212 755 2903

Reprinted from MARKETING BY DESIGN.
Printed in Hong Kong.

HOLIDAY GREETINGS FROM WALLACE CHURCH WERE EXTENDED THROUGH A REMARKABLE SERIES OF GIFT MAILERS: A LOUPE WITH THE FIRM'S NAME INSCRIBED AROUND ITS NECK; A JAM JAR WITH A TAPE OF JAZZ JAMS AND A PEACE GREETING INSIDE; AND A WOODEN HAND DISPLAYING THE PEACE SIGN, ALL SENT OUT DURING THE PERSIAN GULF WAR.

THE ATTENTION GIVEN TO THESE HOLIDAY TOKENS ILLUS-TRATES THE DEGREE TO WHICH WALLACE CHURCH EXTENDS ITSELF TO COMMUNICATE WITH THEIR CLIENTS AND TO UPHOLD THE HIGH STANDARDS UPON WHICH THE FIRM WAS FOUNDED.

STAN CHURCH, THE MOVING FORCE BEHIND THE FIRM, PUR-CHASED TWO BROWNSTONES IN MANHATTAN TO HOUSE THE FIRM'S FACILITIES AND PROVIDE A HARMONIOUS GALLERY ATMOSPHERE CON-DUCIVE TO THE ACT OF CREATION. "I HAD A VISION WHEN I ORIGINAL-LY STARTED WORKING AS AN ART DIRECTOR AT BBDO TO ULTIMATELY CREATE A DESIGN FIRM THAT FELT LIKE A CREATIVE FAMILY AND TO EMPLOY THE MOST INNOVATIVE TALENT AVAILABLE." CHURCH SAYS, "WE MUST REMAIN CONTEMPORARY AND INSTILL A FEELING OF CRE-ATIVE HARMONY IN OUR THINKING ABOUT DESIGN IN ORDER TO REMAIN RELEVANT AND, FOR OUR CLIENT'S SAKE, COMPETITIVE."

In developing brand identity for the Temptato Salsa Company, Wallace Church was faced with creating packaging distinctive enough to carry a product without an advertising budget.

223

*Wallace Church's new
Martex logo emphasizes
the brand's classic but
fashion-forward integrity.*

Signage was developed in the corporate identity program.

SINCE THE FIRM'S CLIENTS INCLUDE MANY LARGE MULTI-
NATIONAL CORPORATIONS, WALLACE CHURCH HAS DEVELOPED
LOCAL DESIGN AFFILIATIONS IN LONDON, TORONTO AND MADRID
WHICH ENABLE IT TO OFFER A GLOBAL PERSPECTIVE. WALLACE
CHURCH HAS ALSO DEVELOPED AN OBJECTIVE, STRATEGIC METHODOL-
OGY—THE VISUAL EXPLORATORY PROCESS™—TO CAPTURE AN AUDI-
ENCE'S VISUAL ASSUMPTIONS AND PREFERENCES AND DEVELOP A
UNIQUE DESIGN "VOCABULARY" THAT COMMUNICATES A PRODUCT'S
CORE MESSAGE TO ENSURE ACKNOWLEDGMENT IN TODAY'S COMPLEX,
SATURATED MARKETPLACE.

*Collateral pieces were developed unifying the
new image and continuing with the design
standard developed by Gene McCarthy.*

*The brand banner is complemented by a
tag containing each product line's logo
and unique selling benefit. The Martex
banner was designed to work with 7
product lines, each with as many as 25
products, in drastically different package
sizes and configurations. At the same time,
it works as an architectural element creat-
ing a store-within-a-store environment.*

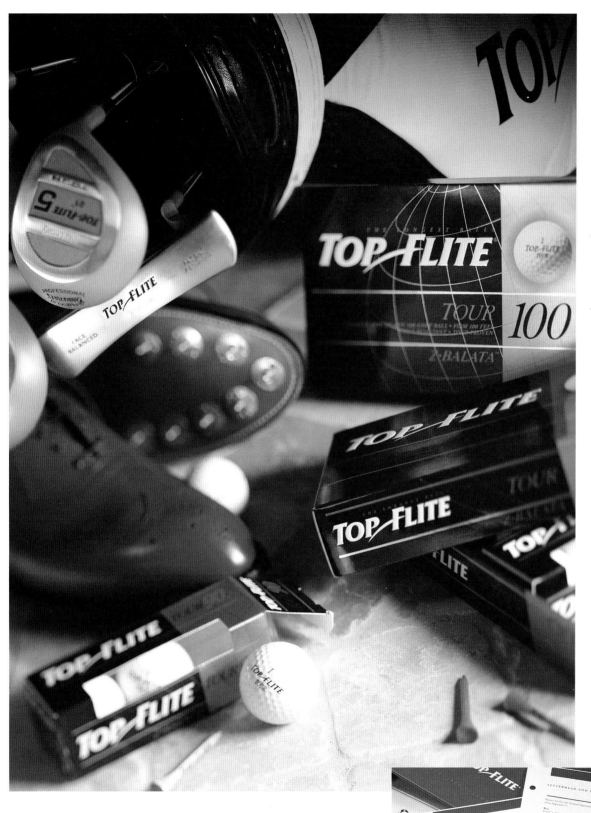

The branding system, by Wallace Church, for Spalding Top-Flite golf balls, has "worldly" appeal and evokes the importance of distance over height. The use of navy and black-and-white, accented with tones of silver, brass and gold, gives a familiar, masculine look to the packaging.

With its curved hyphen, the logo reinforces the arc of the golf ball's flight while emphasizing the tradition of sophistication sometimes associated with golf. A global standards manual was created to ensure the consistency of the brand's image, including application to golf clubs and accessories worldwide.

WILLOUGHBY DESIGN GROUP
602 WESTPORT ROAD
KANSAS CITY, MISSOURI 64111
816 561 4189

Reprinted from MARKETING BY DESIGN.
Printed in Hong Kong.

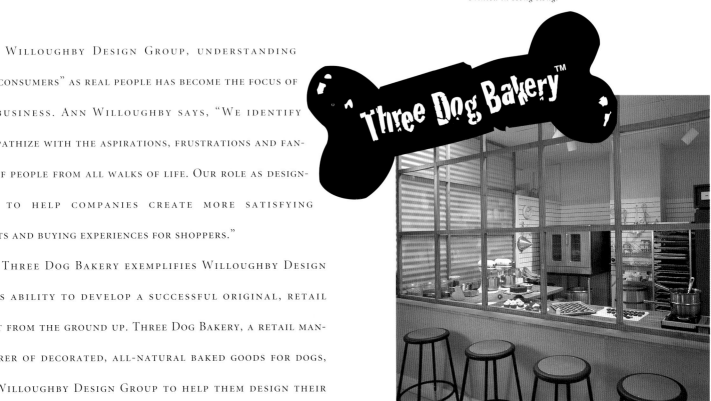

At WILLOUGHBY DESIGN GROUP, UNDERSTANDING "CONSUMERS" AS REAL PEOPLE HAS BECOME THE FOCUS OF THEIR BUSINESS. ANN WILLOUGHBY SAYS, "WE IDENTIFY AND EMPATHIZE WITH THE ASPIRATIONS, FRUSTRATIONS AND FANTASIES OF PEOPLE FROM ALL WALKS OF LIFE. OUR ROLE AS DESIGNERS IS TO HELP COMPANIES CREATE MORE SATISFYING PRODUCTS AND BUYING EXPERIENCES FOR SHOPPERS."

THREE DOG BAKERY EXEMPLIFIES WILLOUGHBY DESIGN GROUP'S ABILITY TO DEVELOP A SUCCESSFUL ORIGINAL, RETAIL CONCEPT FROM THE GROUND UP. THREE DOG BAKERY, A RETAIL MANUFACTURER OF DECORATED, ALL-NATURAL BAKED GOODS FOR DOGS, ASKED WILLOUGHBY DESIGN GROUP TO HELP THEM DESIGN THEIR IDENTITY AND PROTOTYPE STORE. UNDERSTANDING THAT THE PRODUCTS, MADE FOR DOGS, WERE MARKETED TO HUMANS, THE DESIGN TEAM WANTED TO CONVEY THE GENUINE LOVE FOR DOGS THAT INSPIRED THE OWNERS, MARK BECKLOFF AND DAN DYE, TO START THEIR BUSINESS. USING THE FOUNDERS' THREE DOGS AS INSPIRATION, THE TEAM DEVELOPED PROPRIETARY NAMES, PRODUCTS AND MERCHANDISING FEATURES THAT CONSUMERS FOUND IRRESISTIBLE.

Willoughby Design Group developed Three Dog Bakery's store design and merchandising, including the logo (above), to create an exciting, interactive environment for dog enthusiasts.

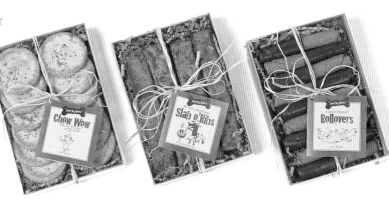

Gift packages were created using illustrations of the Three Dog Bakery founders' dogs: Dottie, Gracie and Sarah.

Dynamic window treatments and a boney doorknob were designed to create a sense of theater and to draw customers into the store.

The Three Dog Bakery graphic vocabulary includes illustrations that are used throughout communications as a proprietary trade dress feature.

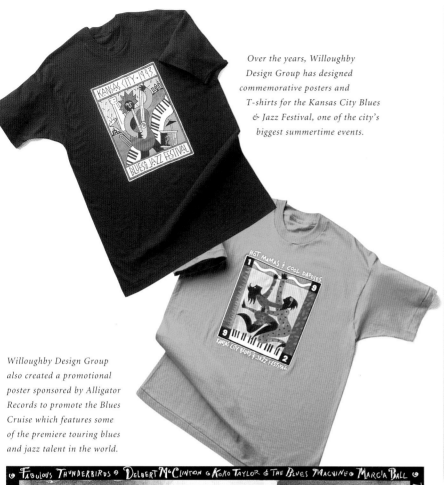

Over the years, Willoughby Design Group has designed commemorative posters and T-shirts for the Kansas City Blues & Jazz Festival, one of the city's biggest summertime events.

Willoughby Design Group also created a promotional poster sponsored by Alligator Records to promote the Blues Cruise which features some of the premiere touring blues and jazz talent in the world.

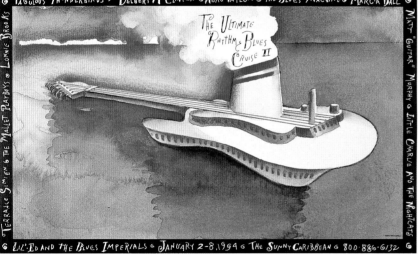

The Kansas City Blues & Jazz Festival celebrates the city's heritage as the home to jazz greats like Charlie Parker, Jay McShann and Count Basie.

THE FINE ART OF BLACK AND WHITE

Collaborations by Willoughby Design Group and photographer Dan White, on Borderline magazine (left) and White's promotional materials (above), share a passion for the historic jazz halls and blues bars around 18th and Vine, in Kansas City.

Catalogs for Robyn Nichols Jewelry and Tableware relate that Nichols' inspiration comes from nature and reflects her philosophy that jewelry should always follow the movement and forms of the body.

Each component of the catalog and packaging design is executed in subtle yet rich silver and black duotones to complement the delicate patinas in the jewelry and tableware.

Willoughby Design Group's packaging reflects Nichols' feeling that each piece should be functional yet exquisitely beautiful. Natural cherry twigs were used as gift box closures and to bind the catalogs.

MERCHANDISING DESIGN IS ABOUT CREATING THEATER AND MAGIC. FROM POSTERS AND PACKAGES TO STORE ENVIRONMENTS, GOOD MERCHANDISING DESIGN IMBUES AN AURA, SATISFIES THE SENSES, AND PROVIDES A DISTINCTIVE BRAND PRESENCE.

— *Ann Willoughby*

Sales collateral and displays for Lee Riders incorporated an industrial approach to communicate that Riders understood the heavy-duty product this consumer segment wanted.

This catalog was among the sales collateral Willoughby Design Group created to help position Riders as the premium brand in the mass market.

Clubs Suit (right), a deck of cards illustrating the features of Adobe Illustrator, produced as a trade show give away.

While most businesses are sending out Xmas cards or calendars, self-promotion for Woods + Woods (below) provides a humorous relief from the predictable.

Paul Woods and Alison Woods, principals, Woods + Woods.

Woods + Woods designed the champagne label for Adobe's celebration of its first ten-million dollar month.

WOODS & WOODS

Woods+Woods Design
414 Jackson Street
San Francisco, California 94111
415 399 1984

Reprinted from Marketing By Design.
Printed in Hong Kong.

A s you enter the offices of Woods+Woods, a sense of childlike fun—in particular, fun with computers—is prevalent. Just as computers were starting to inch into the world of graphic design in the mid eighties, Woods+Woods embraced a vision of what computers could do. Adobe recognized their confident yet easy-going style and capitalized on it by asking them to experiment with their new program Adobe Illustrator, now an essential program in most design offices.

Woods+Woods also designed the packages for the first video games and home computer products, establishing them as pioneers in packaging for the consumer-tech market.

As illustrators and designers they have developed a distinctive and sophisticated style which makes packaging pop off the shelves into your shopping cart—which is, after all, every manufacturer's goal.

GOURMET GARDENS

This CD ROM comedy software (above) was redesigned by Woods+Woods to have more shelf impact and look "funny."

Gourmet Gardens (right), a family-run farm selling to restaurants and specialty markets, wanted a fresh but high-quality image for both produce and homemade gourmet food items.

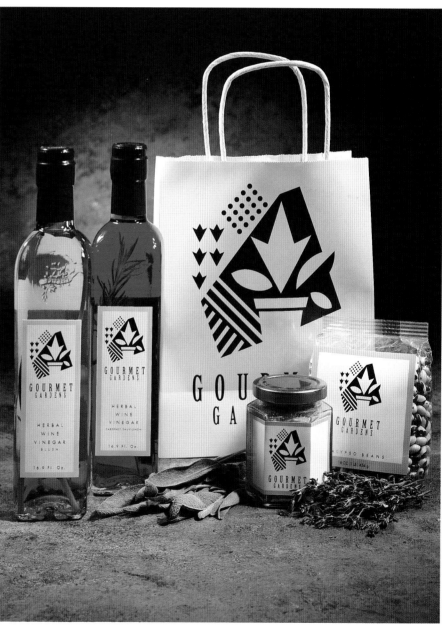

FAIRYTALE UPDATE

BY PAUL WOODS

> *Good design speaks with a strong but silent voice. Good design has to stand on its own.*
>
> — *Paul Woods*

LAB RAT

Computer illustrations by Paul Woods for Club KidSoft, a combination software magazine and catalog of educational software, for kids.

Woods+Woods did research into activity books and magazines for kids, and found that many of them had good content, but that the look was very tired and dated.

KidSoft

MULTIMEDIA COLOR FAIR

The objective was to create an eye-catching magazine that would appeal to kids and parents. For Club KidSoft they used primary colors and simple illustration to grab attention.

The Club KidSoft magazine also comes with a CD ROM that includes demos of top kids' software titles.

By manipulating color, type, illustration and package shape,
Woods+Woods creates distinct and targeted packaging.

Zurk's Learning Safari, early-learning software for a start-up
company, was designed to resemble a puzzle piece, making it
appealing to children as well as highly recognizable.

The Paint Program
Just for Kids!

By Craig Hickman Broderbund

The unique color
and the simple but playful graphics
have helped to make KidPix, a children's
paint program, a run away hit.

Woods+Woods used traditional
typefaces and photography to cre-
ate a nostalgic-looking package
for this geneology product.

The hexagonal packaging system for Knowledge Adventure
software (right) has the advantage of creating a
prominent edge if the packages are shelved spine out.

Sensei Software (left) needed packaging to make potentially dry subjects appealing to teens. Sensei means master or teacher, so Woods+Woods featured images of people who had mastered the subjects, adding a human element. The use of color makes the subjects less intimidating.

Dinosaur Cards (right), promotional pieces for Adobe showing the capabilities of Adobe Illustrator and Adobe typefaces.

For Compton's MultiMedia (right), Woods+Woods designed packaging for the first multimedia encyclopedia on the market. Designed to work as a retail package when shrink-wrapped shut— with all the essential information on the back cover— once opened, the package reveals all of the features of the encyclopedia and can be used as a sales kit and point of purchase display.

Package design for Quicken, a personal finance program, uses a large dollar sign to communicate its nature from a distance and illustrations within the dollar to show features and benefits of the program.

ZCD created accessories for each trend to bring the
look to life–such as these Hometown Blues products.

Zimmermann Crowe Design principals,
Dennis Crowe and Neal Zimmermann.

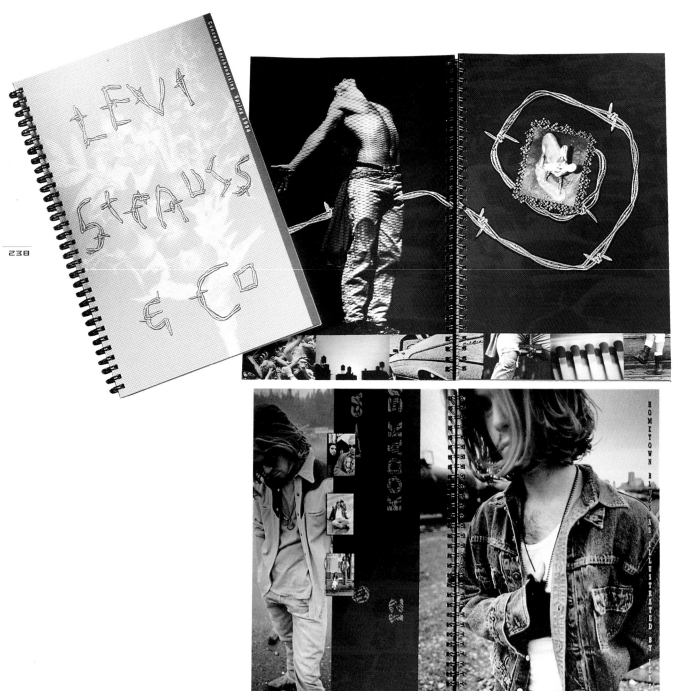

The information from
the sell-in easel has been
repackaged into retail guides
for retail associates. It is a
good example of cost-effective
design that shares all press
materials, but is trimmed
and bound differently. By
handling the materials for
the trade and the consumer,
ZCD provides a streamlined
and cohesive presentation
for their client.

ZIMMERMANN CROWE DESIGN
90 TEHAMA STREET
SAN FRANCISCO, CALIFORNIA 94105
415 777 5560

Reprinted from MARKETING BY DESIGN
Printed in Hong Kong.

THOUGH TRADITIONAL GRAPHIC DESIGN STILL WHETS THEIR WHISTLES, NEAL ZIMMERMANN AND DENNIS CROWE CONSIDER VARIETY TO BE THE SPICE OF AN EXCITING DESIGN BUSINESS. "WE ENJOY EXPLORING A VARIETY OF MEDIA AS VEHICLES FOR OUR CLIENT'S MESSAGE," SAYS ZIMMERMANN. SINCE OPENING THEIR DOORS IN 1988, THE COMPANY HAS EXCELLED IN PRODUCT DESIGN, RETAIL MERCHANDISING, TELEVISION AND VIDEO DESIGN AND PRODUCTION, AS WELL AS TRADITIONAL GRAPHIC DESIGN. THESE CAPABILITIES, PAIRED WITH A KEEN UNDERSTANDING OF MARKETING, PROVIDE THEIR CLIENTS WITH COHESIVE, IMPACTFUL, MARKET-

This logo calls attention to the upper case letter not found on current Levi's red tabs.

THE DENIM

We've dusted off our original narrow 28" loom for the sole purpose of making our vintage blue jean. Notice the jean's rich texture and the slightly irregular weave. This "slubbed" 12 ½ oz. denim has great character and fades to a soft blue patina, the way it used to.

[Narrow 28" Denim Loom]

THE FACTORY

Levi Strauss & Co.'s oldest operating facility, located in San Francisco and built just after the earthquake of 1906, is the exclusive site of manufacture for our vintage denim jean. We think it's fitting that this historical blue jean is made in a turn-of-the-century setting.

Levi Strauss & Co.
250 Valencia Street, S.F., Calif.

THE SEWING

We invite you to inspect our blue jeans very closely. Notice that the seams are all sewn by hand with the original specification thread and are guaranteed for strength. The details of our jeans are unmistakable and quite personal, making them the finest available.

[Hand Sewing at Valencia Street Plant]

ZCD designed a hand-bound leather book, (far right), to educate the retail sales associates on how to explain the details and features of Capital E Jeans to the consumer. This book supports the high-end positioning of the product, which sells for around $100 a pair.

The illustration for the book combines retro illustrations, some of which came from Levi's archives.

RIGHT RETAIL PROGRAMS. LEVI'S CAPITAL E JEANS AND LEVI'S
CONCEPT MERCHANDISING ARE TWO PROGRAMS WHICH HAVE BENEFIT-
ED FROM ZIMMERMANN CROWE DESIGN'S VERSATILITY. CAPITAL E
JEANS ARE AN AUTHENTICALLY DETAILED VINTAGE LEVI'S PRODUCT
TARGETING HIGH-END BLUE JEAN AFICIONADOS. ZCD PRESENTED THE
CAPITAL E CONCEPT TO LEVI STRAUSS & CO. AS A WAY TO REGAIN
THEIR HERITAGE AS THE CREATOR OF THE ORIGINAL BLUE JEAN. LEVI'S
CONCEPT MERCHANDISING IS A PROGRAM THAT INTEGRATES LEVI'S
PRODUCTS WITH CURRENT MARKET TRENDS AT POINT OF SALE. THIS
EVERCHANGING PRESENTATION KEEPS THE LEVI'S SHOPS FRESH TO A
MARKET THAT IS EASILY BORED. IN BOTH CASES ZCD PROVIDES A
WELL-ORCHESTRATED PROGRAM THAT COMBINES VARIOUS MEDIA FOR
MAXIMUM IMPACT.

*The Capital E Box was
created to support the
high-end position-
ing of a product
not normally
sold in boxes.*

*ZCD released a series of eight
vintage countercards from
Levi's archives, all framed
behind glass to reinforce
the historic quality
of the product. ZCD
used turn-of-the-
century photos, engrav-
ings and illustrations from the
archives throughout the program.*

*This free-standing,
two-sided display was
designed with a small
footprint to accommodate
the space limitations
of many high-end
jean boutiques.
The display side
highlights the various
details of the jeans.*

*Details are paramount to the jean aficionado, and the display unit
romanticizes the most miniscule quirks of this vintage jean.*

ZCD created a corporate-
wide labeling system
inspired by Capital E that
reflects Levi's rich
150 year-old history.

The reverse side dis-
plays a vintage
Levi's countercard
with both folded
and packaged product.

The Capital E booklet was
produced as a miniature
version of the leather-bound
book and placed in the back
pocket of all Capital E Jeans
for added persuasion in the
dressing room. Often, that's
where the final buying
decision is made.

Details of free-standing display unit.

◀ *Modern Cowboy is replaced by the next Concept Merchandising trend—Retro Rave. The in-store video incorporates music and images associated with that trend.*

Hometown Blues replaces Retro Rave with a grungier look. ZCD created this window display as a guide to help retailers visualize the trend in their window. ▶

Sell-in easels explain the new trends to the trade and introduce new products and information. These easels are designed to make consistent presentations easy for Levi's massive sales force.

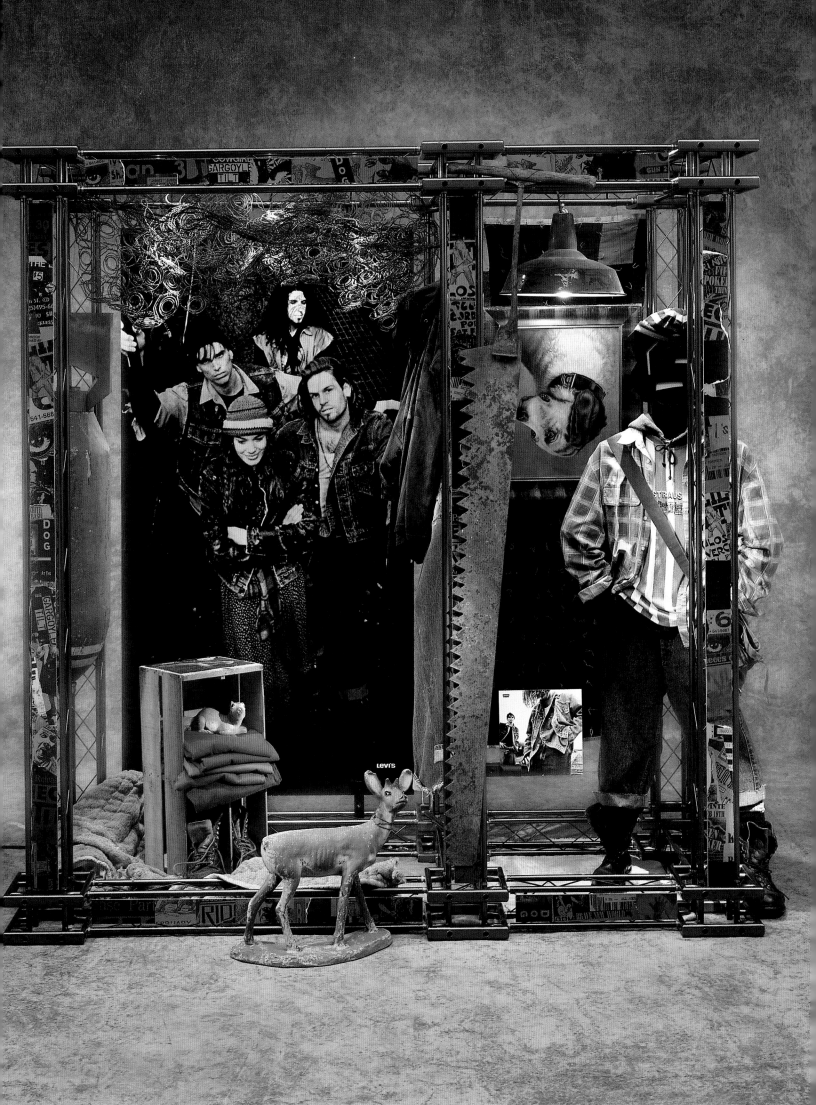

In-store video is an essential element of Concept Merchandisi[ng]. The video attracts consumers to the Levi's shop with sound and motion. ZCD designed, directed and produced all videos for the program, including this one for the Modern Workwear trend.

CONCEPT MERCHANDISING IS THE INTEGRATION OF LEVI'S PRODUCTS STYLED AGAINST A SERIES OF EVERCHANGING CURRENT MARKET TRENDS.

ZCD designed trend-specific mannequins like these two for Modern Workwear. Every few weeks the trend changes—keeping the Levi's shop fresh. This keeps the easily-bored target market coming back.

ZCD created these Workwear accessories to help support the trend at point of sale.

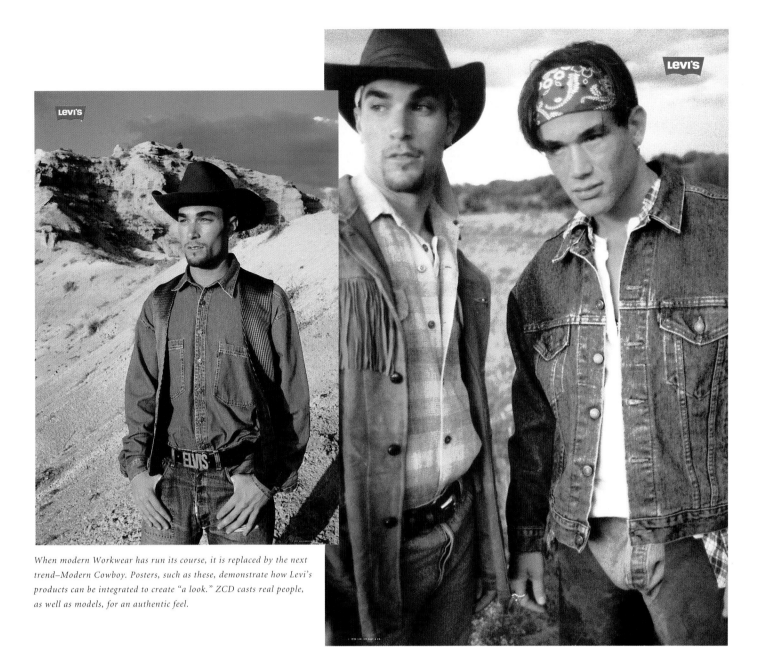

When modern Workwear has run its course, it is replaced by the next trend–Modern Cowboy. Posters, such as these, demonstrate how Levi's products can be integrated to create "a look." ZCD casts real people, as well as models, for an authentic feel.

These trend-specific shopping bags (Cowboy, Classic, Workwear) were designed oversized– to act as walking billboards for Levi's in malls across America.